D0783318

Painters of a New Century

Painters of a New Century:
The Eight & American Art

Elizabeth Milroy

with an essay by
Gwendolyn Owens

Milwaukee Art Museum

This exhibition is sponsored by the Lila Wallace-Reader's Digest Fund

September 6 - November 3, 1991 Milwaukee Art Museum

December 7 - February 16, 1992 The Denver Art Museum

April 16 - June 7, 1992 National Gallery of Canada

June 26 - September 21, 1992 The Brooklyn Museum

Painters of a New Century: The Eight is organized by the Milwaukee Art Museum. The exhibition is sponsored by the Lila Wallace-Reader's Digest Fund.

Additional local funding from Journal Communications: The Milwaukee Journal, Milwaukee Sentinel, WTMJ-TV, WTMJ-AM, WKTI-FM, Perry Printing Corp., Midwestern Relay Co., ADD Inc. Funding for printing of the catalogue was provided by the Donald and Barbara Abert Fund at the Milwaukee Foundation, as advised by Judith Abert Meissner, Barbara Abert Tooman, and Grant D. Abert. A planning grant was provided by the National Endowment for the Humanities, a Federal agency.

Cover: Robert Henri, *The Art Student, Portrait of Miss Josephine Nivison*, 1906, (see cat. no. 50). Milwaukee Art Museum.

Library of Congress Cataloging in Publication Data
Milroy, Elizabeth, 1954-
Painters of a new century: the Eight & American art / Elizabeth Milroy.
p. cm.
Includes bibliographical references and index.
ISBN 0-944110-08-8
1. Eight (Group of American artists)—Exhibitions. 2. Modernism (Art)—United States—Exhibitions.
3. Painting, Modern—20th century—United States—Exhibitions. I Title.
ND212.5.E4M5 1991 759.03'09'04107477595—dc20 91-4955
 CIP

© 1991 Milwaukee Art Museum.

All rights reserved

Edited by Lesley K. Baier
Designed by John Irion
Cover designed by Virginia Hilton
Typography by Susan Marie Kujawa
Type service by Trade Press, Inc.
Color separations by Quality Color Graphics. Printed by Burton & Mayer, Inc. Binding by Reindl Bindery.
Project coordinated by Mary Garity LaCharite

Dedicated to the

memory of Donald and Barbara Abert

Contents

Foreword

The Milwaukee Art Museum is very pleased to present **Painters of a New Century: The Eight**, one of the first museum exhibitions to survey the members of the independent exhibition held in 1908 at the Macbeth Gallery, New York, and certainly the first exhibition to place The Eight in the broader context of a volatile American art world at the beginning of the 20th century. We are gratified to have been the organizing institution for this important exhibition because the Milwaukee Art Museum houses an outstanding collection of School of The Eight works. While twelve of Milwaukee Art Museum works are included in this exhibition, the entire museum collection consists of ten paintings of various periods by Robert Henri, nine by Sloan, three each by Luks and Shinn, two each by Prendergast, Lawson, and Davies, and one by Glackens. In addition, the museum holds major works by Eight colleagues such as George Bellows and Jerome Myers. These paintings are supported by some fifty works on paper including large bodies of prints by Sloan and Bellows. Because a substantial body of these works are usually on view in the museum's permanent collection in a gallery specifically dedicated to The Eight, it seemed particularly appropriate that the museum should organize an exhibition examining the group's contribution to American art.

The Eight collection in the Milwaukee Art Museum is largely, but not entirely, the work of an extraordinary couple, Donald and Barbara Abert. Mr. Abert's long and distinguished career with the Journal began in 1943 as business manager. Progressively assuming greater responsibilities, Mr. Abert became company president and Journal publisher in 1968 and board chairman in 1977. Mrs. Abert shared a heritage of publishing: her father, Harry J. Grant, served as Chairman of the Board of The Journal Company from 1938 to 1963. This true newspaper couple conceived the idea of building a collection of School of The Eight works at the Milwaukee Art Museum that would reflect not only the origins of several of these artists as newspaper illustrators, but also the interest of all these artists in recording the life around them as America grew into the 20th century. Mr. and Mrs. Abert pursued their task assiduously, purchasing 28 works by the various members of The Eight between 1965 and 1981. Following Mr. Abert's death in 1985, Mrs. Abert and her children, Barbara Abert Tooman, Judith Abert Meissner and Grant D. Abert,

provided for the purchase of Maurice Prendergast's *Picnic by the Sea* of 1915, the crown jewel Mr. Abert had been seeking for the collection for some years. In 1988 a reinstalled central gallery dedicated to the School of The Eight was named in honor of the Donald and Barbara Abert Family in recognition of both their extraordinary support of the collection and the museum's operating endowment fund. At Mrs. Abert's death in 1989, a favored work by Henri and numerous prints and drawings came into the collection. The Abert children have continued to support the collection, particularly in the area of prints and drawings by The Eight and their contemporaries and have contributed generously to the support of this catalogue. It is in recognition of the tremendous dedication to building a collection of School of The Eight work in the Milwaukee Art Museum that this volume is dedicated to the memory of Donald and Barbara Abert.

In the realization of the exhibition, many others must be acknowledged. We are very grateful to the Lila Wallace – Reader's Digest Fund for the exceptional interest in and sponsorship of this exhibition. A $175,000 grant from the fund allowed the museum not only to realize the exhibition in a full form but to provide promotional and educational support that will bring the ideas of the exhibition to the greatest possible audience. We are also grateful to Journal Communications, Inc. for funding the local presentation of this exhibition. Journal Communications has long been a partner of the Milwaukee Art Museum, most recently sponsoring **100 Years of Wisconsin Art** as part of our centennial celebration in 1988, and we are particularly grateful to Chairman of the Board, Thomas J. McCollow, for continued support. Our thanks are also extended to the National Endowment for the Humanities which provided a planning grant for this exhibition. Special thanks must go to Elizabeth Milroy who initially conceived this project and has ably carried it through to its present form; to former Chief Curator James Mundy, now Director of Vassar College Art Gallery, who shepherded this project through its formative stages and approached the Lila Wallace – Reader's Digest Fund for support; and Mary Garity LaCharite, Director of Design and Publications, who was instrumental in developing this catalogue. I am grateful to all the Milwaukee Art Museum staff members who have participated in this project and to the many lenders without whom this exhibition would not be possible. Finally,

I would like to extend my appreciation to the staff of the participating institutions: Lewis I. Sharp, Director, and Lauretta Dimmick, Curator of Prints and Sculpture, Denver Art Museum; Dr. Shirley Thomson, Director and Michael Pantazzi, Curator, National Gallery of Canada; Robert T. Buck, Director, Roy R. Eddey, Deputy Director and Larry Clark, Curatorial Administrator, The Brooklyn Museum.

Russell Bowman
Director
Milwaukee Art Museum

Acknowledgments

Many individuals and institutions have contributed to the preparation of this exhibition and catalogue. Special thanks must go first and foremost to Helen Farr Sloan and Janet LeClair, who have encouraged so many students of The Eight and who gave freely of their valuable time and invaluable encouragement, and to the many private collectors who have generously lent their paintings to the exhibition. Thanks as well to Russell Bowman and James Mundy for inviting me to undertake this project; to William I. Homer, Elizabeth Johns, and Garnett McCoy who acted as senior advisers; to a cadre of very special research assistants, Elizabeth Fernandez-Gimenez, Leslie Udell, Lisa Weil, and Jon Sorenson, and to Milwaukee Art Museum staff members Vicki Hinshaw, Ruth Hall, Peggy Weiss, Mary Garity LaCharite, Susan Kujawa, John Irion, and Dedra Walls.

Colleagues whose particular assistance is greatly appreciated include: Cheryl Brutvan, Albright Knox Art Gallery; Doreen Bolger, Amon Carter Museum; Richard Wattenmaker and Jemson Hammond, Archives of American Art; Neal Benezra, Jack Brown, Susan Glover-Godlewski, Milo Naeve, and John Smith, The Art Institute of Chicago; John Driscoll, Babcock Galleries; Linda Ferber and Barbara D. Gallati, The Brooklyn Museum; Edward Lipowicz, Canajoharie Public Library and Art Gallery; Bruce Chambers; Rowland Elzea, Elizabeth Hawkes and Iris Snyder, Delaware Art Museum; Patti Junker, Elvejhem Museum, University of Wisconsin; Sally Mills, The Fine Arts Museums of San Francisco; Kathleen A. Foster, University of Indiana Art Museum; Ilene Fort and Michael Quick, Los Angeles County Museum of Art; Judy Barter, Mead Art Museum, Amherst College; Grant Holcomb, Memorial Art Gallery; John K. Howat and Barbara Weinberg, The Metropolitan Museum of Art; Theodore E. Stebbins Jr. and Carol Troyen, Museum of Fine Arts, Boston; Paul Schweizer, MunsonWilliams-Proctor Institute; Barbara Krulik and Elizabeth Arvidsen, National Academy of Design; Nicolai Cikovsky and Franklin Kelly, National Gallery of Art; Charles Hill and Michael Pantazzi, National Gallery of Canada; Harry Rand, National Museum of American Art; Linda Bantel and Cheryl Liebold, Pennsylvania Academy of the Fine Arts; Darrel Sewell, Philadelphia Museum of Art; Elizabeth Turner and Lisa Rathbone, The Phillips Collection; Harold O'Connell and D. Scott Atkinson, Terra Museum of American Art; David Park Curry and Fred Brant, Virginia Museum of Fine Arts; Linda Ayres and Elizabeth Kornhauser, Wadsworth Atheneum; Anita Duquette, Whitney Museum of American Art; Nancy Mowll Matthews, Williams College Museum of Art.

Many friends also gave assistance and encouragement: Elizabeth Anderson, Carla Antonaccio, Anthony Apesos, Carol Clark, John Coffey, Ellen G. D'Oench, Diane Dillon, Stephen Edidin, Charles Parkhurst, John Peterman, Ruben Piper, Annie Storr, Carolyn Smyth, Catherine Stover, Kathleen Walsh, and Rebecca Zurier. Last but by no means least, very special thanks to Lesley Baier, who edited light from the darkness.

Lenders to the Exhibition

Addison Gallery of Art, Phillips Academy

Albright-Knox Art Gallery

Mr. and Mrs. Arthur G. Altschul

The Art Institute of Chicago

Babcock Galleries

Blanden Memorial Art Museum

Bowdoin College Museum of Art

The Brooklyn Museum

The Butler Institute of American Art

The Carnegie Museum of Art

The Chrysler Museum

The Cleveland Museum of Art

Columbus Museum of Art

Dallas Museum of Art

Delaware Art Museum

Des Moines Art Center

The Detroit Institute of Arts

Everson Museum of Art

The Fine Arts Museums of San Francisco

Rita Fraad

Lana and Ben Hauben

Hirshhorn Museum and Sculpture Garden

Indiana University Art Museum

Kraushaar Galleries

Mr. and Mrs. Alan D. Levy

Mead Art Museum

Memorial Art Gallery of The University of Rochester

The Metropolitan Museum of Art

Milwaukee Art Museum

Mint Museum of Art

Mitchell Museum

Montgomery Museum of Fine Arts

Munson-Williams-Proctor Institute

National Gallery of Art

National Gallery of Canada/Musée des beaux-arts du Canada

National Museum of American Art

The Nelson-Atkins Museum of Art

New Britain Museum of American Art

James R. and Barbara Palmer

Philadelphia Museum of Art

The Phillips Collection

Phoenix Art Museum

Private Collection

Dr. and Mrs. Fouad Rabiah

Santa Barbara Museum of Art

Edward and Deborah Schein

Sheldon Memorial Art Gallery, University of Nebraska

Telfair Academy of Arts and Sciences

Terra Museum of American Art

University Art Museum, University of Minnesota

Virginia Museum of Fine Arts

Westmoreland Museum of Art

Whitney Museum of American Art

The William Benton Museum of Art, The University of Connecticut

Worcester Art Museum

Yale University Art Gallery

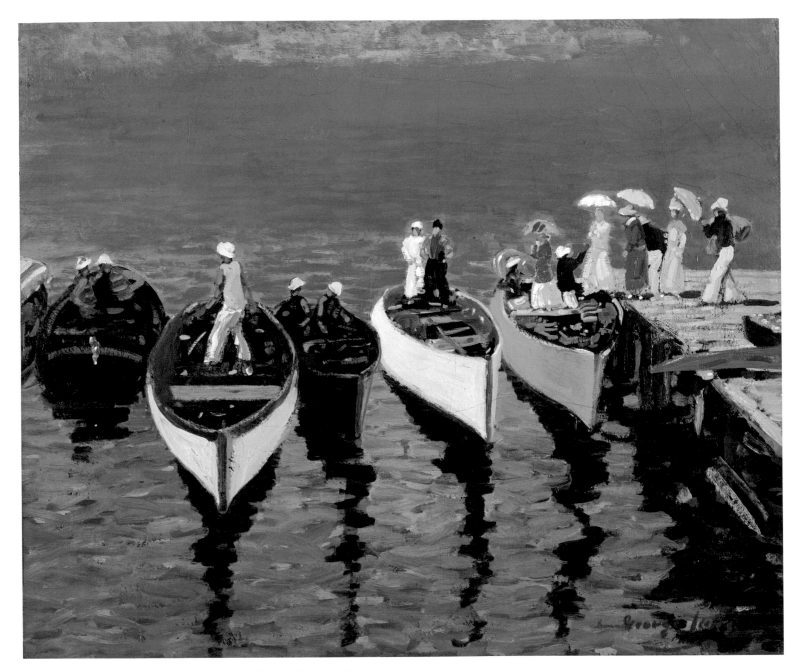

14

George LUKS, *Holiday on the Hudson*, ca. 1912. The Cleveland Museum of Art.

Introduction

During the first decade of the twentieth century, the independent art exhibition assumed unprecedented importance and effectiveness as an instrument for political and aesthetic change within the American arts community. Established institutions were undermined as artists challenged the authority of the academic tradition. Why were American artists in revolt? Because in order to be "of their time" — in effect, to be modern — they had to be. "A modernist likes to be thought a rebel," wrote painter and designer Arthur Wesley Dow, who defined modernism as the many forms of rebellion against the accepted and the traditional.[1] Controversy and confrontation, staged publicly in the exhibition rooms of museums, artists' societies, and commercial galleries, became essential components of the progressive artist's career.

At no time was this more effectively demonstrated than in 1908, when eight painters joined forces in a landmark independent exhibition at William Macbeth's commercial gallery in New York City. Between 1897 and 1917, Arthur Davies, William Glackens, Robert Henri, Ernest Lawson, George Luks, Maurice Prendergast, Everett Shinn, and John Sloan entered the front ranks of American artists and gained widespread respect as painters, teachers, and spokesmen for progressive ideas. Exhibiting together as "The Eight" in 1908, they transformed the art exhibition into political statement and media event and shifted forever the relationship between the American artist and the American public.

In their art and association, The Eight served as a sensitive barometer to the radical changes occurring in American art and culture during the first years of this century. They were also authors of a system of self-imaging and promotion that set a pattern for many compatriot successors. Important cultural issues underlie their shared history: the role of the artist in American society; publicity, self-promotion, and the marketing of art; the internal politics of American art exhibitions; the concept of artistic secession and revolt in America; the process of adaptation from European models, both stylistic and political; and finally, the evolving concepts of "modern art" and "modernism" among American artists and their audiences. The dynamics of interaction among The Eight before, during, and after their 1908 association tell us much about how one group of twentieth-century American painters made what they considered "modern" pictures for a public audience.

❧

When asked in 1943 to write a memoir of The Eight, group member Everett Shinn described the artists as rebellious interlopers who, with the "wind of enthusiasm at the back of their canvas" had voyaged out to find real life. According to Shinn, art in New York at the turn of the century had degenerated into affectation and decrepitude. In an era of overweening materialism and vulgar display, "a deceitful age, drugged in the monotony of pretty falsification," American art had become "merely an adjunct of plush and cut glass." But just as American art was "sinking lower and lower until our galleries and art institutions would have turned into markets for calendars, burnt wood, cigar box lids, cosmetic displays, sofa cushions — sugary and perfumed with the heavy odor of preservatives," The Eight had arrived to rescue their culture from an uncertain fate.[2]

The acerbic Shinn skillfully wove thirty-five-year-old memories into the stuff of legend. Yet historians have unquestioningly accepted his claims that The Eight labored in a barren environment to revive American art. One writer, calling them "warm, courageous human beings," credited The Eight with having "restored self-confidence and joy of life to American painting."[3] They have been described as a valiant band of rebels who "storm[ed] the gates of the establishment" and trounced the academy at a time when American art was "at its lowest ebb."[4] Crusaders for "an independent, indigenous American art free from academic restriction," The Eight are equally said to have reasserted the authority of native realism, inherited from its nineteenth-century masters Winslow Homer and Thomas Eakins, and to have forced their audiences to face the true appearance of American life.[5]

The Eight are frequently equated with the so-called Ashcan School, a felicitous but inaccurate term invented by Holger Cahill and Alfred Barr in the 1930s to describe urban realist painters

working in New York at the turn of the century, artists who brought "the gutsy vitality of common living into the staid atmosphere of the academies."[6] "What shocked the world of art was a preoccupation with types, localities and incidents to which Americans were conveniently deaf and blind," wrote Oliver Larkin in 1949; "A degree of strenuousness could be forgiven in the days of Teddy Roosevelt; but to paint drunks and slatterns, pushcart peddlers and coal mines, bedrooms and barrooms was somehow to be classed among the socialists, the anarchists and other disturbers of the prosperous equilibrium." So attractive is the concept of the Ashcan School that many writers now assume its existence, despite a complete lack of contemporary evidence documenting such a movement.[7]

What then of efforts by The Eight to win a forum for the free display of "American" subjects? In fact there was never a concerted movement isolated from the mainstream of American art to paint city life. During the first decade of this century many artists, not all of them in New York, painted and photographed the contemporary urban scene with varying degrees of verisimilitude. Artists who painted urban subjects were not automatically excluded from exhibitions or publicity, as witness the careers of Jerome Myers, Eugene Higgins, and George Bellows. To limit The Eight to such an estimation distorts both their intentions and their achievements. Certainly George Luks, John Sloan, and Everett Shinn made pictures of New York slums and trash-filled alleys. But William Glackens, Robert Henri, and Maurice Prendergast preferred parks and avenues. Ernest Lawson found pure landscape, not social commentary, in Manhattan and the Bronx. Arthur Davies found dreams. Nor were Prendergast, Lawson, and Davies eccentric adjuncts to an "urban" core headed by Henri and Sloan, but rather equal members of a carefully assembled coalition.

Yet the popularity of the "Ashcan School" label and the pervasive assumption that The Eight were marginalized artists who had to fight their way into the American mainstream, have prompted many historians to treat them as a self-contained and isolated group.[8] Little attention has been paid to their interaction with the larger artistic community. The fact remains that these eight men came together to organize an art exhibition, demonstrating "for the first time in America, that a group of artists who were strongly anti-academic could attract wide public notice and financial return — not as curiosities, but as significant artists who honestly spoke the language of their own time and place."[9] In effect, the Eight became America's avant-garde, combating heterodoxy to spearhead American art into the twentieth century. From 1908 it was a short five years to the Armory Show and the triumph of modernism in America.

The Eight shared a belief in the power of independently organized exhibitions of protest against the art establishment to stimulate the forward progress of modern American art. A wealth of models supported this conviction, from the already legendary Impressionist exhibitions of the 1870s and 1880s in Paris, to the more recent independent exhibitions mounted by "the Ten" and Alfred Stieglitz's Photo-Secession in New York. Indeed, the nationalistic program articulated by The Eight took its inspiration and rhetoric from the very source the artists professed to reject — contemporary Europe.

By 1908, the independent group exhibition had long been a familiar ritual among the European avant-garde. Renouncing academic conventions, progressive artists experimented with new techniques and pictorial idioms. The making and exhibiting of art became a confrontational process as each group promoted their own innovations. Such challenges to academic standards carried broader political implications. In many European countries, the "Academy" had come to mean centralized state administration of the arts. Government bureaucracies created national "aesthetic policy" through state patronage, the administration of professional schools, and indirect influence on the marketing of art. The gradual erosion of this centralized authority would prompt profound changes in public perception of the artist's status and function, and in systems of public presentation and the marketing of contemporary art.

This modernist ritual clearly required a target of established authority. The Eight found theirs in New York's venerable National Academy of Design, which they successfully promoted as representative of a monolithic "academic" hegemony. In truth there was no central institution or "Academy" responsible for a national aes-

thetic policy in the United States. Government administration of the arts, whether state or federal, did not exist. By the 1890s, the American system of making and marketing art, like most industries in the republic, was diversified both locally and nationally. Art students could attend any of a number of schools nationwide: there was no government school like the French Ecole des Beaux Arts, though several American art schools had adopted the Ecole's curriculum. Nor was there a national exhibition or "Salon." Museums, exhibiting societies, and commercial galleries across the country offered a growing variety of exhibition venues.

Although many conservative artists and critics disliked the inelegant subject matter or rough-hewn technique of Henri, Sloan, and their colleagues, such opposition did not prevent their participation in mainstream exhibitions. All of The Eight had become important contributing members of the American arts community even before 1908. Their paintings were seen, perhaps not always at the National Academy, but often and advantageously in other settings, a fact noted in several newspaper reviews of the Macbeth Galleries exhibition. Indeed, in cities other than New York, these artists were fairly successful. Exhibition catalogues from the Pennsylvania Academy of the Fine Arts, the Carnegie Institute, the Art Institute of Chicago, the Corcoran Gallery, and the many other institutions outside New York that sponsored contemporary art exhibitions document the regular participation of The Eight. And despite their vociferous criticism of the National Academy, most members of The Eight maintained ties with that institution. Even as their group exhibition was leaving New York on tour, Arthur Davies' widely-praised painting *Unicorns* was on view at the National Academy's 83rd Annual. Three of The Eight would send paintings to the National Academy for exhibition the following winter; and in 1909, William Glackens served as a member of its selection jury.

Late in life, John Sloan recalled that he and his seven colleagues had come together simply "because it was a real chance to see groups of our own work exhibited properly in a gallery instead of being skyed."[10] Sloan credited reporter James Gregg of *The Evening Sun* and other newspapermen with having created the "hulabaloo." But Sloan and his fellows knew well how to catch the attention of their reporter friends and thence the public. All eight were members of the generation whose careers had coincided with the rise of popular illustrated magazines, mass pictorial advertising, and sensationalist journalism. Six — Davies, Glackens, Luks, Prendergast, Shinn, and Sloan — had begun their careers working for commercial publishers. And four — Glackens, Luks, Shinn, and Sloan — had worked as artist-reporters or illustrators on the editorial staffs of major dailies first in Philadelphia and then in New York. Not only were they familiar with the inner workings of the popular press, they also appreciated the power of well-orchestrated publicity. Indeed, several in the group subscribed to clipping services to keep abreast of current art reviews.

Thanks to the attention and support of such New York-based news writers and art critics as James Gregg, Charles Fitzgerald, Charles De Kay, and James Huneker, The Eight garnered extensive publicity. The full-page spreads that announced the Macbeth Galleries exhibition, featuring photographs of the artists and their works, garish illustrations, and blaring headlines that overwhelmed the written commentary, were unprecedented in the coverage of American art events. Art was making news. At a time when New York boasted over two dozen English and foreign-language newspapers, Philadelphia and Chicago each a dozen, the headline reigned supreme. Daily newspapers provided avid American readers with information and entertainment. And though the heyday of yellow journalism was past in most American cities, editors and reporters still appreciated the effectiveness of a little sensation in selling newspapers. Words like "rebellion" and "revolt" caught a reader's attention, especially when those terms appeared in the otherwise sedate columns of the Women's pages, to which art reviews were typically relegated. During the first week of February 1908, The Eight had to compete with a royal assassination in Portugal, delivery of a verdict of "not guilty by reason of insanity" in the spectacular and interminable trial of architect Stanford White's murderer Harry Thaw, and the ongoing dispatches from the United States Navy's "White Fleet," which had recently commenced a circumnavigation of the globe ordered by Theodore Roosevelt to advertise America's growing military power. Yet so effective was the publicity generated by The

Eight that long after they had dispersed, the art press continued to think of these men together.

With the 1908 Macbeth Galleries exhibition, The Eight assumed leading roles in an ongoing debate about the status of art exhibitions in American society. American artists had initially benefitted from the national exhibition circuit because it enabled them to display their work far afield and to a diverse public. But this transcontinental circuit also complicated the introduction and evaluation of new trends and the assertion of new leadership at a time when the increasingly radical language of modernism demanded swift change. Conservative and progressive artists and critics alike debated the proper structure and function of exhibitions. Should they be juried? Could any exhibition be all-inclusive and therefore truly democratic? Or was the public better served by smaller selective gatherings of high quality? Who then would determine that quality? Indeed, who was the audience? Were art exhibitions even relevant in a society where most citizens showed little if any interest in the fine arts?

The Eight proved that the ostensibly uninterested American public would attend an art exhibition if its curiosity was whetted by a well-orchestrated and pervasive publicity campaign and satisfied by thought-provoking exhibition pictures. Moreover, they achieved this not as marginalized interlopers, but as respected artists working from *within* the establishment. For The Eight and the artists who later joined with them to organize the 1910 Exhibition of Independent Artists, the Armory Show of 1913, and the Society of Independent Artists in 1917, were actually building upon a plan long espoused by liberal elements within the National Academy itself. Well-orchestrated publicity and astute politicking enabled these artists to implement that plan and initiate changes in art exhibitions, first in New York and then nationwide, thereby revolutionizing the way in which the American public saw and comprehended contemporary art.

❧

EXHIBITION
OF
PAINTINGS
BY
ARTHUR B. DAVIES
WILLIAM J. GLACKENS
ROBERT HENRI
ERNEST LAWSON
GEORGE LUKS
MAURICE B. PRENDERGAST
EVERETT SHINN
JOHN SLOAN

FEBRUARY THIRD TO FIFTEENTH
MCMVIII

MACBETH
GALLERIES
450 FIFTH AVENUE
NEW YORK

Catalogue for the exhibition of paintings by "The Eight" at the Macbeth Galleries in New York. American Antiquarian Society Collection, Worcester, MA. Photograph courtesy the Archives of American Art, Smithsonian Institution, Washington D.C.

1. Arthur Wesley Dow, "Modernism in Art," *The American Magazine of Art* 8 (January 1917), 113-16.

2. Everett Shinn, "Recollections of The Eight," in *The Eight* (Brooklyn: The Brooklyn Museum, 1943-44), 22.

3. E. P. Richardson, *Painting in America* (New York: Thomas Y. Crowell, 1956), 362.

4. James MacGregor Burns, *The Workshop of Democracy*, vol. 2 of *The American Experiment* (New York: Random House, 1985), 310.

5. William Innes Homer, "The Exhibition of 'The Eight': Its History and Significance," *American Art Journal* 1 (Spring 1969), 53. See also Bennard Perlman, *The Immortal Eight: American Painting from Eakins to the Armory Show, 1870-1913* (Cincinnati: North Light Publishers, 1979).

6. Holger Cahill and Alfred H. Barr, Jr. *Art in America: A Complete Survey* (New York: Reynal & Hitchcock, 1934), 91.

7. Oliver Larkin, *Art and Life in America* (New York: Rinehart, 1949), 336. By the 1980s, Alan Trachtenberg would call the Ashcan School "a concerted movement to depict city life in its daily unheroic scenes" (*The Incorporation of America* [New York: Hill and Wang, 1982], 183). Literary scholar Peter Conn, writing at the same time, assumed that formation of The Eight was motivated solely by this new subject matter, ". . . dirty streets, threadbare interiors; eccentric, even disreputable people." See *The Divided Mind; Ideology and Imagination in America, 1898-1917* (Cambridge: Cambridge University Press, 1983), 259.

8. See Mahonri Sharp Young, *The Eight* (New York: Watson-Guptill, 1973).

9. Homer, 63.

10. Late in his life, John Sloan dictated reminiscences to his wife Helen Farr Sloan, who transcribed her notes in a 1950 typescript, hereafter cited as Sloan, Notes. The typescript is now on deposit with the John Sloan Papers at the Delaware Art Museum, Wilmington.

19

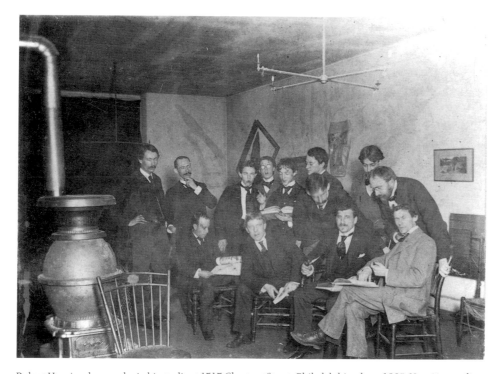

Robert Henri and comrades in his studio at 1717 Chestnut Street, Philadelphia, about 1895. Henri is standing at left, Glackens stands at center holding a book, Sloan is to his left. Archives, Helen Farr Sloan Library, Delaware Art Museum.

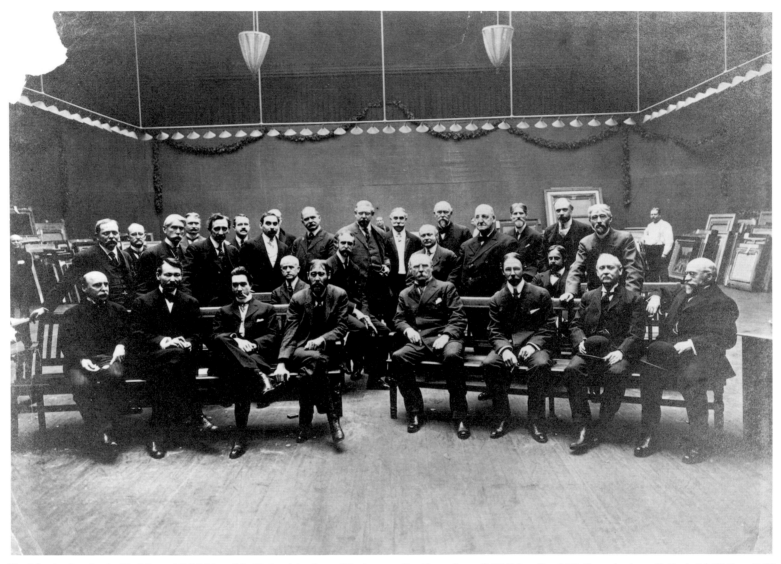

The Selection Jury for the 82nd Annual Exhibition of the National Academy of Design, March 1907. Front row (l-r): Samuel Isham, Robert Henri, F. Luis Mora, Kenyon Cox, Frederick Dielman, Irving R. Wiles, H. Bolton Jones, C. Y. Turner. Back row (l-r): Edward H. Potthast, William H. Howe, Henry B. Snell, Carlton Chapman, Elliott Daingerfield, Frederick G. R. Roth, Louis Loeb, Edwin H. Blashfield (behind Loeb), Ben Foster (seated), W. T. Smedley, J. W. Alexander (seated), Frederick W. Kost, H. W. Watrous, F. Coates Jones, J. F. Murphy, G. W. Maynard, Emil Carlsen, William Sergeant Kendall (seated), Herbert Adams, Leonard Ochtman. Courtesy of the National Academy of Design, New York.

Modernist Ritual and the Politics of Display

Transition and Challenge at the National Academy of Design

To understand the artistic climate in which The Eight's 1908 "rebellion" arose, one must go back to 1897, when the National Academy of Design sold the "Venetian Palazzo"-style building on East 23rd Street that had housed its art school and exhibition galleries for twenty-five years.[1] The Academy planned to move eighty blocks north into quarters yet to be constructed on 110th Street near the new Episcopal cathedral of Saint John the Divine in Morningside Heights. But financial uncertainties delayed construction, and the Academy was forced to find temporary accommodations after vacating the old building in 1899. A temporary building was erected on West 109th Street to house the art school and library. And beginning in 1900, the prestigious spring exhibitions held annually since 1826 were presented at the Fine Arts Building on West 57th Street, a facility built in 1892 to house the Art Students' League, the Architectural League, and the Society of American Artists.

In mid-March 1905, the school building on 109th Street was badly damaged in a fire that destroyed school records, several paintings and prize drawings, as well as much of the teaching collection of plaster casts. Within a week classes had reconvened in facilities provided by Columbia University. But the fire prompted many of the Academy's two hundred members to re-examine the organization's pedagogical activities. In May, Academy president Frederick Dielman met with Columbia University president Nicholas Murray Butler to discuss transferring control of the art school to the university. Agreement was readily attained as the transfer proved equally advantageous to both institutions, providing impeccable academic accreditation to aspiring artists while furnishing Columbia's young art department with an impressive pedigree. Having thus secured an independent future for the art school, the Academy administrators turned their attention to expanding the scale and influence of the Academy's spring annual.[2]

To this end the Academy began negotiating a merger with its rival of almost thirty years, the Society of American Artists. The Society had been founded in 1877 when several young artists, including William Merritt Chase, Kenyon Cox, and Augustus Saint-Gaudens, returned to New York from professional schooling in Europe and, frustrated by the nativist bias of older National Academy members, broke away to start their own exhibiting society. Considered a more liberal, progressive association, the Society sponsored an annual exhibition of paintings and sculpture that competed with the Academy's yearly spring display. Of late, however, the Society's aging membership had grown more moderate. Indeed, by 1897 many of the Society's founders had been elected National Academicians. And the exhibitions of both institutions, featuring many of the same artists, were scarcely distinguishable especially after the two began sharing the same exhibition space in 1900.[3]

A merger of the Society and the National Academy promised to radically alter the balance of power within the New York arts community, setting the stage for a joint New York exhibition that in both size and scope would truly rival the great Parisian Salons. In a statement to the press in April 1905, Academy secretary C. Y. Turner explained:

> We have long felt the necessity of broadening the scope of our exhibitions. The moving of the schools to Columbia will give us the opportunity. . . .We are now free to join hands with the American Society of Artists [sic] and other similar organizations to work for a building where we may hold an annual national salon.[4]

Young's hopes were echoed by Society president (and by then Academician) Kenyon Cox, who suggested that the Academy's exhibition program had been handicapped by academic commitments. Cox rued the popular impression that New York's art interests were divided into warring factions, and he looked forward to the "union of these two societies on a dignified plane."[5]

At a series of conferences held in 1905 and early 1906 to draft a new constitution, Academicians and Society members debated rules and procedures pertaining to meetings, elections, and methods of selecting pictures for exhibition. The terms of the amalgamation

called for important changes to the Academy membership structure. The number of full Academicians was doubled from one hundred to one hundred and twenty-five painters, twenty-five sculptors, twenty-five architects, and twenty-five engravers. Limits on the number of Associate members, hitherto also restricted to one hundred, were removed, and an annual Associates' exhibition to be held in late fall was initiated. Associates were furthermore granted voting power in the election of new Associates and the nomination of Academicians; future elections would permit the admission of no more than ten Associates per year to the rank of full Academician. Finally, the size of the annual exhibition selection jury was increased from nine members to twenty-seven. Formal amalgamation was announced on April 7, 1906 and the Society of American Artists ceased to exist.[6]

But amalgamation did not ensure the end of artistic squabbles. Even before it was finalized, jury deliberations for the 82nd Annual — the first combined spring exhibition — revealed the same dissatisfactions that had originally led to the formation of the Society of American Artists. On March 3, 1907, two days after the selection jury began to examine submissions, Robert Henri walked out to protest what he considered to be irregularities in the selection process. During deliberations, Henri had proposed that several paintings, initially rejected but brought back for reconsideration, be studied in a separate room (that is, away from works already selected) to ensure a fair revisionary vote. Though this was contrary to standard practice, the jury complied. Yet few of the twenty-seven jurors made an effort to review the paintings and the rejections went unchanged. Revisions were made, however, to the evaluation of works that had initially won selection. And here Henri himself was a victim of jury reappraisal. On the first round of votes, jury members gave two Henri portraits — *Colonel David Perry* and the matador *Asiego* — a grade of "1," signifying unanimous approval. His third submission, *Gypsy Mother and Child*, was rated "2" for approval by a majority. After the second round of votes, however, *Asiego* was downgraded to a "2." Angered at the slight, Henri promptly withdrew both Spanish portraits, leaving only the *Perry* for exhibition.

Later, while viewing the completed installation of works, Henri inquired as to why two approved paintings, one by George

Luks, the second by Carl Sprinchorn (one of Henri's students) were not on display. Told there was insufficient room, Henri noted a blank wall space and insisted that the pictures be hung. The jury at first conceded, but when Henri returned the next day, he discovered that both works had been removed to storage with the explanation that they disturbed the "mural effect" of the gallery wall. "I don't care for the wall, I only care for the men," Henri was later said to have retorted.[7]

In frustration, and perhaps according to premeditated plan, Henri boldly took his disagreements to the press, assuring both publicity for himself and his cause. The New York *Evening Post* of March 13, 1907, was the first to report Henri's withdrawal of two canvases. "As the various paintings were placed before the jury and votes were taken, Mr. Henri evidently became impressed with the belief that some painters, young and old, who had brought into their work new and original notes, individual expression of life and its philosophy, were not faring as they should." The situation was described as "extremely delicate."[8]

Henri's fellow jurors and Academy members publicly claimed to be unperturbed by his protest to the press. "Mr. Henri's case is not unique," Kenyon Cox stated. Dissension was the rule, not the exception in Academy deliberations.[9] Indeed, as reporters interviewed other jury members, they discovered that unanimity was seldom reached on any issue or decision. "We all give Henri credit for standing by his men," commented C. Y. Turner. This was simply a case of one man against the majority. "He seemed to show some personal spirit when he withdrew his pictures," said Dielman, "but as far as I and the other members of the jury are concerned, I don't believe there was any personal feeling at all."[10]

Privately, however, these men were incensed that Henri had abused the privilege of membership to court publicity from a news-hungry and not always discriminating press. Academy members were well aware of the weaknesses of the jury system, but felt there was no fairer way to select the approximately three hundred canvases which the Fine Arts Building galleries could accommodate, from among the hundreds of entries received for each exhibition. Any artist

who submitted work was implicitly expected to honor the jury's decisions. In his Annual Report of May 1907, Dielman decried the villifications and misrepresentations mounting against the Academy in the press, encouraged by "the cheap heroic attitude of the champion of the oppressed genius and the prospect of a row." Yet the Academy issued no official public rebuttal, relying instead on the good will of the discriminating few among the exhibition-going public who would disregard the controversy.[11]

Once sparked, however, the interest of the press and the public in Academy affairs intensified. In April, the Academy's membership policies came under scrutiny when only three artists from the thirty-six nominated were elected Associates, obviously contradicting the goals implicit in the recent liberalization of membership. Criticism centered on this inconsistency and on the credentials of the three successful candidates: printmaker and Whistler biographer Joseph Pennell, and two relatively little-known painters, Robert Brandegee and Frederick Williams. By comparison, as the press asserted, the thirty-three unsuccessful candidates, who formed a veritable cross-section of the New York arts community, included some of the "most gifted and accomplished candidates for associate membership nominated in recent years." All were Academy exhibitors (a requirement for nomination) and some were prize-winners. The noted Impressionist Willard Metcalf was not elected, nor were well-known painters and regular Academy exhibitors Colin Campbell Cooper, Charles Hawthorne, and Albert Sterner, or the up-and-coming young sculptress Edith Woodman Burroughs, winner of the Julia Shaw Memorial Prize at that year's 82nd Annual. Those rejected also included Henri's friends Arthur B. Davies, Ernest Lawson, Henry Reuterdahl, and Jerome Myers.[12]

The press reported that the election results represented the conservative camp's response to Henri's very public protest a month before. Their suspicions were confirmed by the election, at the same meeting, of the selection juries and hanging committees for the next two Academy exhibitions. Though he had served on the selection jury twice, Henri's name was conspicuously absent from both lists. Said one unnamed artist, "It means the progressives will stand no chance."[13]

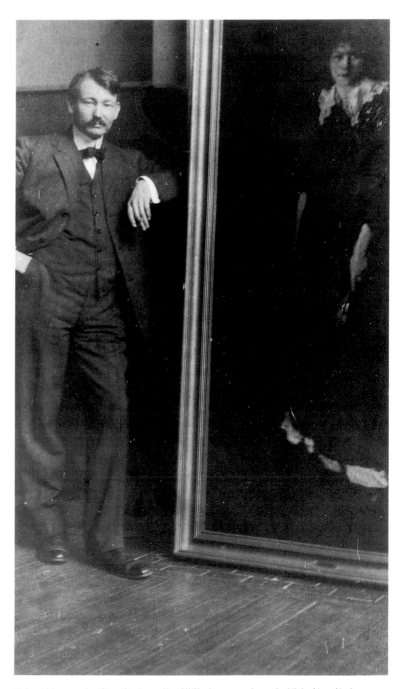

Robert Henri in his New York studio, 1906. Courtesy Janet LeClair, New York.

Again publicizing his outrage in the press, Henri — now described as "the leader of the progressive minority" — accused the National Academy of reactionary conservatism. The artists who were not elected were among the country's best and strongest, progressives who had broken away from convention to depict "life as they see it." "It is not a question of a lot of striving youngsters against a lot of arrived old men. It's a question of good art against bad." Henri suggested publicly for the first time that the rejected artists should sidestep the Academy and hold their own exhibitions: "small or large group exhibitions so that the people may know what the artists who have something important to say are doing."[14]

In pursuing this story, the press interviewed artists known to be Henri's close associates. John Sloan called the Academy's actions "honest stupidity." He had submitted two paintings to the 82nd Annual. One, a portrait called *Foreign Girl* was rejected; the other, a view of a Bayonne, New Jersey park entitled *Picnic Grounds,* was accepted. Although the painting was hung above the line, Sloan noted in his diary that it was "plainly to be seen and I think it looks right well." He nonetheless concurred with Henri's assessment of the Academy vote. Academicians were blinded by convention. "They simply don't see life the way we other painters see it and for that reason they cannot see any art in our pictures." "The Academy is doing everything for itself and its members and nothing for American art," added Henry Reuterdahl, another Henri associate. "If it is the guardian of American art, as it pretends to be, it ought to give the young man a chance."[15]

Such angry outbursts made news, and rumors of revolution in the New York art world began to circulate. Sloan, Jerome Myers, George Luks, and William Glackens were named with Henri as leaders of this "revolutionary" new movement. "A sturdy strain runs through this body of artists," declared Samuel Swift in *Harper's Weekly*. "There is virility in what they have done, but virility without loss of tenderness; a manly strength that worships beauty, an art that is conceivably a true echo of the significant American life about them." These were artists who "convince us of their democratic outlook." Yet Swift questioned whether the Academy would ever encourage such new elements in American art: "Or will it continue hostile, and thus force this unconquerable new expression to seek or make some quicker channel?"[16]

Charles De Kay, senior art critic at *The New York Times* and longtime spokesman for the Society of American Artists, published his own challenge to Robert Henri after the notorious Academy vote in April. Asserting that outside opposition was healthier than internal squabbling, he questioned Henri's motives in remaining a member of the Academy. In fact however, De Kay perceptively recognized Henri's motivation, "because things turn out exactly as he knew they would, [Henri] insults his fellow jurors and poses as a martyr." De Kay dismissed the National Academy as a moribund institution that continued to operate only because artists were impressed by the title "academician." "Let the young outsiders come together and form a new organization of a lively, militant sort which will attract innovators and at the same time keep the Academy from going to sleep."[17]

Robert Henri and the Nationalist Cause

The author of this controversy was a forty-three-year-old painter. Tall and rangy, with handlebar mustache and high cheekbones, Robert Henri spoke with a soft Nebraska drawl and called himself "Hen-rye." Although he affected a quiet, diffident manner, Henri was in fact a powerful, charismatic man and a born teacher. An article published in *Vogue* several months before the controversy already described him as magnetic: ". . . no one could see and talk with him for five minutes, meeting him as an absolute stranger, without feeling the force of his personality."[18]

Henri had arrived in New York in 1900, after a decade spent studying and teaching in Philadelphia and Paris. He carried impressive credentials — in 1899, his painting of a Paris street, *La Neige*, was purchased from the Paris Salon by the French government for the contemporary art museum at the Palais de Luxembourg.[19] Once settled in New York, by submitting his paintings successfully to exhibitions at both the National Academy and the Society of

John SLOAN, *Stein, Profile* (also called *Foreign Girl*), 1905. Collection of Dr. and Mrs. Fouad A. Rabiah.

American Artists, Henri quickly distinguished himself as a talented landscape painter and portraitist. In the brochure published for his 1902 one-man show at the Macbeth Galleries, art dealer William Macbeth praised Henri's "terse way of insisting on that only which is worth remembering of the scene before him."[20] Critics likened his work to Manet and Whistler, and by 1905 Henri was building a respectable roster of portrait clients. Occupying the second rank of New York portraitists, he attracted sitters who wanted the cachet of a New York artist but could not, or would not, pay the fees charged by William Merritt Chase or other leading practitioners. In 1903, Henri was elected a member of the Society; election to the rank of Associate at the Academy came in 1905, election to full Academician a year later.

John Sloan, who had been Henri's closest friend for fifteen years, described him as "the master." "In fact he had been called 'the old man' from the time he was nineteen, and one was a follower or in the opposition. In all the years of our close friendship, I always looked up to him as a disciple and never dreamed of crossing him."[21] Sloan considered the 1907 jury's deliberations an insult, writing in his diary: "The puny, puppy minds of the jury were considering his work for #2, handing out #1 to selves and friends and inane work and presuming to criticize Robert Henri. I know that if this page is read fifty years from now it will seem ridiculous that he should not have had more honor from his contemporaries."[22]

Theodore Dreiser, then editor of *Broadway* magazine, likewise lamented in the March 1907 issue that Henri's recognition as a painter abroad was not matched at home: "But if New York does not know Robert Henri the reverse cannot be said. Henri does know his New York and he has a school of followers who go with him to the tenements and the alleyways to paint — Glackens, Sloan, Shinn to name a few of them. 'New York is better than Paris for artists,' says Henri, 'Stop studying water pitchers and bananas and paint every day New York life — a Hester Street pushcart is a better subject than a Dutch windmill.' "[23]

In fact, however, Henri's renown stemmed chiefly from his effectiveness as a teacher. Since 1902 he had been a member of the faculty of the New York School of Art, founded by William Merritt Chase in 1896. Henri taught and led by sheer force of personality. Popular with students, he gained a reputation as a "progressive" because he opposed academic conventions and technical formulae and insisted on the power of instinct and observation, disciplined by memory. A 1906 newspaper profile singled him out as the mentor of a band of art students who had moved into the Lower East Side to paint dark, lusty images of the Manhattan cityscape and its denizens.[24] A year later, Henri's growing influence in the New York School forced Chase to resign his post. Whereas the older artist advocated technique and discipline, Henri encouraged intuition. "Art is draughtsmanship," Chase declared to an interviewer at the time of his departure, "Color is the natural gift of the artist, but without drawing and a thorough understanding of it, no supremacy in art can be obtained." To which Henri responded, "Because I do not require my student to draw a map of the model and keep his ideas subordinate to the sense of outline, I am criticized . . . I do not teach my students to lean on what I say or what I see. I want them to see for themselves."[25]

It is not surprising, given Henri's personal magnetism and the esteem in which he was held by many fellow artists and critics, that his conflict with the Academy won him sympathy and support. Within a week of his dispute, talk of a "split" began to circulate among John Sloan, William Glackens, Ernest Lawson, Jerome Myers, and other artists in Henri's circle. Although several had exhibited together in the past, no particular group had yet coalesced and ideas and suggestions came from many quarters. At the end of March, Myers broached the subject of forming a rival Society or Academy to Sloan, who doubted they possessed the business abilities necessary to succeed in so ambitious a venture. But plans for some kind of exhibition were already taking shape. "The time seems to be quite ripe for such a show," Sloan noted in his diary on 18 March.[26]

On April 4, Henri hosted an after-dinner meeting to discuss the planned exhibition. "Henri, Luks, Davies, Glackens, Sloan and Lawson were present," Sloan recorded, "and the spirit to push the thing through seems strong. I am to take charge of the money for the purpose. Henri to do the correspondence."[27] Sloan, whose apartment

became something of a meeting-place, recorded the steady activity in his diary. Henri unsuccessfully approached the manager of the American Art Galleries about renting space. Davies had better luck in persuading his dealer William Macbeth, who also handled the work of Henri and Luks, to make the Macbeth Galleries available the following winter. Glackens and Everett Shinn joined in the planning efforts, and Lawson and Luks agreed to participate. On May 2, Sloan went to Henri's studio to meet "the crowd" — Glackens, Lawson, Davies, Luks, Henri, and Shinn. "Each man, save Shinn, 'forked up' his fifty dollars toward an exhibit at Macbeth's Galleries next winter. Lawson will give check tomorrow, Shinn also." By mid-May, Davies had received a letter from Boston artist Maurice Prendergast voicing strong support for the exhibition project. With his promise to participate, the final group of eight artists was determined.[28]

On May 15, 1907, just two months after Henri left the Academy jury, the eight "independent" painters announced in the press that they would hold a group exhibition the following winter in Macbeth's Fifth Avenue galleries. "We've come together because we're so unalike," read the group's press statement.[29] Each of the eight in fact owned a distinctly individualistic approach to the rendering of what the artists would call "reality"; and all shared a desire to advance the cause of American art. "We want true American art, and not bad copies of foreign artists," said George Luks; "What we have decided to do is for the best interests of the future of American art. It will give the people of this city a chance to see true American art."[30]

The artists insisted that their association was an informal one and that they did not intend to rival or challenge any existing organizations. Indeed it was reported that several members of the new group planned to continue submitting their pictures to Academy exhibitions.[31] Since all exhibited frequently in New York and hence were known to, if not equally appreciated by, the arts community there, they had no need to organize an American "Salon of the Refused." Such disclaimers notwithstanding, however, they planned eventually to acquire a gallery large enough to accommodate one or two hundred canvases in order to mount a regular schedule of shows. And there was already discussion of inviting other artists — perhaps even English ones — to contribute to subsequent exhibitions.[32]

The pretense of non-competitiveness contradicted both the artists' reputations and the timing of their announcement. Unchallenged by the Academy, Henri could command the news-hungry media. Eloquent and effective, if verbose, he was always delighted to issue pronouncements — especially when asked for his opinion of the National Academy of Design's organizational responsibilities:

> The fact of a National Academy should mean an organization for the advancement of the art of those who have new ideas to express. That there are such men is the encouraging sign for the future of art in this county, and they should be brought forward and sustained instead of rebuffed in their efforts for recognition. Because they do look through the veil of accustomed things and catch an original point of view, is no argument against their art — on the contrary, it is this element which should entitle them to recognition as seers who, out of a humdrum life of ruts, have abstracted a new point of view, a new story, a new element of life.[33]

Henri cunningly injected the issue of nationalism into the controversy. The Academy discriminated not against artists who were mediocre painters, but against artists who were truly *American*. If a selected exhibition is necessary, then devote such a show to the country's one hundred best artists, Henri proposed. The National Academy needed to offer "something broader in scope, something that will reveal the true progress of art in America." The truly enlightened exhibition sponsor would display a "comprehensive, patriotic viewpoint" and would welcome such artists as Luks, Glackens, Sprinchorn, and Rockwell Kent "with honor."[34]

In both headlines and text, the press advanced Henri's cause. Dubbing the association "The Eight," it paired nationalism with the struggle against marginality in portraying the artists as a valiant band of patriots battling the monolithic National Academy. Early newspaper reports put all eight artists at the center of the recent "Academy controversies." *The Sun* identified each according to his record of rejections there, and the group exhibition was widely advertised as a slap in the face of this venerable institution whose discouragement of new and original ideas in American art had

precipitated the actions of The Eight.[35] The *New York Herald* labelled the planned exhibition a "new Salon," organized by "Men of the Rebellion" and led by Robert Henri "to an artistic promised land."[36]

When the exhibition opened nine months later, publicity continued to herald The Eight as rebels in the cause of American art. They were "artists whose work is representative of the best that America has yet achieved in painting . . . men who are not afraid to put into their work the big, vital, simple conditions and experiences of life," argued Mary Fanton Roberts, writing as Giles Edgerton in the February 1908 issue of *The Craftsman*. Her article, entitled "The Younger Painters of America, Are They Creating a National Art?" was illustrated with their works as well as portrait photographs of the artists themselves.[37]

Citing the uniqueness of America's frontiersmen and the independence and innovation of her inventors, educators, and scientists, Roberts lamented that in art, "the blight of imitation is still upon us." The art of Europe was an acceptable guide or teaching tool, but sophisticated imitation could not replace the artist's grasp of truth. Why copy continental themes when the United States offered a rich variety of subjects for all who would look, Roberts insisted. Simplicity, even provincialism were not without merit: "The art that is worth recognizing as a phase of national life is as insular as the type of people, as the language, as the ways of life," Roberts asserted. "It shows equally the conditions of city and country." Every man among the Eight was "doing the kind of work that is essentially creative and absolutely typical of our own racial characteristics, our social conditions and our widely diversified country."[38]

Art in New York and the National Scene

The Eight constituted a fairly representative sampling of younger artists just beginning to make their marks in New York and nationally. Four — Glackens, Luks, Shinn, and Sloan — had started their artistic careers as illustrators in Philadelphia. The publishing industry was declining in that city however, and all moved on to New York after the turn of the century.[39] But by then, they had already begun to distance themselves from commercial art, encouraged by the charismatic Robert Henri, who urged his friends to abandon the limited creative potential and restrictive working conditions of commercial illustration for the independence of painting and the "fine arts." The four had known Henri since the early 1890s, when he was an instructor at Philadelphia's School of Design for Women. During informal meetings at his studio, Henri inspired their self-confidence and ambition with tales of the Parisian studios and lengthy digressions from Whitman and Tolstoi. "No studio in Philadelphia has dearer associations than this one," critic Helen Henderson would write for the Philadelphia *Public Ledger* in 1903:

> In the days when Henri lived and worked there it was the rendezvous at all hours of the coterie of geniuses who were his struggling contemporaries. Glackens, George Luks, John Sloan ... Shinn ... and a score of others met there night after night, drinking in Henri's wonderful personality, absorbing his strength of art ideals and growing great because of the intimacy of their association one with the other.[40]

He had found an attentive audience. "Henri could make anyone want to be an artist," Sloan recalled, "[He] could light the fire and if there was a self-reliant growing mind, the artist was started on his way for life."[41]

As their mentor, Henri felt an obligation to assist in the professional development of the four ex-Philadelphians. He recognized too that his own success as a teacher was measured by that of his students and protégés. Once in New York, all four continued to work in painting, while supporting themselves as free-lance illustrators. Glackens divided his time between free-lance illustration work for magazines such as *McClure's* with work in portraiture and landscape. George Luks, who had worked as a cartoonist for Joseph Pulitzer's *World*, painted dark, boldly brushed character studies, which some critics and an increasing number of collectors called works of genius. Everett Shinn was the author of witty pastel renderings of New York's streets as well as the city's burlesque stages. John Sloan, last of the group to leave Philadelphia, painted and etched

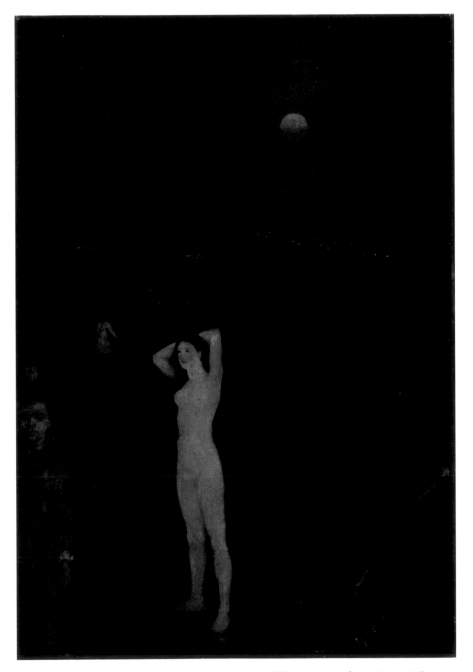

Arthur DAVIES, *Full-Orbed Moon*, 1901. The Art Institute of Chicago, Mr. and Mrs. Martin A. Ryerson Collection.

lively studies of New Yorkers at home and in crowded streets and parks, as well as thoughtful portraits. Clearly it was an opportune time to advance their cause. When Henri's lobbying efforts for Luks failed, the independent exhibition was the next move. But to succeed it had to represent a collective gesture, not an excuse for the promotion of disparate individuals who shared a single mentor.

In Arthur B. Davies, Henri found an ideal sixth collaborator, sympathetic to the cause and widely respected, yet not a member of Henri's immediate circle. The two had met in 1894 after critic Sadakichi Hartmann alerted Henri to Davies' work. Visiting New York exhibitions with Glackens in April of that year, Henri was enchanted by Davies' paintings at a private exhibition: "Works lacking in everything academic. God grant he may never go to school and learn to draw and all that he is an artist now — poetic."[42] Davies occupied an uncertain place within the New York arts community. In the early years of his career, he exhibited eccentric but attractive landscapes — typically vistas of gently rolling meadows inhabited by stiffly-drawn children — at both the Academy and the Society. Critics and fellow artists alike recognized his talent even when interpretation of his imagery eluded them. "None has seemed to know what exactly to do with him or where to put him," wrote William Macbeth, "but, somehow, none seemed willing to let him alone." Davies stubbornly resisted categorization. "To the stickler for realism, Mr. Davies will not give pleasure, nor will the impressionist claim kinship with him," wrote Macbeth, "He certainly belongs to no school of today, nor for the matter of that to any school of the past. Yet before his pictures one is made to feel that he is strongly in sympathy with the best that is in the old painters who put heart and soul into their creations. His methods are not theirs and yet the same spirit breathes in the work of both."[43]

By 1900, Davies had replaced the children in his landscapes with enigmatic nudes and no longer sent his paintings to the Academy or Society, preferring to mount a series of one-man shows at Macbeth's. Henri regarded him as the victim of organized neglect on the part of the New York exhibiting societies. But Davies himself was the chief author of this "neglect." Though not well-known to the public because of his avoidance of larger shows, Davies was nonethe-

less highly regarded by professional colleagues in New York, and financially supported by a devoted coterie of wealthy and influential collectors, including Benjamin Altman, H. H. Benedict and Colonel Henry Chapman.[44]

Maurice Prendergast and Ernest Lawson came to the group on the recommendation of Arthur Davies and William Glackens. As early as 1898, Henri noted having seen Prendergast's works on exhibition, but the two men did not meet until 1902, possibly introduced by Davies.[45] By that date Prendergast was pursuing increasingly experimental directions in his work. Of the group, he was most familiar with the radical new colorism of Henri Matisse and the Fauves and the most willing to adapt their saturated palette to his own art. Ernest Lawson joined the Henri group in 1904, introduced by Glackens who was his neighbor. A pupil of the much-admired American Impressionist John Twachtman, Lawson made rough-hewn and brightly colored views of the rural countryside still to be seen along the Harlem River in upper Manhattan. His paintings also documented the urban sprawl threatening that landscape — in 1907, Lawson started a series of views of Morningside Heights and the Cathedral of St. John the Divine, newly under construction, which would occupy him for the next decade.[46]

Each of these men had followed similar paths, relying on public exhibitions to promote and sell their paintings. By 1908 all of The Eight, including those who continued to work in illustration, had found venues for their work and were beginning to attract critical comment and some controversy: even the eccentric George Luks had been profiled more than once in the press.[47] Members of a generation that enjoyed a greatly expanded circuit of exhibitions nationwide, The Eight ironically found their efforts thwarted in the city in which seven made their homes and which should have offered the greatest opportunities for self-promotion — New York.

As the country prospered in the decades after the Civil War, communities and would-be patrons turned their attention to the business of culture. Arts institutions, professional societies and clubs, art schools and commercial galleries multiplied exponentially. Writing in 1910 of the "miraculous" wave of interest in art matters

sweeping the United States, newly-appointed National Academy president John White Alexander observed that "it is extremely difficult now to discover a place of importance which has not its public gallery devoted to exhibitions of the allied arts."[48]

Before the Civil War, fewer than two dozen museums owned art collections or sponsored temporary art exhibitions. By 1900, several of the country's premier institutions had been founded. A short list would include the Corcoran Gallery of Art (1869); the Metropolitan Museum and Boston's Museum of Fine Arts (1870); the Philadelphia Museum of Art (1876); the Museum of the Rhode Island School of Design (1877); the Art Institute of Chicago (1879); the Cincinnati Art Museum (1881); the Indianapolis Museum of Art (1883); the Carnegie Institute of Art, the Worcester Art Museum, and the De Young Memorial Museum (all 1896); and the Brooklyn Museum (1897).[49] The same period witnessed the founding of major national and regional artists' exhibiting societies, such as the San Francisco Art Association (1872), the Sacramento-based California Museum Association (1884), and the Society of Western Artists, based in Chicago (1896). National exhibiting societies based in New York included the Society of American Artists (1877), the American Watercolor Society (1866), and the Society of Pastellists and the National Arts Club (1898). Local artists' clubs such as the Copley Society, and the Saint Botolph and Boston Art Clubs in Boston; the Art Club of Philadelphia; the Providence Art Club in Rhode Island; the Palette and Chisel Club in Chicago; and the Artists' Club in Denver also held regular public exhibitions.[50]

Particular impetus to this increase in art display was provided by the success of the 1876 Centennial Exhibition at Philadelphia and the 1893 World's Columbian Exposition at Chicago, which had showcased America's technological achievements and alerted thousands of visitors to national as well as international cultural offerings. Subsequent international trade fairs such as the Pan-American Exposition at Buffalo (1901), the Louisiana Purchase Exposition at Saint Louis (1904), the Lewis and Clark Exposition in Portland, Oregon (1907), and the Panama-Pacific Exposition at San Francisco (1915) all incorporated extensive exhibitions of contemporary American and foreign art.[51]

Smaller state and local fairs also proved a breeding ground for art exhibitions and art museums. In the rapidly developing mid-west and western regions, art exhibitions became a popular feature of the great Inter-State Industrial Expositions held yearly from the 1870s in such cities as Louisville, Detroit, and Dallas. These were essentially county fairs expanded to satisfy the burgeoning community. From 1883 until 1904, when the City Art Museum was built for the Louisiana Purchase Exposition, the Saint Louis Exposition and Music Hall Association sponsored annual art exhibitions; similarly, the Dallas Art Museum grew out of art exhibitions at the Texas State Fair.

New museum buildings featured large galleries that trustees, directors, and exhibition organizing committees were eager to fill. To this end, most of the new museums and exhibiting societies sponsored a regular schedule of temporary loan exhibitions, often designating at least one per year for a select but comprehensive survey of contemporary trends in painting and sculpture. Submission policies to most were fairly liberal and works accepted were often purchased subsequently for growing collections. In general institutions issued calls for applications, which were then judged by an appointed committee. Typically a certain number of entries were also invited from specific artists: the director of the Worcester Museum asked Davies, Henri, Shinn, and Sloan to contribute paintings to its 9th Annual in 1906; and the Pennsylvania Academy appointed juries in several other cities to submit recommendations. Some museum directors simply asked two or three dealers to send a sampling from their current inventories. Several of the small and mid-size institutions, such as Buffalo and Saint Louis, shared exhibitions, leading to the creation of informal regional "circuits."[52] While the majority of these "Annuals" featured the work of American artists, the Carnegie Institute instituted a series of "Internationals" in 1896 for which, thanks to endowment support from Andrew Carnegie, it invited submissions from major European and American exhibitors; in addition, it sent a committee abroad to visit artists' studios, dealers, and continental exhibitions. By the turn of the century, critical reviews of the Pittsburgh, Philadelphia, and Chicago exhibitions had become a regular feature in both the American and international art press.[53]

The models for these temporary loan exhibitions were the annual juried exhibitions at the Pennsylvania Academy of the Fine Arts in Philadelphia, which had sponsored annuals since 1811, and at the National Academy of Design in New York and the Boston Atheneum, both in operation as exhibiting societies since the 1820s. These older American institutions served to link the new with their common origins in the European tradition of art exhibition and public display, as embodied in the great Paris Salons and the Royal Academy Summer Exhibitions. From their beginning in 1826, the National Academy annuals were particularly noteworthy for showing only work by living *American* artists, at a time when the Philadelphia and Boston shows featured a majority of work by Europeans, both living and dead.

Enterprising artists injected themselves and their work into these annual exhibitions as often and as widely as possible, sending paintings or sculptures literally cross-country from one museum or gallery to the next. All of The Eight were veterans of this national circuit. Henri's diaries after 1900 were filled with deadline reminders for submission and shipment of pieces to various venues ranging

from Bethlehem, Pennsylvania to Minneapolis, New Orleans, or San Francisco in any one year. In 1906 alone he exhibited in annuals at the National Academy of Design, the Society of American Artists, the Pennsylvania Academy of the Fine Arts, and the Art Institute of Chicago, as well as in the inaugural annual of the Albright Art Gallery in Buffalo, to which Davies, Glackens, Shinn, and Sloan also contributed. That same year, Prendergast sent paintings to the Boston Art Club, the Cincinnati Art Museum, the John Herron Institute in Indianapolis, and the Philadelphia Art Club; Shinn also exhibited at three of these institutions. Sloan went farthest afield that year, sending three paintings to the Dallas State Fair. And though George Luks did not exhibit frequently at either the Society of American Artists or the National Academy, and as a rule did not send his paintings out of town, he did show regularly at certain New York clubs — most notably the Colonial Club where he was a regular contributor to group shows by 1908.

Four members of The Eight had already had one-man museum exhibitions. Henri's first was at the Pennsylvania Academy in 1897. Five years later, forty of his paintings were again shown there

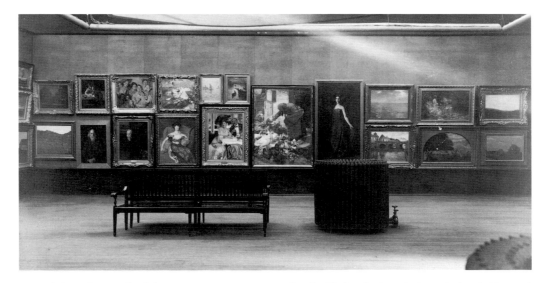

View of the 10th Annual Exhibition, Carnegie Institute, Pittsburgh. Glackens' prize-winning painting *At Mouquin's* (now in the collection of The Art Institute of Chicago) can be seen at center. Courtesy the Carnegie Museum of Art, Pittsburgh, Pennsylvania.

as well as at the Pratt Art Institute in Brooklyn. Davies also had a one-man show at the Pratt in 1901, and in 1906 at the Copley Society in Boston. Also in 1901, the Detroit Museum of Art organized an exhibition of Prendergast's watercolors and monotypes, that traveled to the Cincinnati Museum. In 1907 Lawson was given a one-man show at the Pennsylvania Academy. And most in the group had won prizes or Honorable Mentions at various exhibitions. Davies won a Silver Medal for *Full-Orbed Moon* at the Pan-American Exposition of 1901 in Buffalo, Henri a silver for his *Woman in Black* at the Louisiana Purchase Exposition. Both Glackens and Sloan were given Honorable Mention for paintings shown in the Carnegie Institute's 10th Annual in 1905: Glackens for *At Mouquin's* and Sloan for the *Coffee Line*.

Pre-exhibition publicity for The Eight in New York asserted that no National Academy jury could be counted on to accept their works because each "saw" and rendered reality in a fashion unacceptable to established standards. But this attention-getting assertion is contradicted by the fairly consistent success these artists had enjoyed at exhibitions outside New York. Clearly academic rule was not the only factor influencing the careers of The Eight in New York. Indeed, members of the National Academy insisted that they were not unsympathetic to young artists or new ideas. The institution simply lacked adequate facilities to exhibit all of the work being produced. Until a philanthropist could be found to underwrite the construction of adequate gallery space, the Academy was forced to make do with available facilities. The jury system reviled by Henri and his associates was necessary to ensure the fairest and most judicious selection of paintings from one year to the next.

Like many of their contemporaries, The Eight were frustrated by the limited opportunities for exhibition in New York at a time when exhibitions elsewhere were attracting international attention and praise. New York was home to more professional artists' societies than either London or Paris, which it rivalled in the number and importance of art sales. And yet this supposed art capital of the United States had no adequate facility for a comprehensive exhibition of contemporary painting and sculpture. The largest regular such exhibition there was the National Academy's spring annual. While annuals at the Pennsylvania Academy of the Fine Arts, the Art

Institute of Chicago, and the Carnegie Institute displayed upwards of seven hundred to one thousand works of painting and sculpture, the small and badly-lit 57th Street galleries of the Fine Arts Society, now used by the National Academy, could accommodate only about three hundred and fifty paintings; there was almost no room for sculpture.[54]

The Academy was not alone in attributing the endless bickering and charges of inequity among New York's artists to the lack of a central exhibition hall large enough to accommodate all of the city's myriad artists' clubs and exhibiting societies. Soon after the completion of Madison Square Gardens in 1891 a group of artists investigated the building as a possible exhibition facility, but judged the necessary construction for a temporary exhibition too expensive. In 1902, a special committee appointed by the Fine Arts Federation of New York, an umbrella organization for eleven New York-based artists' societies, recommended that a "united fine arts exhibition building" be constructed with adequate galleries for the display of contemporary art exhibitions "and every facility for the centralization of the interests and activities of the Art societies of this city." As the premier art exhibiting organization in New York, the National Academy was ideally suited to act as manager for this "art trust."[55]

The chief benefit of a central exhibition building would be the cultivation of an interest in and appreciation of the arts, perceived by many in the arts community to be sadly lacking among the general public. Attendance was low at New York exhibitions in part because there were too many of them. According to Will H. Low, writing in 1902, New Yorkers were bewildered by "constantly recurring exhibitions of the various societies, supplemented by the special exhibitions of the art dealers, which through the winter and spring succeed each other at such short intervals that if New York's initial interest in art was a dominating passion, it would tire itself to extinction before the rounds of exhibitions could be made." Low, a well-known mural painter and a member of both the National Academy and the Society of American Artists, envisioned a grand civic exhibition that would bring together not only painters and sculptors, but craftspeople and artisans:

. . . posters, woven and printed stuffs, street and shop signs, locks, keyplates, doorknobs, embroideries, illustrative designs for books, magazines, advertisements, the work of the silversmith and jeweler . . . all these and many industrial and useful articles which receive or should receive the vivifying touch of art could be exhibited.[56]

He cited the high attendence at the fine arts exhibits of the 1893 Chicago World's Fair — the obvious inspiration for his own idea — as evidence that Americans would visit exhibitions if they were sufficiently entertaining and edifying. The comprehensive character of the exhibition itself, he argued, would attract many who otherwise would never visit an art exhibition *per se*. But most important, the exhibition would provide invaluable support and encouragement to America's artists. "To show that art touches on life and utility in a thousand places would not be the least lesson that a great exhibition could teach."[57]

Times critic Charles De Kay echoed Low's assessment, comparing the New York arts community to an army without commander-in-chief and general staff. Community integrity had been undermined by the tendency of artists, especially younger ones, to split into various splinter groups, thereby depriving older exhibiting societies of new ideas and energy. Furthermore, De Kay suggested, this pluralist impulse alienated artists from the public whose attention they so dearly wished and needed to attract. "In New York energy is frittered away by the various societies with their several appeals to the public — and the public ends by ignoring the very existence of art." As he would later reveal when challenging the recalcitrant Henri in 1907, De Kay recognized that innovation came more often from these splinter groups than from the Academy. His concern stemmed from the fact that the various groups were dispersed throughout the city, often exhibiting in facilities not readily accessible to the public. Better to consolidate and bring all artists together under one roof, thereby presenting the average American viewer, whom De Kay could clearly be accused of patronizing, with a united front:

What's the use of a hundred art shows, scarcely visited at all save by the exhibitors, their friends and a few outsiders,

when comparison is made with the crowds that visit such a comprehensive gathering of work as the Paris Salon? True it is, that these big collections necessarily contain much indifferent work. The majority of objects shown are really painful to connoisseurs; but the latter can select the gems and the crowd can enjoy what the crowd understands.[58]

There was another benefit to this comprehensive exhibition plan, though no writers stated it outright. A great exhibition hall would in effect constitute an expanded and centralized marketplace, readily available to New York artists and regularly accessible to an audience of more educated buyers.

But the grand exhibition hall remained a dream. Despite the validity of Low's and De Kay's criticisms, small exhibitions mounted in a variety of locations provided the only forum for many artists unable or unwilling to satisfy the necessarily restrictive policies of the Academy. Under the conditions that prevailed in New York during the first decade of this century, ambitious artists had to take the initiative, seizing every opportunity to get their work shown; New York clubs often provided the most accessible and congenial exhibition facilities. By 1898, there were more than half a dozen men's clubs in the city that regularly scheduled art exhibitions, including the Union League, the Century Association, the Colonial Club, the Lotos Club, and the Salmagundi Club. In 1907, the Colony Club was founded to provide New York's female artists and clubwomen with similar facilities.[59]

Charles De Kay was the founder of one of the more innovative of these organizations, the National Arts Club. In 1898, he had assembled several prominent members of the New York arts community, including painters, sculptors, architects, museum and art school administrators, and art patrons, to establish a social forum for the display and discussion of the fine arts. The club's chief aims were to promote the mutual acquaintance of "art lovers and art workers" in the United States and to stimulate and guide the artistic sense of the American public through a program of exhibitions and the publication and circulation of news, suggestions, and discussions relating to the fine arts.[60]

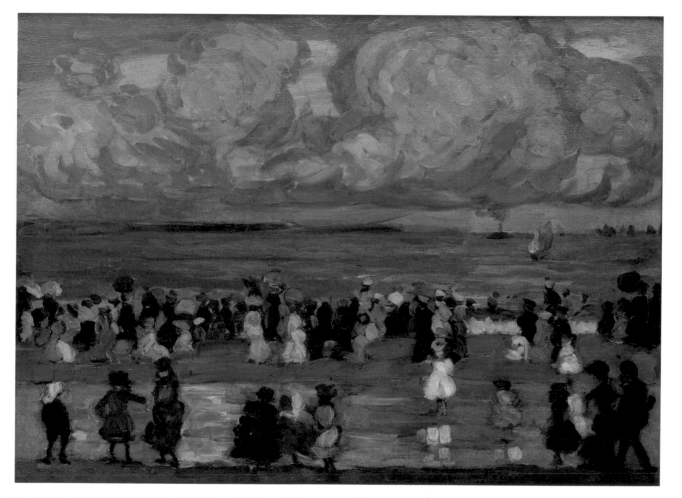

Maurice Brazil PRENDERGAST, *By the Seashore*, 1902-4. Mitchell Museum, John R. and Eleanor R. Mitchell Foundation, Mount Vernon, Illinois.

As Secretary and Managing Director from 1899 to 1904, De Kay supervised a varied schedule of exhibitions through a nine-month season. During the first four years, the club hosted exhibitions of Japanese prints, American pastels, art leatherwork, colonial portraits, art pottery, stained glass, and Rodin sculptures; memorial exhibitions honoring the painter John L. Breck and the sculptor John A. Fraser; and the annual exhibition of the Women's Art Club. A particular concern of the club's founders was to provide New York with sorely needed space for the display of decorative arts and industrial design products. Indeed the National Society of Craftsmen operated a sales gallery on the premises.[61]

In January 1904, the National Arts Club hosted a loan exhibition of forty-five paintings selected by Robert Henri. The show was advertised as including Henri's work and that of four painters whom he admired and sought to promote — Arthur Davies, William Glackens, George Luks, and Maurice Prendergast. Each exhibited between seven and ten paintings, making this the largest display yet in New York of works by Glackens, Luks, and Prendergast. At the last minute, Henri added two canvases by John Sloan: "You should see your pictures — particularly Independence Square. It has fine place and looks great," Henri wrote. He was concerned about the comparatively slight press coverage the exhibition was attracting. "There should be more newspaper notice of it but unfamiliar names are awkward to critics."[62]

Notwithstanding Henri's fears, most critics who took note of the exhibition were impressed by the selection of lively and unconventional works. *The Mail and Express* praised the gathering: "Here are men with various creeds, all of them robust and emphatic. They know what they want to do, they are not content to drift with the majority and they are, every one, gifted in more than usual degree."[63] *Town Topics* echoed this review, calling the six artists enthusiastic experimenters and commending Henri for his originality, Luks for "vigorous and healthy" canvases, Sloan for "straightforward sentiment," and Glackens for his "appreciation of Nature's appeal." "It is a guess what he means," this writer noted of Davies' paintings, "but in that he does not differ from many writers who are, nevertheless, considered poets." Only Prendergast, who sent seven

canvases all titled "Promenade at the Seashore," was singled out for criticism. *Town Topics* feared too many of his "decorative" pieces might produce the same reaction as "a surfeit of sugar candy."[64]

In his own review of the show, De Kay set the stage for greater controversy which would fulfill the club's goal, encouraging artistic debate. "A collection like this has the most enlivening effect on the beholders; no one can remain indifferent; it is either admiration or damnation, and the style of the paintings is such as to demand an instant decision." Here in an intimate and comparatively informal setting, artists could exhibit work of an experimental or developing character that would be unsuitable for the larger Academy or Society of American Artists annuals. De Kay hoped that the exhibition would give "a great deal of enjoyment both to those who denounce it as the degeneracy of silly minds and those who regard it as the last screech of genius." He described the six artists as "red-hot American painters" who painted their own feelings for a subject as well as its appearance. "They represent the vigorous school of picture-making which tries to get the object on the canvas before the enthusiasm that caused their selection has had time to evaporate and the red-hot impression time to cool." Two portraits in particular by Luks, *Whisky Bill* and the *Prizefighter,* drew his praise as "triumphs in their way, so thoroughgoing is the psychology which the painter has expressed without undue elaboration."[65]

De Kay's challenge did not go unanswered, for several critics astutely foresaw political confrontation brewing between these six innovators and the guardians of conventional taste. "Hardly a jury sits that would not refuse these works, and hiss them, too, upon occasion," wrote the anonymous editor of *The Black Mirror,* "then fill their places with those paintings which show only a stencil-like mechanism."[66] Other reviews consistently linked the exhibitors to the French Impressionists, both stylistically and politically. Like the Impressionists, the six Americans were described as possessing an innovative "vision" which prompted them to defy academic taste, painting urban subjects in an exuberant, even slap-dash fashion that had been widely identified with the radical fringe since the mid-nineteenth century and the ascendance of Edouard Manet.[67] Even

George Luks' work was likened to that of Toulouse-Lautrec and Paul Gauguin, for a similar "broad way of seeing men and things."[68]

The most explicit such reference appeared in a trenchant exchange between Arthur Hoeber, critic for *The Commercial Advertiser* and Charles Fitzgerald of the *Evening Sun*. The former characterized the paintings at the Arts Club as "lugubrious" and "unhealthy," and questioned the artists' perception of their subjects, "so different is humanity here from the way we see it."[69] To which Fitzgerald retorted: "What is the precise nature of this 'normal' vision employed consistently by the champions of the 'commonplace mortal' to confound every new painter who has a definite outlook?" As Glackens' brother-in-law and a close associate of the Henri circle, Fitzgerald was a strong defender of the Arts Club exhibitors. Describing his visit to a recent National Academy exhibition, he concluded that "by 'normal' is meant *average,* and . . . normal vision is the vision that comes nearest to the ideal vision of 215 West 57th Street." The Arts Club exhibitors, by comparison, possessed a vision that was anything but "average." "There is nothing here of the vague compromise that we are accustomed to even in many of [our more famous painters], no fumbling of awkward facts, none of the usual bribes to taste," he announced. Rather, the work of these young Americans displayed the "frank decision and forthright power" that Fitzgerald associated specifically with the school of Manet.[70]

Fitzgerald had borrowed this concept of a "new" kind of vision — derived not from academic practice but directly from nature and driven by each artist's individual genius — from French critic Théodore Duret's recently published biography of Manet, which he had reviewed for the *Evening Sun* in 1902. It was Duret who first described public opposition to Manet's art as a "difference of vision," charging that the artist in fact possessed the keener sight:

> Manet did not see as others saw; he and they perceived the same images differently . . . While others looked out on the world with dull eyes, Manet possessed a vivifying vision. In a full light everything appeared to him to glow with exceptional splendour. Nature had actually endowed him with a

very special gift, and in so doing had created him to be a painter, in the great sense of the word.[71]

Young artists in New York were highly sensitive to Manet's influence at a time when the first histories of the European avant-garde, and of Manet's career in particular, were being written. One press reporter even dubbed Henri the "Manet of Manhattan," on the basis of his "iconoclastic" attitude to the artistic status quo and his encouragement of students at the New York School of Art to paint street life on the Lower East Side.[72] Nor was it coincidental that Henri's portraits bore a strong similarity to the French master's. At a time when the catalogue of the Metropolitan Museum described Manet as "an eccentric realist of disputed merit," purposeful and obvious emulation of his art was a sure sign of recalcitrance.[73]

In his review of Duret, Fitzgerald had compared Manet's struggle for public recognition with the plight of American artists. Shunned by the establishment, his paintings rejected from the official Salon, with its monopoly on exhibition and publicity, Manet had finally boycotted the Salon and devised his own independent exhibition. In Fitzgerald's opinion, Manet's struggle against pervasive popular opposition could never be equalled in America, not so much because of American intolerance, but because of American indifference. "In France, opposition makes more noise, because it is generally in part 'official' and also because the public takes a certain interest in matters relating to art," the critic explained. Yet perhaps American artists could still take heart from Manet's example. Fitzgerald ended his review by translating from Duret the public statement Manet made when he opened an exhibition in his own studio in 1867:

> As [Manet] himself said in the course of the dignified appeal addressed to the public on the exhibition held at his studio in 1867: "To exhibit is the vital question, the *sine qua non* for the artist, for it happens after some study that one grows familiar with what surprised, or perhaps shocked, at first. Little by little one understands and admits it . . . To exhibit is to find friends and allies for the struggle.[74]

Fitzgerald's review was directed to a very specific readership, for Duret's biography had not yet been translated into English. The final quotation from the French master would resonate most profoundly upon those New Yorkers who knew France and French art at first-hand — the city's artists. These words could well have been the rallying cry for Robert Henri and the painters he would gather together in the "new movement."

Modernist Ritual: Secession and Europe

The National Arts Club exhibition enabled Henri to test the constellation of artists he wished to promote and to see that although diverse, they would function as an integral unit. Moreover the exhibition alerted press and public to a group of associated artists whose works directly challenged the standards of the National Academy and who promised to effect a revolution in the American art world comparable to that incited by the French avant-garde. Like their French predecessors, the National Arts Club exhibitors painted urban subjects in a brash, unpretty style. And like the French, they were a gregarious crew, frequenting cafes and bars and celebrating such places in their pictures. They lived in the bohemian enclave of Greenwich Village and were known eccentrics and non-conformists. "When next the 'impressionists' expose, my friends, go and see — if you can," counselled *The Black Mirror*, "You will find much of interest, and may you profit by their example of courage. At any rate, be sure you are looking upon what so far has proven to be 'New York's most notable event.' "[75]

The 1904 exhibition also went far to confirm Henri's leadership. When five of the six exhibitors (lacking Davies) were represented at the 1905 Society of American Artists Annual, reviewer James Gregg described them specifically as "Henri's group."[76] The next year, art critic Sadakichi Hartmann described Henri as "the patriarch of the Cafe crowd," and leader of "a new movement":

. . . it is Henri's personality first of all that has made a mark in our American art life. The Cafe coterie may produce in time stronger men than he is himself, but none of them will ever occupy a similar place of esteem, for we younger men have always looked at Robert Henri as a typification of the new movement in art.[77]

Yet this 1904 gathering had no lasting impact, for it lacked both a distinguishing agenda and a rallying issue. Not until the 1907 Academy jurying controversies did Henri and his associates find the ideal motive and opportunity to correct these omissions. Promoted as a protest against exclusionary Academy policies by artists concerned with that institution's over-reliance on foreign standards, their 1908 exhibition was proclaimed a "Secession" from the Academy, perpetrated to advance the cause of a truly American art. But in launching this challenge, The Eight were themselves ironically drawing upon European models: by 1908, the independent exhibition organized as a gesture of protest against and separation from the academic establishment, had become a common occurrence.

Seven of The Eight had spent varying periods of time in Europe. Henri studied in Paris for most of the 1890s and made frequent trips to the continent thereafter. Luks claimed to have spent two years at the Royal Academy in Dusseldorf in the 1880s. After several trips to Europe in the following decade, he lived in Paris for a year in 1902, where he was joined by Everett Shinn who was on his first trip to the continent. Thanks to the patronage of department store magnate and art collector Benjamin Altman, Davies was able to supplement some formal art training in Chicago with extended tours of the continent in 1895 and again in 1897, visiting museums in England, France, Germany, Italy, and Spain while working as an agent for art dealer William Macbeth. Glackens, Lawson, and Prendergast worked at the Académie Julian during the mid-1890s and all three made regular return visits to Europe throughout their careers. Indeed, even as preparations for the Macbeth Galleries exhibition were underway, Prendergast and Glackens had left for France. Likewise Henri was abroad from June to October 1907, traveling with students to Holland, Belgium, England, and Paris.[78]

Only John Sloan steadfastly refused to go abroad, pleading poverty and lack of interest when Henri wrote from Paris in 1899

urging him to leave Philadelphia: "when you decide to take another trip into the world you want to come over here — its my old cry — but I believe it is a good one."[79] Nevertheless, Sloan was fully cognizant of the European academic tradition, both by virtue of his early studies at the Pennsylvania Academy, which offered a curriculum based on the French system, and through the efforts of Henri, who encouraged Sloan to study the works of Goya and Daumier.

Several factors prompted an ever-growing exodus of American art students to European schools for professional training after the Civil War. It was in the capitals of Europe that one found the monuments of Western art with which every educated artist was expected to be familiar. And though instruction was available at various American art schools, true pedagogical authority still remained abroad. The sanction of European education could gain the American student an entree into — as well as a marketplace among — the community of artists and teachers who nurtured the academic style so popular with American collectors.[80]

At the same time that Americans flocked to art schools in Paris and London or other continental cities, European artists themselves were challenging the standards and traditions of the academic system of aesthetics and pedagogy. During the course of the nineteenth century, the political and economic frameworks of art production and patronage changed dramatically. Traditional princely patronage faded as an increasingly prosperous middle class brought new attitudes to the appreciation and acquisition of art objects. The artist became an independent entrepreneur, vulnerable to changes in fashion and market demand. As a result the public art exhibition assumed great importance as both a forum for aesthetic policy and a marketplace, expanding from small, infrequent events to regularly scheduled displays encompassing hundreds of paintings and sculptures.

In many European cities, the administration of art exhibitions devolved upon existing professional artists' organizations, more often than not the local art school or academy. The operative model for state-sponsored exhibitions of contemporary art was the Paris Salon, established in 1673. Originally restricted to members of the Académie Royale de Peinture, the Salon became an administrative function of the state after the Revolution. Although admission policies relaxed, responsibility for standards of selection and the distribution of prizes nevertheless rested with the "Institut," an elected committee of senior artists and intellectuals.[81]

By the 1860s, the Paris Salon was a major annual social and cultural event. But this exhibition and those patterned after it proved to be fragile instruments. As a grand comprehensive sampling, the Salon attempted to reconcile too many divergent factions in an increasingly pluralist art world. And as an event sponsored and selected by a single organization, it was vulnerable to accusations of discrimination and exclusion. Notwithstanding the fact that the Salon increased steadily in size, exhibiting thousands of works by the 1870s, many artists suffered rejection at the hands of the selection jury, prompting them to challenge the standards by which works were judged admissible.[82]

Counter-exhibitions to the official Salon dated back to the 1840s. The most famous of these was the notorious "Salon des Réfusés," organized in 1863 with the approval of Napoleon III by artists whose works had been rejected by that year's Salon jury. Eleven years later, artists calling themselves the Société Anonyme des Peintres et Sculpteurs bypassed the Salon altogether to present a group exhibition at a commercial gallery. Dubbed the "Impressionists" by critics, they were only the most widely publicized of numerous independent artists' associations and temporary exhibiting groups, which gathered to challenge the central authority of the "academy" and its Salon.[83]

The culmination of this trend came in 1890, when the official Salon itself was split. In 1881 the French government had relinquished control of the Salon in order to focus its attention and resources on the international exposition scheduled for the 1889 centenary of the Revolution. Administration of the Salon became the responsibility of the newly-founded Société des Artistes Français, a professional organization very similar in structure and purpose to a trade union. For nine years the Société administered the Salon with relative equanimity. But in the aftermath of the 1889 Universal

Exposition dissension arose within the senior ranks about the inclusion of foreign exhibitors, and a group led by the painter Ernest Meissonier resigned to form the Société Nationale des Beaux-Arts and organize an alternative annual which became known as the "New" Salon.[84]

For almost two hundred years, the Salon exhibition had presented an "official" selection of contemporary painting and sculpture to the art-going public of Paris and the world. But the schism of 1890 "decisively ended [this] hegemony" and altered the ground rules for the study and practice of art in Paris.[85] Centralized authority in the French art establishment gradually disappeared. By 1908, Paris was hosting not two but four large "Salons."[86]

As the stalwart advocates of academic tradition and the daring innovators of the avant-garde battled for control of major exhibitions — and ultimately the marketplace — the public exhibition became a forum for political confrontation. Secessionist movements sprang up across the continent, now started not only by the radical avant-garde, but by middle-of-the-road artists. "Even when the salons accepted innovative works, the abler artists, whether avant-garde or traditional in outlook, preferred to put some distance between themselves and the mass of their colleagues. Splinter groups, whether called the Société anonyme cooperative des artistes, Salon du Champs-de-Mars or Münchner, Wiener, or Berliner Secession, banded together to create their own forums and launch their own publications; in these ways they educated the public, stimulated demand for their works, and changed the attitudes and policies of the art establishment." Though typically these groups first gathered together because of shared aesthetic sympathies, "where unanimity did exist it rarely lasted for long." More often than not, such secessions were short-lived as the groups were ultimately re-absorbed into the official fold. By the 1890s disagreement or dissatisfaction within liberal and conservative artists' societies alike could lead automatically to schism or secession and a new exhibition on the calendar.[87]

Sending a work to exhibition, be it a self-selected group show or a large juried annual, became a conscious political act. Artists had to determine where their works were most likely to be accepted, and in what company they wished to be seen. This evolving situation had a tremendous impact on the generation of American artists who studied abroad in the 1890s, because acceptance into a major European exhibition, especially the Paris Salon, carried tremendous prestige among American collectors. The majority of Americans set their sights on the official shows. Even here there was some room for manouevring: "If I don't get in at the Salon it will be a collapse for me," Henri wrote to his parents in 1897.[88] He was referring to the "Old" Salon of the Société des Artistes Français. In fact, Henri had more success with the "New" Salon of the Société Nationale des Beaux-Arts: his painting *La Neige* was purchased by the French government from the 1899 "New" Salon.

Though American artists abroad were seldom directly privy to the stylistic and technical innovations that motivated the various European secessionist groups, they nevertheless had access to their independent public exhibitions.[89] The sheer variety of these in a city such as Paris served as important teaching tools. For example, within a two-month period in 1890, Robert Henri visited the Salon des Indépendants, the "Old" Salon of the Société des Artistes Français, and the "New" Salon of the Société Nationale des Beaux-Arts. He described the first of these, which that year featured works by Vincent Van Gogh, Henri Rousseau, and Henri Toulouse-Lautrec, as "a strange show, . . . Eccentric, childish, wild, even crazy, some pitiful . . . art lost 50 years behind the date and art lost 50 years beyond."[90] After several visits to the "Old" Salon at the Palais de l'Industrie, he concluded that this too was a disappointment. Though he admired some among the over three thousand paintings on view, the exhibition was too diffuse, with few surprises. Works by such artists as Léon Bonnat, Jean-Léon Gérôme or William-Adolphe Bouguereau simply repeated each artist's standard formula. And the impact of hundreds of gold-framed canvases stacked four and five high beyond sight through the cavernous exhibition hall was daunting: "One sees hundreds and hundreds of pictures more or less claiming the attention all off on different keys calling one into as many different moods. There are all the problems of technic [sic] to aggravate one — finally one sees very little that pleases him and he becomes very severe in his criticism." The experience disheartened the young American. A

Robert HENRI, *La Neige*, 1899. Musée National de la Coopération Franco-Américaine, Blérancourt (dépot du Musée d'Orsay).

student of Bouguereau at the Académie Julian, he questioned how he could continue to study with a man whose work he did not like.[91]

Henri regained his faith in art exhibitions in mid-May when the "New" Salon opened. It was more "interesting and splendidly arranged," he wrote in his diary, "one can look at each thing with more ease, not the everlasting crowd and a whirl of old [exhibitions] which dazzles and fatigues." Henri noted in particular the absence of the huge eye-catching "machines" many painters sent to the old Salon in an effort to catch audience attention in the crowded galleries. At the Champs-de-Mars, artists Henri called the "moderns" predominated — Carrière, Cazin, Carolus-Duran, Lhermitte, Dannat, Roll. Besnard showed a "wild" *Vision de Femme*, Zorn a "stunning" portrait. Henri thought John Singer Sargent's portrait of *Ellen Terry as Lady Macbeth* "great," and Philadelphia-born Alexander Harrison's things were "splendid." "This split in the salon will bring about some great improvements," the young American noted. He would devote the rest of the month to alternating visits to each of the salons.[92]

Nor was Henri alone in his fascination with Paris' annual salons. More than a decade later, Paris exhibitions continued to provide American visitors with access to both the most innovative and the most fashionable trends. When Maurice Prendergast returned to Paris in 1907 after a twelve-year absence, he wrote home most excitedly about the work he saw on exhibition. In addition to the three spring Salons, Prendergast was able to see a major retrospective of Cézanne's watercolors, as well as a selection of works by Vuillard, Vallotton, and the Fauves, whom he called "Independents." "All these exhibitions worked me up so much that I had to run up and down the boulevards to work off steam . . . I wish we had some of it in Boston or New York our exhibitions are so monotonous."[93]

Americans who thus observed the decline of academic authority and centralization returned home skeptical about their own academies. Visiting the annual exhibition of the National Academy of Design in 1894, Henri invoked the heroes of the schism and the "New" Salon. "Oh so many miserable old fogys," Henri lamented, "Out with the Academy! Down with the school — [it] kills art . . . Vive the japonese [sic] Whistler, Chevannes [sic], Besnard."[94]

Artistic secessions were not unheard of in the United States. Indeed, the National Academy of Design itself had been founded in 1826 by New York artists frustrated by the indifference shown by directors of the older American Academy of the Fine Arts to the needs of local art students.[95] Fifty years later, when young painters and sculptors lately returned to New York from study in Europe encountered opposition from the conservative nativist leadership of the National Academy, they responded by withdrawing — in effect seceding — from the Academy to form the more liberal Society of American Artists in 1877.[96]

Representing a critical split in the arts community in New York, the Society became an important forum for the display of progressive styles and the encouragement of a more cosmopolitan internationalist approach among American artists. As one writer has noted, "the Society sought artistic interdependence with Europe, and promoted this philosophy by supporting the American artists' desire to equip themselves with a broad range of European artistic attitudes and techniques, to participate in the international artistic arena, and to define America's artistic identity as one rooted in western civilization, rather than in a distinctly nationalistic mode of expression."[97]

By the mid-1890s, however, the Society of American Artists was losing its liberal character. "The controlling members are advancing in years, they are growing conservative as they advance, and they no longer care to be startled by bizarre sky-rockets shot across their artistic heavens," noted the *Evening Post* in 1897. "Instead of the pyrotechnics of young men they are now disposed to insist upon sobriety of method, and sincerity of purpose [in] painting."[98] Ironically, progressive New York artists now began to send their more innovative work back to the exhibitions of the National Academy.

Late in 1897, the Society was rocked by the resignations of ten leading members, the majority of whom were popular and influential Impressionists, including Julian Alden Weir, John Twachtman, and Childe Hassam.[99] These artists, dubbed "the Ten," left to form their own informal association for the purpose of organizing small exhibitions more conducive to the display of their works

42

William GLACKENS, *Figures in a Park*, 1895. Kraushaar Galleries, New York.

than the overcrowded Society annuals. Beginning in 1898, the Ten would present annual shows until 1917.

Press reports quoted spokesmen for the Ten as saying that their group departure from the Society had been prompted by the increasing commercialism and resultant decline in quality of the Society annuals. Society spokesman Kenyon Cox countered by noting that as long as Impressionism was in vogue, all ten painters had received more than enough consideration, but now "people are beginning to see there are other things." Those other things included the work of a coterie of figure painters led by Cox, who had taken over control of the Society administration from the landscapists by the mid-1890s.[100]

What is significant about the formation of the Ten is that they described their association as a "secession," and claimed to have been inspired by the secessionist movements which had brought "more vital art" to France and Germany. And the press quickly adopted this term when reporting the split. Indeed, William Merritt Chase, who would join the Ten in 1904 after the death of Twachtman, was a veteran exhibitor with the pioneering Munich Secession group in Germany. In general secessions in Europe had been led by younger artists, seeking to release themselves and their art from the creative restrictions of academic tradition and the political constraints imposed by the status quo. The secession of the Ten was prompted by the second of these concerns, but not by the first. Notwithstanding the fact that when they departed the Society of American Artists, all of the Ten were well-established and successful middle-aged men, as Impressionists they belonged to the more progressive ranks of American painters. But they were by no means an avant-garde. By 1897, after all, Impressionism was almost a quarter century old. Indeed, some press writers questioned why these artists had resigned at all: they had never encountered discrimination from the Society and until recently the "Impressionist" bloc had dominated the annual exhibition juries.[101]

We must return to the National Arts Club, and the prescient Charles De Kay, to find the American "secession" which came closest to the European model, and was closest in date to that engineered by The Eight. In 1902, De Kay had invited the brilliant young photographer and editor Alfred Stieglitz to mount an exhibition of his work at the club. Stieglitz responded by instead assembling a survey of work by American photographers whom he admired and considered deserving of wider public attention — including Gertrude Käsebier, Clarence White, F. Holland Day, and Frank Eugene. As an organizer of important photographic exhibitions in the United States and abroad, and as editor of the magazine *Camera Notes* for the New York Camera Club, Stieglitz had made a name for himself as an eloquent advocate of photography as a fine art. But he saw his ambitions for photography hampered by what he considered the parochial concerns of the New York Camera Club, many members of which complained of Stieglitz's dictatorial concern for the "art" of a select few photographers and disregard of their own efforts.

When asked to title the National Arts Club show, Stieglitz called it the "Photo-Secession," thereby publicly renouncing and distinguishing himself and his associates from the New York Camera Club. He furthermore publicly allied his efforts with those of the European groups who had similarly broken with centralized authority and put himself in the lead of anti-establishment forces within the American community of photographers. "*Photo-Secession* actually means a seceding from the accepted idea of what constitutes a photograph; besides which, in Europe, in Germany and Austria, there've been splits in the art circles and the moderns call themselves Secessionists, so *Photo-Secession* really hitches up with the art world."[102]

The Ten and Stieglitz borrowed the device of secession from the Europeans as a means of distancing themselves from the status quo. But their application of that device was passive, with no implications of violent change. In both cases publicity was restrained. "Artists Agree to Disagree" read a headline in the New York *Herald* announcing the resignations of the Ten from the Society; "Art Schism Regretted," opined *The Commercial Advertiser*. Similarly Alfred Stieglitz promoted the Photo-Secession to a very narrow audience and did not advertise his efforts. Indeed Stieglitz advised using the term "secession" judiciously. "The idea of secession is hateful to the Americans," he told Charles De Kay, "They'll be thinking of the Civil

War."[103] Though Stieglitz pushed ahead in promoting novel art forms and promising young artists, he disdained excessive publicity. Exhibitions at 291 were discussed and critiqued extensively in the professional photographic journals, especially Stieglitz's own *Camera Work*, which had succeeded *Camera Notes*, but comparatively little coverage was given the innovative gallery in the popular press. In March of 1908, Stieglitz explained to an interviewer that he had dispensed with brochures and exhibition catalogues at 291 as needless advertising. "Those who are interested in the things we have here will find them and those who are not interested we don't care to waste time with."[104]

The Eight, by comparison, systematically exploited the news-hungry press, advertising their association in language specifically chosen to alert the interest of the man-in-the-street. No doubt remembering Charles Fitzgerald's 1902 lament about the indifference of Americans towards the arts, the cadre of veteran newspaper illustrators John Sloan, George Luks, William Glackens, and Everett Shinn and their four associates called upon journalist friends to advertise their activities and thereby incite public interest. Master promoter Robert Henri made full use of promotional opportunities by issuing press releases, while all of The Eight obligingly granted interviews.

The timing of the Eight exhibition was critical. The absorption of the Society of American Artists back into the National Academy of Design had supplied Henri and his associates with a consolidated target against which to aim their artistic "revolt," and gain some much-needed publicity. But though they enjoyed the reputation of a rebellious avant-garde, The Eight still had not achieved political separation from the status quo. Indeed this was a difficult task. As late as January 1908, a month before the Macbeth Galleries exhibition, Henri, Luks, Lawson, Glackens, Sloan, and Shinn were among contributors to a "Special Exhibition of Contemporary Art," at the National Arts Club. Fellow exhibitors included Mary Cassatt, William Merritt Chase, Rockwell Kent, and Eduard Steichen — a curious and eclectic gathering of generations and personalities reflecting the still ambiguous politics of the New York arts community.

News coverage of the Macbeth Galleries exhibition served to counter this ambiguity, for the press now was hardly restrained in its use of unequivocally belligerent language to advertise The Eight's explicit agenda of cultural nationalism. The implications of "secession" feared by Stieglitz were exploited, as blatant allusions to the Civil War appeared in print. "Secession in Art," read a headline in the *New York Herald*. "The rebels are in arms, their brushes bristling with fight," echoed *The World*, "and the conservatives stand in solid phalanx to resist the onslaught of radicalism." Viewed as a defiant gesture of self-determination, The Eight exhibition was touted as having started an "art war" in New York.[105]

Even the usually understated *Philadelphia Press* proclaimed "A Rebellion in Art." The author of this review noted that American artists everywhere were attentive to the exhibition because the work of The Eight constituted an eloquent challenge to existing standards,

"New York's Art War . . .," *The World Magazine* (New York), 2 February 1908. Courtesy the Whitney Museum of American Art, New York.

45

defying "the prevailing custom of depicting America and its life in a style that is borrowed, piece by piece, from other lands." These artists demonstrated that America, the land and her people looked different, were different, and should be represented thus. The *Press* article was illustrated with photographs of the artists — four of whom had once worked in the newspaper's editorial offices — and their works, grouped around the drawing of a cowboy-knight errant. Modernity and tradition now combined, riding to the aesthetic battle on a quarter horse.[106] Echoed a reviewer for the *New York American*: "Here was nothing idealistic, no golden-haired and white-skinned goddesses, no landscapes from fairyland, but the real objects, the real people and the real happenings of our every-day life."[107] Words like "secession," "rebellion," and "revolt" caught the American newspaper reader's attention. As attendence figures for their group exhibition would demonstrate, The Eight and the popular press succeeded in awakening the slumbering public interest.

The Macbeth Galleries Exhibition and National Tour

From opening day visitors crowded into what one newspaper called the "outlaw salon" in Macbeth's galleries at the rate of three hundred an hour. "There has been a line — just as if it was the entrance to the Metropolitan Opera House — before the door when the gallery employes have arrived in the morning," reported the New York *Press*, "And Mr. Macbeth himself has looked dazed — not at the pictures — but at the jam in his beautiful rooms and at the manner in which the supply of catalogues has been consumed by the spectators."[108] The run of the exhibition in New York had to be extended an extra day. Income from the sale of eight paintings at the exhibition totalled some $4,000. Even more might have been sold, Macbeth assured the group, had the national economy been healthier. By February 18th, when the show closed, John Sloan wrote in his diary, "we've made a success — Davies says an *epoch*."[109]

The exhibition was installed in two adjoining octagonally-shaped rooms with Prendergast, Sloan, Lawson, and Shinn in one;

Davies, Glackens, Henri, and Luks in the second. Each artist had roughly twenty running feet on which to hang pictures and no restrictions governed their number or selection. Nor did the artists make any effort to co-ordinate their displays. The number of works exhibited ranged from Lawson's four to Prendergast's seventeen. Henri, Shinn, and Sloan hung nine, eight, and seven canvases respectively; Davies, Glackens and Luks each displayed six. The scale of pictures varied widely as well, from Prendergast's small sketches and watercolors to Glackens' life-sized portrait of his wife Edith Dimock and Everett Shinn's wife Florence Scovel, called *The Shoppers*.

Henri selected dark, boldly brushed portraits: Hals-inspired bust-length studies made during his recent trip to Holland. With *The Shoppers* and the brilliant *At Mouquin's*, Glackens hung a group of city park scenes already familiar to exhibition-goers. Luks' somberly colored portraits of eccentric New Yorkers and their urban surroundings faced Davies' pastoral fantasies. Lawson's blond Impressionist landscapes hung next to Shinn's spotlit theatrical paintings. And alongside Sloan's umber-hued vignettes of lower Manhattan, Prendergast arrayed small oils and watercolors of beaches and promenades, most of which were studies made at St. Malo during his trip to France the previous summer. One critic described Prendergast's wall as a "jumble of riotous pigment."[110]

In effect, visitors were confronted by eight separate and independent constituent exhibitions: eight designers, eight varieties of subject matter, eight approaches to the handling of paint. Even the usually sympathetic James Huneker, noted arts critic for *The Sun* and a longtime admirer of Davies and Luks, had to admit that the exhibition reminded him of "the clashing dissonances...the jangling and booming of eight differently tuned orchestras."[111] On the one hand, the diversity of The Eight was a pointed subversion of academic standardization. On the other, it accurately reflected the typical heterogeneity of many contemporary annuals. In effect, their 1908 exhibition at the Macbeth Galleries offered in microcosm both a view of what a progressive National Academy annual *should* look like, and a taste of what could already be seen on exhibition in many other American cities.

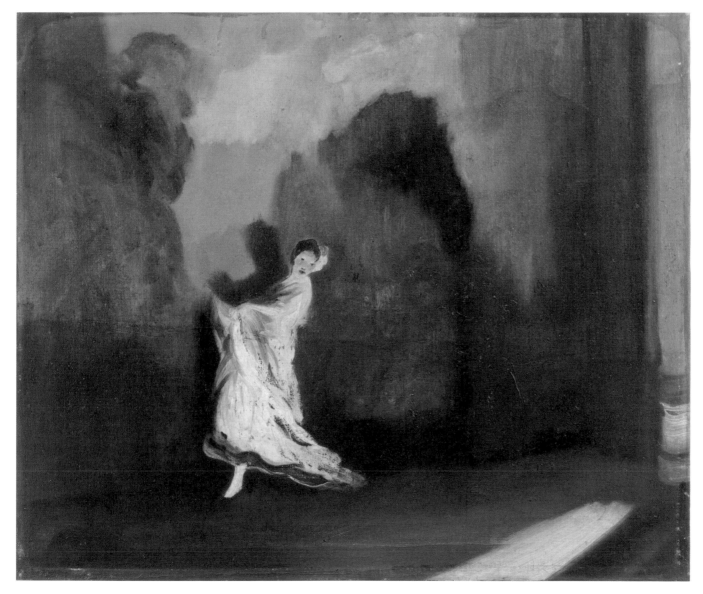

Everett SHINN, *Keith's, Union Square*, ca. 1906. The Brooklyn Museum of Art, Dick S. Ramsay Fund.

Mirroring public curiosity, the exhibition attracted widespread media coverage. Some New York newspapers simply reprinted earlier descriptions of the "rebellion" and appended a list of the artists and the works exhibited. But on the pages of many others, critical reaction was lively. Charles De Kay reprised his praise of The Eight as artists whose work inspired healthy debate. "Join the throng that fills the elevator to the Macbethan sky parlors and if you do not remain to pray, you will surely remain to curse." Though he did not like all of what he saw, De Kay admired the artists for their persistence. "There is no going to sleep over the sallies and whimsies of the Eight Painters," he concluded. "Whether it be an abstraction put in a clumsy way by Mr. Davies, or a bit of rollicking fun by Mr. Luks, or a clever piece of instantaneous observation in a hippodrome by Mr. Shinn, there is a live man behind the brush."[112]

Henri's nativist pronouncements supplied the press with eye-catching copy. And no one doubted that the Macbeth Galleries exhibition improved upon the tedium of an Academy annual. But after viewing the show, several writers did question the truth of this artistic "rebellion." Royal Cortissoz, writing for the *Tribune*, was not convinced that the artists had anything especially new to contribute, and he reported leaving the exhibition with the uncomfortable impression that they "had developed their ideas within ill-lighted studio walls, under the influence of this or that foreign master." No matter how hard they might strive for "reality," The Eight missed achieving "the element of nature, the truth accurately seen and sensitively painted."[113] In a similar review in the *Press*, a critic called the paintings of Henri, Davies, Luks, and Prendergast truly innovative, but found the other four artists "thoroughly French in spirit," and the exhibition in general "the most foreign, the most Frenchified show of paintings that we have seen in New York in years." "Surely it is not 'revolutionary' to follow in the footsteps of the men who were the rage in artistic Paris twenty years ago."[114]

In two reviews for *The Sun*, James Huneker provided the longest and most considered evaluation of The Eight exhibition in New York. Having recognized the contradiction between the artists' anti-Academy, anti-European publicity and their work when the group first formed, he warned that "there is no more deadly cant than the pose of persecution, of genius unappreciated." Huneker granted that individually, The Eight were painters of uncommon power and character. Associating realists Luks, Sloan, and Glackens with such writers as Maxim Gorky, Frank Norris, and Theodore Dreiser, he praised them for painting what they saw, whether sordid, ugly, or commonplace. He labeled Lawson a sensitive pantheist, Prendergast a "neo-impressionist" whose "whirling arabesques tax the eye," and Henri a classicist whose powerful portraits were "masculine and not the mere brushwork of an artistic artisan." Shinn had never before displayed such glitter and bravura. Bound together by the sincerity of their work, these seven were unquestioningly dedicated to the "straightforward portrayal of visible things," investing the commonest attitudes and gestures of contemporary life "with the dignity of earnest art." Finally there was Davies, whom Huneker admired most, an artist who "paints out of time, out of space," a poet and seer "who would penetrate the earthly envelope and surprise the secret fevers of the soul." With his participation the group battled for the assertion of "personality in art . . . always a cruel conflict."[115]

But as "performances in paint," the works of The Eight were decidedly reactionary in comparison to paintings Huneker had recently seen in Paris. "Any young painter recently returned from Paris or Munich — the Munich of the secessionists — would call the exhibition of the eight painters very interesting but far from revolutionary," he observed.[116] But then these Americans were fighting the inherent provincialism of New York and the American arts community. Huneker hoped, if anything, that their exhibition would teach American audiences to tolerate and even encourage sincere experimentation.

When the exhibition closed in New York in late February, the paintings were sent to the Pennsylvania Academy for a two-week showing that coincided with the Academy's spring exhibition. In succeeding months Sloan, aided by businessman friend Carl Lichtenstein, organized a tour to eight additional cities, beginning in September 1908 with the Art Institute of Chicago. From there the exhibition traveled to the Toledo Museum of Art, the Detroit Institute, the Herron Art Institute in Indianapolis, the Cincinnati Art Museum, the Carnegie Institute in Pittsburgh, and the Bridgeport

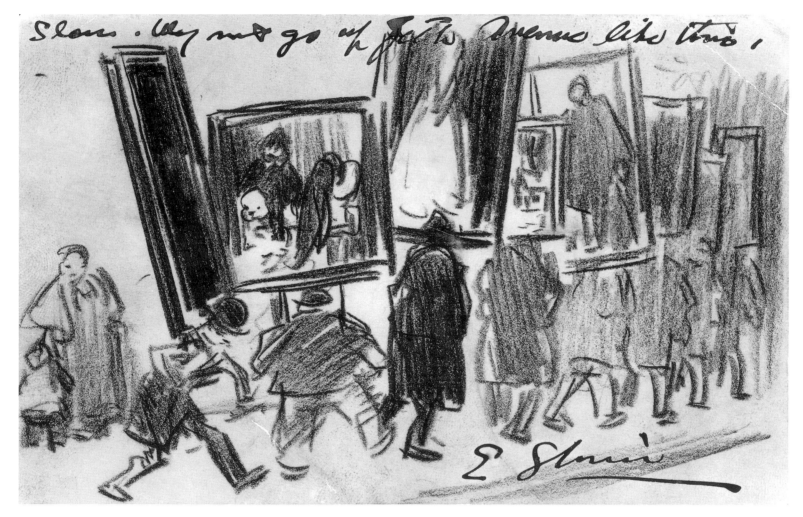

Everett SHINN, "Why not go up Fifth Avenue like this!," ca. 1907. Delaware Art Museum, Wilmington, Delaware.

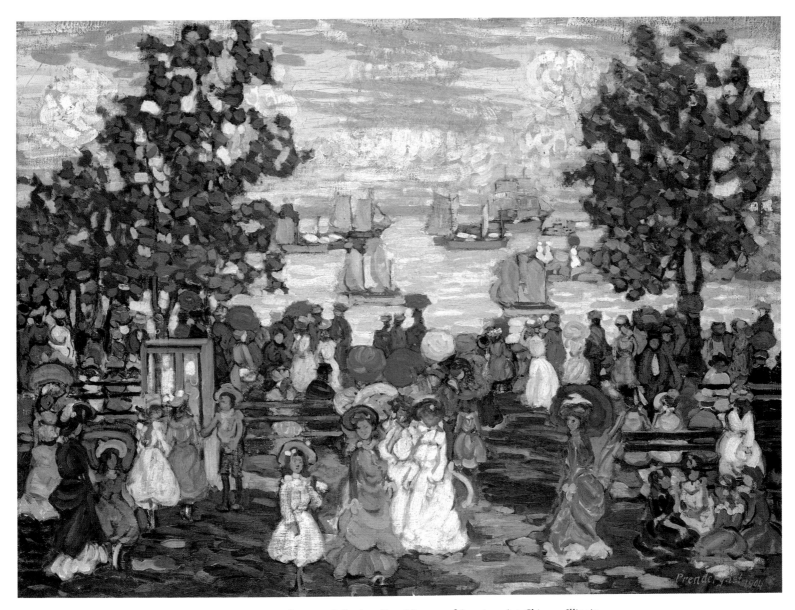

Maurice Brazil PRENDERGAST, *Salem Willows*, 1901-4. Daniel J. Terra Collection. Terra Museum of American Art, Chicago, Illinois.

(Connecticut) Art Association, closing in May of 1909 after a two-week showing at the Newark (New Jersey) Public Library. The selection and number of paintings exhibited at these later venues varied as several artists added or subtracted pictures during the course of the tour.[117]

As the exhibition made its way through eastern and mid-western cities, opinions remained divided over the quality of work on view. Paintings by Glackens, Lawson, and Shinn were generally praised, while most critics judged Henri's "not representative of the artist at his best." Of Davies, one Bridgeport reviewer wrote, "to look at his work after seeing the others is like getting in out of the sun and resting under a shady tree."[118] In Chicago, where Davies had studied art and was considered something of an adopted son, his paintings were called "charmingly poetic."[119] Reactions to Prendergast's paintings ranged from admiration to disbelief, though a surprising number of writers proved sympathetic to his "advanced" style. Luks and Sloan received mixed reviews. Bertha O'Brien of the *Detroit Free Press* derided Sloan's paintings, calling his *Hairdresser's Window* "the kind of realism which has become familiar through the study of advertising fences."[120] Yet in Chicago a few months previously, Maude Oliver had praised the artist's command of composition and design, and called the same picture "sound, original and essentially modern."[121]

Assessments of the significance of The Eight and their exhibition also varied. In the *Indianapolis News*, W. H. Fox judged the exhibition one of the most interesting collections brought together in the history of American art.[122] Maude Oliver found "a bit of too much unnatural struggling after effect, if not of sensationalism, in the canvases of 'The Eight.'"[123] A writer for the *Chicago Evening Post* called the artists "tangential personages" and dismissed the exhibition altogether:

These painters stop where most of us begin to paint. Is technique and cleverness everything and subject nothing? Is the art of the future to be judged on how paint is used, regardless of the message of the painter? In what other age was talent content to paint dancing girls, wine shops, bleary-eyed topers, ugly noisy streets and sordid scenes without a ray of sunshine? One word describes it all — an affectation.[124]

Yet the *Toledo Bee* reviewer saw nothing especially controversial. "These eccentric 'Eight' are by no means rebels against the academy or its tradition, they are merely individualists, bound together in a league of originality and unconventionality."[125]

❦

1. Boston architect P. B. Wright had patterned the Academy building after the Doge's Palace in Venice. The property was sold to the Metropolitan Life Insurance Company, which was planning construction of a new company headquarters. See Eliot C. Clark, *History of the National Academy of Design* (New York: Columbia University Press, 1954), 142-48.

2. Clark, 154-55. Agreement was reached that the Academy schools become part of Columbia's Faculty of Fine Arts, responsible for the School of Design, and that the Academy faculty be granted university standing. During negotiations Columbia agreed to make land available to the Academy for construction of a new school building. When necessary building funds were not forthcoming, the agreement was dissolved by mutual consent in 1914.

3. For a history of the founding of the Society of American Artists and its impact on the National Academy of Design, see Clark, 105-8; Lois Marie Fink and Joshua C. Taylor, *Academy: The Academic Tradition in American Art* (Washington: Smithsonian Institution Press, 1975), 79-86; and Jennifer A. Martin Bienenstock, "The Formation and Early Years of the Society of American Artists, 1877-1884" (Ph.D. diss., City University of New York, 1983).

4. "Now Plan Great Annual Art Salon," *New York Herald*, 18 April 1905. At a meeting on March 30, Academy secretary C. Y. Turner read a letter from the secretary of the Society accepting the proposition that a Committee of Conference be appointed to discuss a possible union. Committee Minutes. National Academy of Design Archives, New York.

5. "Art Salon Awaits Division of Funds," *New York Herald*, 19 April 1905.

6. Clark, 108-10. During negotiations, each organization made gestures of good faith by electing members of the other group to their own ranks. Academy president Frederick Dielman was elected to the Society of American Artists in April 1905. That same month, Society members Robert Henri and William Glackens were deemed eligible for nomination to the junior rank of Associate in the National Academy of Design, though only Henri won election the following month. NAD Minutes, 15 April 1905 and 10 May 1905. A year later, following formal amalgamation, Henri was elected a full academician (meeting of 1 May 1906). And at the autumn 1906 meeting, he was appointed to the Committee of Selection. Glackens was elected an Associate in 1907.

7. Quoted in "The 'Thirty' and Mr. Henri. Why the Painter Withdrew His Academy Canvases," *The Evening Post* (New York), 13 March 1907. See also "Jar in Jury of National Academy," *The World*, 15 March 1907; and "The Henri Hurrah," *American Art News*, 23 March 1907 for other reports of the jury proceedings.

8. "The 'Thirty' and Mr. Henri." *The Evening Post* art critic, Byron Stephenson, mentioned by Sloan in his diary as usually sympathetic to Henri and his group, probably wrote this piece.

9. Quoted in [Frederick James Gregg?], "Academicians and Outsiders [Editorial]," *The Evening Sun* (New York), 14 March 1907.

10. Quoted in "National Academy Stirred," *The Sun* (New York), 14 March 1907.

11. President's Report, Committee Minutes, 8 May 1907. National Academy of Design Archives.

12. "Some have been prize-winners at the Academy's exhibitions in competition with present-day Academicians, practically all of them have been exhibitors" ("Art According to the Academy," *The World* [New York], 14 April 1907); see also "Academy Bars Noted Artists," *The Evening Mail* (New York), 11 April 1907. An 1882 by-law had raised Academy membership from fifty to one hundred academicians. Fink and Taylor, 86-88.

13. Quoted in "National Academy Elects 3 Out of 36. 'Progressive' Painters Criticize the 'Conservatives' Who Are in Control," *The New York Times*, 12 April 1907; see also "Mr. Henri Off 'Academy' Jury," *New York Herald*, 12 April 1907.

14. Quoted in "National Academy Elects 3 Out of 36."

15. "National Academy Elects 3 Out of 36." In his diary entry of 11 April 1907, Sloan noted that a "MacAdam" of the Times had called to ask his opinion of the Academy vote. "I told him it was resentment of good work; that a young man with 'fossilized' ideas had no trouble getting in" (John Sloan, *John Sloan's New York Scene*, ed. Bruce St. John [New York: Harper & Row, 1965], 121. Hereafter cited as *Sloan's New York Scene*).

16. Samuel Swift, "Revolutionary Figures in American Art," *Harper's Weekly* 51 (13 April 1907), 534-36. Swift noted that in recent years in various countries opposition to new art developments had typically originated in established arts institutions and that even Kenyon Cox, now the voice of artistic conservatism, had begun his career as a "radical" in the 1870s. Twenty-three members of the 1907 selection jury were over forty-five years old. Hence it was hardly unexpected that the National Academy would decline to accept for exhibition every painting by the new generation of innovators.

17. Charles De Kay, "Artists at Their Little Games," *The New York Times*, 17 March 1907. De Kay heralded the successful union of the National Academy and Society, and called for artists to join in a great national Salon. If their motives were commercial, so were those of any exhibition organizer. And if the jury system was flawed, "a prey to professional prejudices and unconscious favoritism," united

artists could find a better system. It was essential to relinquish the factionalism of the past in favor of consolidation to seek "an approach to the art-loving public by every avenue which shows them fair and aboveboard, concerned chiefly with the object of providing the very best that can be brought to exhibition" ("Art Consolidation," *The New York Times*, 11 March 1906).

18. "Portrait Painters of To-Day; Robert Henri," *Vogue*, 3 January 1907.

19. Henri was an inveterate diarist and his journals from the 1890s are filled with descriptions of his activities and ambitions. Always eager that his teachers notice him and his work, Henri was particularly proud of having gained the reputation of a "revolutioniser" at the Pennsylvania Academy, where he agitated for additional sketch classes and increased access to the sculpture studio. William I. Homer, *Robert Henri and His Circle* (Ithaca: Cornell University Press, 1969; revised edition, New York: Hacker Art Books, 1988), 27-28.

20. *Paintings by Robert Henri*, Macbeth Galleries, April 1902. Henri's first one-man show had been held at the Pennsylvania Academy in the fall of 1897. Following his 1902 Macbeth Galleries showing, Henri added several canvases and sent it on to the Pennsylvania Academy and the Pratt Art Institute.

21. Sloan, Notes, 111-12 (see p. 19, n. 10).

22. *Sloan's New York Scene*, 3 March 1907. See also Sloan, Notes, 111-12.

23. Quoted in Joseph J. Kwiat, "Dreiser and the Graphic Artist," *American Quarterly* 3 (Summer 1951), 15-16.

24. "New York's Art Anarchists," *The World* (New York), 10 June 1906.

25. Quoted in "Wm. M. Chase Forced Out of N. Y. Art School: Triumph for the 'New Movement' Led by Robert Henri," *New York American*, 20 November 1907. Rather than support "revolutionary methods which he felt were in direct opposition to the theories and practices which have made him one of the leading artists of America," Chase elected to resign his post and return to teaching at the Art Students' League.

26. *Sloan's New York Scene*, 3 March 1907 and 18 March 1907. In fact, talk of an independent exhibition had been ongoing since early 1906. On 8 January 1906, Sloan noted in his diary, "Talk of the exhibition next year . . . some seven of the 'crowd' to contribute $10 for an exhibition fund." Again in May 1906, Sloan recorded discussions with Henri and Glackens about an invitational exhibition of "graphic art," with "no officers, division of space by lot, no enlargement of membership." Invitations would be sent to such younger artists as Arthur Davies, Everett Shinn, Ernest Lawson, Maurice Prendergast, and George Luks, but also to senior figures Winslow Homer, Childe Hassam, Julian Alden Weir, Willard

Metcalf, and Robert Reid, all of whom maintained some distance from the National Academy.

27. *Sloan's New York Scene*, 4 April 1907.

28. *Sloan's New York Scene*. Around this time, Jerome Myers left the group, probably as the result of a dispute with Henri. According to Sloan, Henri disliked the sentimentality of Myers' work. See Homer, 129. Davies' suggestion that young Rockwell Kent, a pupil of Henri, be invited to join, was also rejected and the group coalesced by early April. See Arthur B. Davies to Robert Henri, 5 April 1907. Robert Henri Papers, Beinecke Rare Book and Manuscript Library, Yale University. Hereafter cited as Henri Papers, Beinecke Library.

29. "Eight Independent Painters," *The Sun* (New York), 15 May 1907.

30. Quoted in [Royal Cortissoz], "A New Art Group," *New-York Daily Tribune*, 15 May 1907.

31. "Eight Independent Painters."

32. "A New Art Group."

33. "The 'Thirty' and Mr. Henri." The *Evening Post* writer (Byron Stephenson?) noted that on occasion, these "new" and more innovative artists, William Glackens and Arthur B. Davies in particular, *had* won recognition and acceptance at National Academy exhibitions. But such recognition was inconsistent and often summary, as acceptance to an exhibition did not ensure that an artist's work would be shown to best advantage: the works of non-academicians and other "outsiders" typically were "skyed" or hung high above the viewer's eye level.

34. "The Henri Hurrah," *American Art News*.

35. Beginning with George Luks, "who sends pictures to the academy show every year religiously, but so far has had only one accepted." Arthur Davies was described as "ranked among the very highest as a colorist, who always refuses to accept the academy's invitation to send in pictures"; Ernest Lawson as one who "sends pictures to the academy jury with indifferent success"; Robert Henri, "an academician, but who never boasts about it"; William Glackens "who painted a picture of children in the park ranked 'big' which the academy threw out"; Maurice Prendergast, a Boston artist "who rarely sends to the Academy," and the two younger artists John Sloan and Everett Shinn, noted as rising fast but as yet unrecognized by the Academy. "Eight Independent Painters."

36. "New Art Salon Without a Jury," *New York Herald*, 15 May 1907. There is some confusion about who first named "The Eight." Late in life, John Sloan attributed the name to Frederick James Gregg and Charles Fitzgerald. Gregg was an editorial page writer for the *The Evening Sun* and had written sympathetic

reviews of these artists in the past. However, as noted above, initial coverage of the Macbeth Galleries exhibition appeared not in the evening paper, but in the morning *Sun* — the papers combined in the 1920s, but at this time they were separate and employed different editorial and reporting staffs. Gregg may have invented the term "The Eight," but there is no certain proof that he first published it. Fitzgerald's involvement is also uncertain — by 1907, arts reviews in *The Evening Sun* no longer carried his by-line. For Sloan's recollections, see Sloan, Notes. For Gregg's contribution, see John Loughery, "The New York Sun and Modern Art in America: Charles Fitzgerald, Frederick James Gregg, James Gibbons Huneker, Henry McBride," *Arts Magazine* 59 (December 1984), 77-82.

37. Mary Fanton Roberts [Giles Edgerton, pseud.], "The Younger Painters of America, Are They Creating a National Art?" *The Craftsman* 13 (February 1908), 522.

38. Ibid., 531.

39. The 1890s had been the golden age of popular illustration. Glackens, Luks, Shinn, and Sloan were among the hundreds of artists predictably attracted to commercial work. Leading practitioners, such as Charles Dana Gibson, whose "Gibson Girl" become the icon of modern American womanhood, commanded salaries in excess of $60,000 at a time when most Americans survived on yearly incomes one-tenth of that sum. See "Fortunes for Pen Artists," unidentified clipping. Everett Shinn Papers, Archives of American Art. This report lists the following illustrators and their incomes: Gibson, $65,000; Howard Pyle, $35,000; Frederic Remington, $30,000; Maxfield Parrish and A. B. Frost, $20,000; Jessie Wilcox Smith, $18,000. It also notes that photographer-correspondent James Hare made more than $20,000 per year.

40. Helen Henderson, "Glimpses of the Studio Life in Philadelphia," *Public Ledger* (Philadelphia), 4 October 1903, describing Henri's second studio at 1717 Chestnut Street. Henderson went on to describe the group production called "Twillbe," a parody of George du Maurier's best-selling novel of bohemian Paris, *Trilby*. Not insignificantly, Henri played Svengali, the mysterious pianist who hypnotizes Trilby to artistic greatness as an operatic singer, to young John Sloan's "Twillbe." By 1903, Sloan and his wife Dolly had taken over the studio from Henri, long since relocated to New York.

41. Sloan, Notes. For a thorough discussion of Henri's influence as a teacher and mentor to Sloan, Glackens, Luks, and Shinn, see Rebecca Zurier, "Picturing the City: New York in the Press and the Art of the Ashcan School, 1890-1917" (Ph.D. diss., Yale University, 1989), 21-70.

42. Even at such an early date, rumors and legend were circulating about Davies to the effect that he was an untutored farmer who had entertained himself by painting on barrelheads until "discovered." "The romance is of course made to satisfactory length and set in regulation words employed in such narratives," was

Henri's wry comment. "If this same world does not spoil and 'educate' this Davies he may figure high." Henri Papers, Beinecke Library.

43. [William Macbeth], *Exhibition of Pictures by Arthur B. Davies*, Macbeth Galleries, 9-21 March 1896.

44. Henri noted in his 1904 diary that he accepted election to the post of Chairman of the Committee of Selection for the Society of American Artists in the hope of gaining some recognition for Davies. "It does not seem to be a practical thing ... however, because there is a general rule not to invite a resistant artist in N.Y. — because others would kick or hold out for some honor — they would do well if they but had a fair appreciation of Davies' work (which however is only appreciated by a few)." Henri diaries, 5 December 1904. Collection of Janet LeClair. Only a month earlier however, Davies had been one of the few younger American painters represented at the important "Comparative Exhibition of Native and Foreign Art," organized in New York by the Society of Art Collectors.

45. Homer states that Henri knew Prendergast by the fall of 1901, but Henri does not note having met Prendergast in his diary until 29 April 1902. Henri diaries. Collection of Janet LeClair. See Homer, 100-2.

46. Lawson had rented a studio in MacDougal Alley, a block away from Glackens' Washington Square apartment. See Perlman, 102-3.

47. See for example, Charles Fitzgerald, "George B. Luks, Painter," *The Evening Sun* (New York), 10 May 1902; "George Benjamin Luks, Arch Impressionist," *The New York Times*, 4 June 1905; James Huneker, "George Luks," *The Sun* (New York), 21 March 1907; "George Luks," *The National Advertiser*, 1 April 1907; John Spargo, "George Luks, An American Painter of Great Originality and Force Whose Art Relates to All the Experiences and Interests of Life," *The Craftsman* 12 (September 1907), 599-607.

48. John White Alexander, "The Need of a National Academy, and Its Value to the Growth of Art in America," *The Craftsman* 17 (March 1910), 608.

49. Many of the new institutions incorporated art schools. During the 1870s alone such schools as The Art Students' League in New York and the Pratt School of Art in Brooklyn were founded as were the schools of the Museum of Fine Arts in Boston and the Art Institute of Chicago. In larger cities the new museums were typically founded by a committee of community business leaders; museums in smaller cities often resulted from a start-up bequest from one individual, as in the Layton Art Gallery in Milwaukee, the George Walter Vincent Smith Museum in Springfield (Massachusetts), the Carnegie Institute in Pittsburgh, or the Crocker Art Gallery in Sacramento. Local artists also made significant contributions to the founding and encouragement of museums, art schools, and artists' clubs, often working with business leaders to establish endowment support and initiate acquisitions. The founding trustees of the Metropolitan Museum in New York,

for example, included architect Richard Morris Hunt and painters Frederic Edwin Church, John F. Kensett and Daniel Huntington (ex-officio as President of the National Academy of Design).

50. A listing of the various arts organizations in existence at this time can be found in the annual *American Art Directory*, first published for the year 1898.

51. In several cases exhibition buildings constructed for these fairs were maintained for use as city museums, including Memorial Hall in Philadelphia from the 1876 Centennial, the Museum of Science and Industry in Chicago from the 1893 Columbian Exposition, the City Art Museum and Missouri Historical Society in Saint Louis from the 1904 Louisiana Purchase Exposition, and the Palace of the Legion of Honor in San Francisco from the 1915 Panama-Pacific Exposition.

52. Thus the Fourth (1909), Fifth (1910), Sixth (1911) and Seventh (1912) Annuals in Saint Louis were received as packages from the Albright Art Gallery in Buffalo.

53. Exhibitors at the inaugural annual of the Carnegie included Americans Winslow Homer, Mary Cassatt, Thomas Eakins, John La Farge, and James McNeill Whistler. European contributors included Claude Monet, Edgar Degas, Pierre Puvis de Chavannes, Franz Stuck, Fritz von Uhde, and Anders Zorn. See Carnegie Art Galleries, *Catalogue: First Annual Exhibition*, 1896.

54. Clark, 163-65. In the 1905 annual, only thirteen pieces of sculpture were displayed. In 1911, when the number of sculptures on view had increased to one hundred and sixty-seven, a special resolution was carried that one gallery would be specially designated for sculpture during the winter exhibition. It was also from this date that the number of sculptors elected to membership in the Academy began to increase.

55. The search for larger exhibition facilities is recounted by Will H. Low in "National Art in a National Metropolis," *The International Quarterly* 6 (1902/1903), 117. See also Clark, 143-47.

56. "National Art in a National Metropolis."

57. Ibid. See also Herbert D. Croly, "New York as the American Metropolis," *Architectural Record* 13 (March 1903), 193-206; and a spirited rebuttal to New York's claims from Bostonian William H. Downes, "Boston as an Art Center," *New England Magazine* 30 (April 1904), 155-66; cited in Trevor J. Fairbrother, *The Bostonians: Painters of an Elegant Age, 1870-1930* (Boston: Museum of Fine Arts, 1986), 64.

58. Charles De Kay, "Art for the People Versus Popular Art," *The New York Times*, 22 October 1905. In New York, the Colonial Club presented two exhibitions per year, the Union League, Lotos Club, and Century Association scheduled

exhibitions every month. William T. Evans, leading collector of American art who in 1909 bequeathed his collection to the National Gallery of the Smithsonian (now the National Museum of American Art), was chairman of the Art Committees for both the Lotos and Colonial clubs. Charter members of the Colony Club, one of the first private women's clubs in America, included actresses Ethel Barrymore and Maud Adams, designer Elsie de Wolfe, and sculptress Gertrude Vanderbilt Whitney. "Colony Club Opens," *The Evening Sun*, 12 March 1907. See also Avis Berman, *Rebels on Eighth Street* (New York: Atheneum, 1990), 82.

60. National Arts Club Papers, Archives of American Art.

61. I am indebted to Catherine Stover of the Archives of American Art for information about the early National Arts Club shows, and for assistance researching the National Arts Club documents.

62. Henri to Sloan, 25 January 1904. Sloan Papers, Delaware Art Museum. This was not the first group show Henri had organized. Three years earlier he had assembled paintings by Glackens, Sloan, Ernest Fuhr, Alfred Maurer, Willard Price, and Van Deering Perrine in a show for the Allan Gallery. However it received almost no publicity. Unfortunately and uncharacteristically, Henri made no note in his 1903 diary about the Arts Club show. However, since De Kay was still Secretary and Managing Director at this date, it is likely he invited Henri to organize the show. Henri noted meeting De Kay at Macbeth's in a diary entry of 7 April 1902. Henri diaries. Collection of Janet LeClair.

63. The Mail and Express (New York), 25 January 1904.

64. "[The Gilder]." "Palette and Brush. Some Good Exhibitions at the Clubs," *Town Topics*; undated clipping. Everett Shinn Papers, Archives of American Art.

65. Charles De Kay, "Six Impressionists. Startling Works by Red-Hot American Painters," *The New York Times*, 20 January 1904.

66. *The Black Mirror* 2 (1904), 26, 31.

67. In 1886, a group of London-based painters who had adopted the new French styles formed the New English Art Club to present counter-exhibitions to the Royal Academy annuals. Spokesman Walter Sickert, a close friend of Edgar Degas, defined the "beauty" of Impressionism as found in the city, not in nature: ". . . for those who live in the most wonderful and complex city in the world, the most fruitful course of study lies in a persistent effort to render the magic and poetry which they daily see around them." Quoted in Denys Sutton, *Walter Sickert* (London: Michael Joseph, 1976), 63.

68. [James Huneker], "George Luks," *The Sun*, 21 March 1907.

69. [Arthur Hoeber], "A Most Lugubrious Show at the National Arts Club," *The Commercial Advertiser* (New York), 21 January 1904.

70. [Charles Fitzgerald], "A Significant Group of Paintings," *The Evening Sun* (New York), 23 January 1904. Fitzgerald was one among a small group of arts writers in New York, including Frederick James Gregg, who also wrote for *The Evening Sun*, James Huneker of *The Sun*, and Mary Fanton Roberts of Gustav Stickley's *The Craftsman* magazine, who made an effort to promote the six National Arts Club exhibitors following their 1904 show. Both Fitzgerald and Huneker wrote profiles of George Luks at a time when the artist's work was seldom seen outside small club shows and dealers' galleries. Works by Henri, Glackens, Davies or any of the others, if on view at the Academy or the Society, or in Macbeth's showrooms, were guaranteed long and generally sympathetic notices by these writers. For a history of the relationships existing among The Eight and Fitzgerald, Gregg, and Huneker see Loughrey, "The New York Sun and Modern Art in America."

71. Theodore Duret, *Manet*, transl. J. E. Crawford Flitch (New York: Crown Publishers, 1937), 86.

72. [Gregg], "That Tragic Wall," *The Sun* (New York), 16 March 1907.

73. *Catalogue of the Paintings in the Metropolitan Museum of Art* (New York: The Metropolitan Museum of Art, 1898), 100.

74. [Charles Fitzgerald], "Manet and His Work," *The Evening Sun* (New York), 23 May 1902.

75. *The Black Mirror* 2 (1904), 31.

76. [Frederick James Gregg], "Certain Painters at the Society," *The Evening Sun* (New York), 1 April, 1905.

77. Sadakichi Hartmann, "Studio Talk," *International Studio* 30 (December 1906), 183.

78. Letters from Davies to William Macbeth during the 1895 and 1897 trips can be found among the Macbeth Galleries Papers, Archives of American Art.

79. Henri to Sloan, 5 November 1899, Sloan Papers, Delaware Art Museum. As Sloan later recalled: "I was afraid of life over there . . . I dreaded and had a distaste for the Parisian art student's life, attacking saucers in a corner and living with a combination model, housekeeper and mistress. I was afraid of being 'caught' in this atmosphere" (Sloan, Notes). Sloan never did make the trans-Atlantic journey; see David W. Scott, *John Sloan, 1871-1951* (Washington: National Gallery of Art, 1971), 20.

80. For a comprehensive history of American artists studying in France, see H. Barbara Weinberg, *The Lure of Paris* (New York: Abbeville Press Publishers, 1991).

81. The relative stringency of admissions policies had varied as governing regimes changed in France. For histories of the Salon in the nineteenth century see Nikolaus Pevsner, *Academies of Art, Past and Present*, rev. ed. (New York: Da Capo Press, 1973); Albert Boime, *The Academy and French Painting in the Nineteenth Century* (London: Phaidon, 1971), and Fink and Taylor, 11-24.

82. For a history of the independent exhibition movement in France, see Pierre Vaisse, "Salons, Expositions et Sociétés d'Artistes en France 1871-1914," in *Saloni, gallerie, musei e loro influenza sullo sviluppo dell'arte dei secoli XIX e XX: Atti del XXIV Congresso, C.I.H.A.* (Bologna: Editrice CLUEB, 1979), 141-55.

83. By the 1880s, independent societies and temporary exhibiting groups were proliferating. Groups included the Union liberale des Artistes Français, the Société nouvelle de Peinture et de Sculpture, as well as such colorfully named smaller groups as "Cimaise," "Eclectique" and the "Inquiets."

84. Constance Cain Hungerford, "Meissonier and the Founding of the Société Nationale des Beaux-Arts," *Art Journal* 48 (Spring 1989), 71-77. Protests arose when Meissonier, who had chaired the Fine Arts jury at the Universal Exposition, and several other artists, including Pierre Puvis de Chavannes, Albert Besnard, and Auguste Rodin, proposed that foreign award winners be granted the same privileges as artists awarded medals at the regular Salon: that is, that they be permitted to exhibit their work in future Salons without first having to submit to the jury. This was hardly a new procedure: winners from previous expositions had been designated "hors concours." But at no previous exposition had so many awards been distributed, or to so many foreigners. Many in the Société des Artistes Français, most notably William Bouguereau and Tony Robert-Fleury, were horrified by the prospect of an influx of foreigners. Others pointed out that the Salon was already too large: the admission of so many artists without restriction would severely limit the opportunities for younger men. Meissonier and his supporters argued that the Société compromised France's honor by reneging on the awards. No solution was reached and in the summer of 1890, Paris hosted two "official" Salons — the "Old" Salon held in the Palais de l'Industrie on the Champs-Elysées, and the "New" Salon, installed in an exhibition hall left from the Exposition Universelle in the Champs-de-Mars.

85. Ibid.

86. In 1884, the Société des Indépendants had been founded to organize annual exhibitions open to any exhibitor: there was no selection jury and no prizes were awarded. In 1903, a fourth "Salon d'Automne," organized by a private businessman to showcase the most radical trends was added to the schedule in October.

56

87. Peter Paret, *The Berlin Secession: Modernism and Its Enemies in Imperial Germany* (Cambridge: Harvard University Press, 1980), 35.

88. Henri to his parents, 17 February 1897 Collection of Janet LeClair.

89. The majority of American artists in Paris had little if any direct personal contact with European students in the teaching ateliers, much less with the local "avant-garde." Aside from the language barrier, considerations of class were also a factor: artists from the French upper class seldom mixed with foreigners on an informal basis; the bourgeois and working-class French artist, typically short of funds, often envied and therefore ignored the American, whose very presence in a foreign country implied some financial security. As a rule, the Americans socialized with each other and with other English-speaking artists, predictably from England, Canada, Australia, and other countries in the British Empire. British writer Somerset Maugham, who shared a Paris studio with Ernest Lawson in 1893, commented on this situation in his semi-autobiographical *Of Human Bondage*: "There were legends in the Latin Quarter of a time when students of different countries lived together intimately, but this was long since passed, and now the various nations were almost as much separated as in an Oriental city. At Julian's and at the Beaux-Arts a French student was looked upon with disfavour by his fellow countrymen when he consorted with foreigners, and it was difficult for an Englishman to know more than quite superficially any native inhabitants of the city in which he dwelt. Indeed, many of the students living in Paris for five years knew no more French than served them in shops and lived as English a life as though they were working in South Kensington" (W. Somerset Maugham, *Of Human Bondage* [London: 1915; London: Penguin Books, 1963], 231).

90. Henri diary, 30 March 1890. Collection of Janet LeClair.

91. Henri diary, 30 April and 26 May 1890. Collection of Janet LeClair.

92. Henri diary, 27 May 1890. The new Société Nationale des Beaux-Arts had elected no selection jury and issued no medals or awards. Instead, letters of invitation were sent to sympathetic French and foreign artists; the invitation held good in perpetuity and for any number of works the entrant might wish to exhibit. Fewer than a thousand paintings were put on display, many of them hung singly on the line and grouped by artist. Such improvements in hanging made the "New" Salon seem selective and special, "like the numerous small salons that had become common in galleries and private clubs." Hungerford, 73-74.

93. Maurice Prendergast to Mrs. Oliver Williams, 10 October 1907. Williams Papers, Archives of American Art. For Prendergast's contacts with European modernism, see Nancy Mowll Mathews, "Maurice Prendergast and the Influence of European Modernism," in Carol Clark et al., *Maurice Prendergast, Charles Prendergast: A Catalogue Raisonné* (Williamstown: Williams College Museum of Art, 1990), 35-45.

94. Henri class notes, April 1894. Beinecke Library. At the Académie Julian, Henri had worked under William-Adolphe Bouguereau and Tony Robert-Fleury, both defenders of the Société des Artistes Français and the status quo. But he admired and emulated in his own work the bright impressionist palette and vigourous brushwork of portraitists Albert Besnard and Anders Zorn, artists of the Société Nationale. "Bouguereau drew a long breath and then gave me the devil, " 'all those purples!*** ' " Henri diary, 1 April, 1891.

95. For the early history of the National Academy of Design, see Clark, 10-15, and Fink and Taylor, 29.

96. Bienenstock, "The Formation and Early Years of the Society of American Artists, 1877-1884," 182-84.

97. Bienenstock, 182-84.

98. "Society of American Artists," *The Evening Post*, 3 April 1897.

99. Founding members of the Ten, with Weir, Twachtman, and Hassam, were Frank W. Benson, Joseph R. DeCamp, Thomas W. Dewing, Willard Metcalf, Robert Reid, Edward Simmons, and Edmund Tarbell. See William H. Gerdts et al., *Ten American Painters* (New York: Spanierman Gallery, 1990).

100. "Art Schism Regretted," *The Commercial Advertiser,* 10 January 1898. See also Gerdts et al., 9-12.

101. Charles Caffin, for one, noted that the European secessions were typically part of well-orchestrated and explicitly-stated aesthetic programs, whereas the Ten, because they lacked any specific political or aesthetic mandate, became just another group of publicity-seekers. See "Society of American Artists," *The Evening Post*, 13 January 1898.

102. Alfred Stieglitz, "Four Happenings," *Twice a Year* 8-9 (Spring-Summer, Fall-Winter, 1942), 117; quoted in Edward Abrahams, *The Lyrical Left* (Charlottesville: University of Virginia Press, 1986), 130-31. Stieglitz went on from the 1902 show to consolidate the Photo-Secession as a formal exhibiting group. In 1905, he and fellow photographer Eduard Steichen rented space at 291 Fifth Avenue for the purpose of presenting regular exhibitions of work by members of the Photo-Secession. By 1907, Stieglitz's interests, and the exhibition schedule of Little Galleries of the Photo-Secession, had expanded to include paintings, drawings, and sculpture by European and American modernists.

103. Ibid.

104. "Alfred Stieglitz, Artist, and His Search for the Human Soul," *New York Herald*, 8 March 1908.

105. "New York's Art War and the Eight Rebels," *The World*, 2 February 1908.

106. "A Rebellion In Art Led by Former Philadelphians," *The Philadelphia Press*, 9 February 1908. Perhaps expecting that the "rebellion" perpetrated by The Eight might attract male readers to the arts, the *Philadelphia Press* Sunday editor printed the review in the sports section.

107. " 'The Eight' Exhibit New Art Realism," *New York American*, 4 February 1908.

108. William B. McCormick, "Art Notes of the Week," *The New York Press*, 9 February 1908.

109. *Sloan's New York Scene*, 17 February 1908. This was the original closing date for the show, but Henri noted in *his* diary entry for 17 February that the exhibition had been extended to Tuesday. 1907 had been a serious depression year in the United States; William Glackens wrote to his wife on February 25, 1908 that Macbeth claimed he could have sold $25,000 worth of pictures if the economy had been stronger. See Vincent J. de Gregorio, "The Life and Art of William Glackens" (Ph.D. diss., Ohio State University, 1955), quoted in Homer, 281, n. 34. The major purchaser from the exhibition was Gertrude Vanderbilt Whitney, who bought four canvases: Henri's *Laughing Child*, Shinn's *Revue*, Lawson's *Winter on the River* and Luks' *Woman with Pet Goose* for a total of $2,225. Charge Book, Macbeth Galleries Papers, Archives of American Art. On Whitney's purchases, see Berman, *Rebels on Eighth Street*, 91-92.

110. [Arthur Hoeber], "Art and Artists," *New York Globe and Commercial Advertiser*, 5 February 1908.

111. [James Huneker], "Eight Painters: First Article," *The Sun* (New York), 9 February 1908.

112. [Charles De Kay], "Eight-Man Show at Macbeth's," *The New York Evening Post*, 7 February 1908.

113. Royal Cortissoz, "Art Exhibitions," *New-York Daily Tribune*, 5 February 1908. This review prompted Sloan to comment in his diary. "The Tribune has a sermon for us in this morning edition. Advised us to go and take an academic course, then come out and paint pictures — (like all the rest of the salable things). It is regrettable that these art writers, armed with little knowledge (which is granted a dangerous thing) can command attention in the newspapers" (*Sloan's New York Scene*, 5 February 1908).

114. William B. McCormick, "Art Notes of the Week," *The New York Press*, 9 February 1908.

115. [James Huneker], "Eight Painters: First Article."

116. Ibid.

117. Even before the Macbeth Galleries exhibition opened, Sloan noted in his diary that a gallery in Boston had inquired if the show would be available for tour, but nothing came of this. Sixty-three paintings were shown in New York and Philadelphia, though not the same sixty-three. The number of paintings sent to subsequent venues ranged from sixty-seven to sixty-eight and pamphlets printed at several of the host institutions followed different numbering sequences. For a detailed reconstruction of the tour and local critical reaction to the work of The Eight, see Judith Zilczer, "The Eight on Tour, 1908-1909," *American Art Journal* 14 (Summer 1984), 21-48.

118. "Art Exhibition Opens Tomorrow," *Bridgeport Standard*, 9 April 1909, quoted in Zilczer, 35.

119. Maude I. G. Oliver, "Exhibitions," *The Sunday Record-Herald* (Chicago), 13 September 1908. Newspaper scrapbook, Ryerson and Burnham Libraries, Art Institute of Chicago.

120. Bertha V. O'Brien, "Canvases of 'The Eight' No Beauty Feast," *Detroit Free Press*, 29 November 1908, quoted in Zilczer, 31.

121. Maude I. G. Oliver, "Exhibitions," *Chicago Record-Herald*, 20 September 1908. Newspaper scrapbook, Ryerson and Burnham Libraries, Art Institute of Chicago.

122. W. H. Fox, "Eight Painters' Work Gives Shock to Many," *Indianapolis News*, 9 January 1909, quoted in Zilczer, 35.

123. Oliver, "Exhibitions," *The Sunday Record-Herald*, 13 September 1908.

124. I. M. McCauley, "Art and Artists," *Chicago Evening Post*, 26 September 1908. Newspaper scrapbook, Ryerson and Burnham Libraries, Art Institute of Chicago.

125. "Striking Originality in the Work of 'The Eight,' " *Toledo News-Bee*, 15 October 1908, quoted in Zilczer, 29.

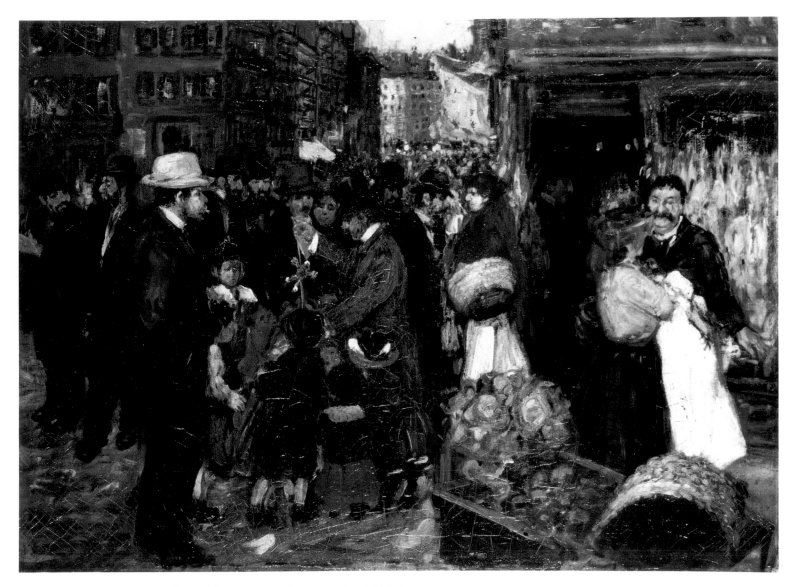

59

George LUKS, *Hester Street*, 1905. The Brooklyn Museum, Dick S. Ramsay Fund, 40.339.

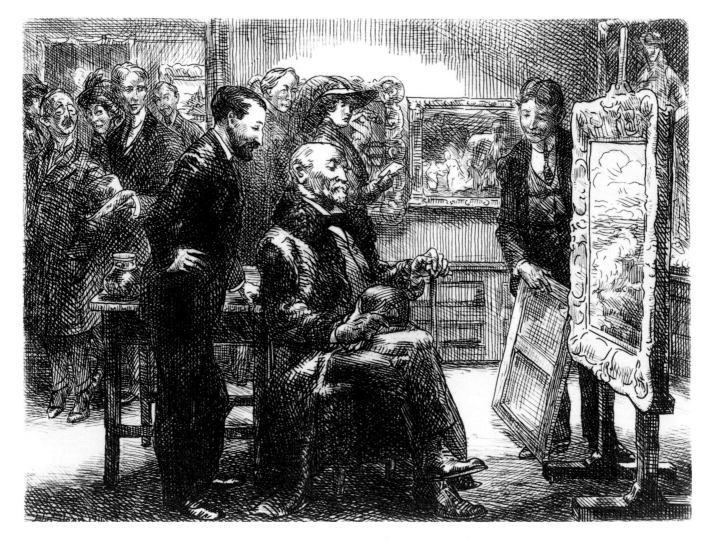

John SLOAN, *The Picture Buyer*, 1911. Bowdoin College Museum of Art, Bequest of George Otis Hamlin.

Art and Commerce: William Macbeth, The Eight and the Popularization of American Art Gwendolyn Owens

In March of 1908, one month after The Eight exhibition had attracted crowds of visitors to New York's Macbeth Galleries, founder and owner William Macbeth described the event to readers of *Art Notes*, the gallery's quarterly magazine, as "a remarkable success." Noting that the public had been largely receptive, he implicitly made an appeal for broadmindedness toward new art: "Many frankly confessed that they were unequal to form any estimate of pictures that presented to them new sensations, but they wisely refrained from condemning what they could not understand." Macbeth concluded with a summary of the reaction of the New York newspapers:

> Several reviewers in the daily press took special pains to correct some erroneous impressions concerning the exhibitors, who, in spite of themselves, were made to pose as terrible fellows. Among the corrections it seems necessary to repeat are these facts — these artists are not either formally or informally a banded together "eight," as so frequently dubbed. Their exhibition was in no sense "a protest" against anything under the sun, nor intended for "a new departure" from any tradition or in any direction.
>
> Every one of the group had frequently been a welcome exhibitor in many exhibitions, even in the Academy sometimes, and had no occasion to assume a defiant attitude.[1]

These comments on the exhibition, which in part echoed Robert Henri's statements concerning the purpose of the show, reinforced the eight exhibitors' standing as important American artists, but not revolutionaries. Yet Macbeth was careful to avoid the partisan commentary or references to the press' inflammatory rhetoric regarding "rebellion" and "secession," lest he offend other more conservative artists and clients whom he represented, and whose goodwill was essential to his own livelihood. He clearly viewed the exhibition as simply one event among many in his long struggle to win greater recognition for American art.[2] Nine years later, when Macbeth wrote a brief history of the Galleries, The Eight show was not even mentioned among the highlights of the history of the twenty-five year old establishment. Not until 1938 would his successors — his son Robert Macbeth and nephew Robert McIntyre — stage an anniversary show of paintings by The Eight and claim for the original exhibition a more

singular and dramatic significance in their institution's history. Despite the roles that mythologizing and hindsight played in this reversal, it is their assessment that we share today, in our recognition of the 1908 exhibition's landmark status in the history of American art. Thus, the lives and reputations of The Eight have been greatly affected, not only by the Macbeth Galleries' original decision to host the 1908 show, but also by the later use of the exhibition to further the Galleries' own ambition to be remembered as the most important commercial gallery in turn-of-the-century New York.

The Early History of the Macbeth Galleries

By 1908, William Macbeth (1851-1917) had been waging a campaign to encourage collectors to buy American art for sixteen years. An immigrant from Ireland, he took a job as a clerk for Brooklyn print dealer Frederick Keppel in 1873 and after a decade with the firm became a full partner.[3] The diary Macbeth kept during his nineteen years at Keppel's, the American branch of the London firm of Frederick A. Keppel and Son, records his success there and, significantly, his great enthusiasm for his work. A surviving Keppel receipt for the $5 sale of an Albrecht Dürer woodcut, with a guarantee of authenticity signed by Macbeth for Keppel, documents not only the affordability of old master prints in the era, but also the way in which the dealer's young assistant was able to act on his own.[4] A mere three months after hiring Macbeth, Keppel left for Europe and placed his new employee in charge of the business; within several years, Macbeth himself was traveling to Europe on behalf of the firm. In his diary, he recorded the excitement of his travels and the museums that impressed him. And conscious of the need for self-improvement, he even studied French.[5] In the late 1880s, possibly testing the market for American art with the idea of opening his own gallery already in mind, Macbeth organized a series of exhibitions of watercolors by American artists for Keppel.[6]

The success of these exhibitions persuaded Macbeth to leave Keppel's in the spring of 1892. In a printed "Announcement" of his new business at 237 Fifth Avenue near 27th Street in Manhattan,

Macbeth described his new venture in a tone that would characterize much of his writing about art for the next twenty-five years. Asserting that he intended the Macbeth Galleries to become known for American art, he reported his own experience and confidently offered an assessment of the present climate for art:

> The work of American artists has never received the full share of appreciation that it deserves, and the time has come when an effort should be made to gain for it the favor of those who have hitherto purchased foreign pictures exclusively. As I shall exhibit only that which is thoroughly good and interesting, I hope to make this establishment known as *the* place where may be procured the very best our artists can produce.[7]

Thus began William Macbeth's campaign to expand the market for American art. To his clients and to many artists, he was not only an art dealer, but a trusted friend, confidant, and adviser. Through conversations in his Fifth Avenue galleries, statements to the press, correspondence, and, above all, the publication of *Art Notes*, Macbeth subtly but persistently sought to convince Americans that buying American, rather than European art, was a wise choice.

We know far more about Macbeth's business than those of his competitors because records were carefully preserved. Correspondence from artists, collectors, other dealers, shippers, even Macbeth's dentist, was saved; as were scrapbooks, stockbooks, "charge books" recording sales, and various other account books.[8] Unfortunately, the letterbooks with copies of Macbeth's pre-1910 letters, as well as his diaries after 1892 are missing; and there are no photographs of the gallery installations. Yet we can follow the development of the Galleries in considerable detail. Moreover, the extant records allow us to test the accuracy of Macbeth's own claims, and those of his successors, about the history of the Galleries. Beginning in 1917, when Macbeth wrote a short history of the firm for *Art Notes*, and later in many retrospective exhibitions, the Galleries reinforced for the public the importance of its own role in the popularization of American art. While not all claims in later articles and exhibition catalogues about the early history of the Galleries are borne out by a review of the actual records, the basic premise — that Macbeth made a difference, influencing the kind of art shown and the clients who would buy it — is correct.

From the 1870s and well into the early twentieth century, prominent and wealthy Americans favored European art: works by Old Masters, French Barbizon landscapes, and genre paintings by Dutch artists of the contemporary Hague school, to name but three popular categories. When Macbeth opened his business, some New York art dealers, such as S. P. Avery, Reichard and Company, and the American Art Association, exhibited and sold American as well as European art; it could also be seen (and purchased) at artists' studios, auctions (one artist's work or an individual's collection), at the exhibitions of the National Academy of Design and the Society of American Artists, as well as at numerous men's clubs, such the Lotos Club, the Union League Club, or the Century Association. But "good art," according to the rising middle class, was synonymous with European art. Describing the assets of Basil March, the hero in his popular 1890 novel, *A Hazard of New Fortunes*, William Dean Howells wrote, "Their house . . . had some good pictures which [Mrs. March's] aunt had brought home from Europe."[9] Though Howells' plot centers on the rise of an illustrated New York magazine and includes as characters several American artists, the author never even considers the possibility that Cecil Beaton, the art director for the magazine, or Alma Leighton, his precocious former pupil, might produce *good* art, equal in importance to European art.

For collectors of modest means, American art offered an opportunity to buy original paintings at affordable prices. Noting that good pictures existed in every school of painting, Macbeth argued that while "pains are taken to sift the foreign wheat from the foreign chaff," no one had done enough to determine the best in American art.[10] Although he clearly meant to assume this role himself, he was equally determined to educate the public, more generally, about contemporary American art. And, as a dealer, he was not above making an appeal to those interested in art as a commodity. As he would remind his clients and potential clients repeatedly, native art was a good investment that would increase in value.

Macbeth set out to attract the growing group of middle-class professionals to the Galleries, both capitalizing on and guiding their incipient interest in art, while appealing to their desire to decorate their homes in emulation of their wealthier counterparts. Although Charles Lang Freer, J. P. Morgan's banking partner and founder of the Freer Gallery in Washington; William Evans, who made his fortune in the dry goods business; Benjamin Altman, another giant in the dry goods business; and architect Stanford White were among his clients, few others are well known today. Some we can identify as prominent citizens of the era: industrialist Charles K. Fox of Haverhill, Massachusetts; lawyer Louis Marshall of New York; and bank president Edwin Muhlenberg Bulkley of Banker's Trust in New York. But the majority remain anonymous in the history of American collecting.

At the outset, the art exhibited at the Macbeth Galleries was predominately Tonalist landscapes as well as some figure painting. In his selection of art, Macbeth was following the example of the Avery Gallery and the American Art Association, both of which were successfully exhibiting contemporary American art by painters whose tonal works reflected the influence of French Barbizon color and composition.[11] Macbeth's first sale was on April 15, 1892 when a landscape by William Fitler — an artist who would become a frequent exhibitor at the Galleries — sold for $35 to George H. Neale of Brooklyn. *Sunset* by Alexander Wyant sold the next day for $750 to F. B. Pratt, another Brooklyn collector, greatly encouraging Macbeth's new venture.[12] In 1917, he reported with pride in his essay on the history of the Galleries that the original purchasers still owned the Wyant.[13]

In that same essay, Macbeth recalled that the business began with the help and encouragement of the artists themselves, who provided the pictures for his "rash venture."[14] Given his personal success as a dealer, one must expect that there was an element of exaggeration in such a description. Among those artists whose work was shown at the Galleries in Macbeth's first year were Leonard Ochtman, Robert Minor, Henry Ward Ranger, Alexander Wyant, J. Francis Murphy, and Guy Wiggins.[15] To build up his stock, Macbeth probably visited the studios of New York artists to see if they would exhibit, while letters reveal that the fledgling dealer solicited art from

Stephen Douglas VOLK, *William Macbeth*, 1917. The Brooklyn Museum. Gift of a group of American artists and amateurs.

a number of well-known painters of the period from outside the city. Winslow Homer responded positively to Macbeth's invitation in August 1892,[16] while Philadelphia painter and Pennsylvania Academy teacher Thomas Hovenden, invited to show at the Galleries after his sentimental genre painting *Breaking Home Ties* became a sensation at the World's Columbian Exposition in Chicago, declined.[17] Had Hovenden accepted, his participation might have led the development of the Macbeth Galleries in another direction, away from landscape painting which quickly grew to dominate the art seen at the Galleries in its first decade.

Following the pattern of other art dealers, Macbeth kept a stock of pictures on hand, rotating what he put on view. In addition to the paintings he obtained directly from the artists, he soon acquired a stock of pictures from collectors who, like Thomas B. Clarke, hoped to realize substantial gains on their earlier investments in American paintings.[18] Records of paintings were kept in two ledgers; one included paintings for which the art dealer was liable and the other contained names of pictures on the premises at the artist's own risk. Paintings were frequently switched from one ledger to the other, and works by frequent exhibitors were found in both ledgers. Indeed, the vast number of works in Macbeth's stock makes it difficult to identify with any certainty a specific "Macbeth style" of painting. There was even a stock of works by non-professional artists recorded in a separate section of the stockbooks called "Sunday painters."

In what may best be described as a democratic approach to selling art, prices at Macbeth's ranged from $5 for drawings, prints, or small sculpture, to several hundred dollars and later several thousand for works by artists of established reputations: George Inness, Homer Dodge Martin, or Alexander Wyant. Sales records reveal the rise in prices; in 1896, Henry B. Pettes paid $1000 for a 24 by 36 inch *Landscape* by George Inness and by 1912, H. C. Henry had to pay $2500 for the more modestly sized 20 by 30 inch painting *Goochland* by the same artist. Works on view were not always organized as exhibitions per se, for by frequently changing the arrangements on the gallery walls, Macbeth hoped to gain the free advertising of a notice in the press. Although these did not appear at first with any great regularity, by 1894 Macbeth was well-enough

established to merit notices at least every two to three weeks. Especially in the early years, these exhibitions offered a virtual smorgasbord of art, rather than one specific type of painting, in what was probably an effort by the dealer to present a variety of styles and determine more about what would appeal to his clients. However, much of what was actually sold was from stock, not from these exhibitions.

Not until December of 1892 did Macbeth hang an exhibition with a printed checklist. *Watercolors by American Artists*, on view from December 7 to December 21, 1892, was likely a show similar to the exhibitions he had staged at Keppel's in the years just prior to the opening of his own establishment.[19] Henceforth until 1910, Macbeth mounted between two and four of these special exhibitions annually, each with a checklist, some with a short essay and in later years, a photograph of a work of art. In addition to organizing group shows that most often focused on a particular subject — the landscape, figure studies, or paintings of California, to give three examples — he gave solo shows to both male and female artists. Arrangements with the artists in special exhibitions seem to have varied, and it is unclear what costs for a solo show the dealer routinely expected the artist to pay; on occasion, as for The Eight show and an exhibition of portraits by Cecilia Beaux in 1910, Macbeth rented out the galleries for a fee. From letters, it appears that the dealer took a 25% commission on sales, although this figure cannot be confirmed from information in the sales books.

In recollections of these early years, Macbeth — and later his son and nephew — neglected to mention that by the end of 1893, he had expanded his inventory to include European art in order to make ends meet. An exhibition of *Watercolors by Dutch Artists* was held from March 20 to April 8, 1893, and the Galleries' stationery was reprinted with the legend *Pictures in Oil and Watercolor by American and Foreign Artists*.[20] A dramatic upswing in business occurred at the end of that year when Macbeth began selling paintings and drawings by the nineteenth-century Dutch artist Anton Mauve. While a major work by American landscapist Alexander Wyant sold for around $750 and Mauve paintings — whose imprecise titles render them difficult to locate and identify for comparison today —

realized only $350, collectors bought the latter en masse. Joseph Jefferson of Buzzards' Bay, Massachusetts, bought four Mauve paintings within two weeks at the end of 1893 and the start of 1894; C. H. Tweed of New York purchased three paintings and five drawings all on January 19, 1894; and Charles A. Walker of Brooklyn bought four paintings on January 24, 1894. Given the depression of the 1890s, Macbeth can hardly be faulted for deviating from his original mission in order to ensure the survival of his business. He even borrowed money from some of his clients including Benjamin Altman, Colonel Henry T. Chapman, and H. H. Benedict.[21] Yet Macbeth continued to focus the bulk of his attention on American art, including such younger American painters as Arthur B. Davies, whose work was first seen at the Galleries in 1894. By the end of the decade, both the economy and the market for American art had improved and while Macbeth continued to sell European art through the Galleries into the first years of the twentieth century, it would never again be the focus of a special exhibition.

Histories of American art to the present day have long stressed how difficult it was from the 1870s on for American artists to exhibit, and particularly to sell, their work. In the catalogue of the Brooklyn Museum's 1943 exhibition of *The Eight*, Everett Shinn reinforced the conviction when he recalled with exaggerated gloom that "art galleries of the time were more like funeral parlors wherein the cadavers were displayed in the sumptuous coffins."[22] Yet the history of the Macbeth Galleries reveals that by the turn of the century, the situation was hardly so dire. Despite his struggles in the 1890s, Macbeth's position had improved by 1900 and he was grossing a substantial sum of money. The Galleries' income that year was $22,318; in 1901 it more than doubled to $46,242.[23] Such a sharp rise in sales reflects both the rapidly expanding market for art in general and more specifically, Macbeth's growing share of the dollars spent by collectors. Between 1898 and 1906, the number of dealers selling paintings in New York (as opposed to artists' supplies, prints, or decorative arts) almost doubled from twenty-three to forty-five.[24]

Nor was Macbeth's the only profitable commercial art establishment in New York selling American art. By 1900, at least seven other firms dealt to some degree in American paintings. the American

Art Association, S. P. Avery, Durand-Ruel, Louis Katz, Christian Klackner, M. Knoedler, N. E. Montross, and Herman Wunderlich.[25] And noting in April 1902 that by his count, eleven exhibitions of American art were on view in New York simultaneously, Macbeth declared, "it can no longer be said that native artists are denied a hearing."[26] Nevertheless, advertisements in early twentieth-century art periodicals testify to the persistent, seemingly exclusive, popularity of anything old and European. As late as February 8, 1908, Macbeth's ad for "Paintings by American Artists" in *American Art News* is almost lost in a sea of type promoting "Old Masters" (Erlich Galleries) and "High Class Old Paintings" (E. Gimpel and Wildenstein). Yet the advertisements themselves were often deceiving. Some dealers who sold American art did not necessarily announce that fact in their publicity; the ad for N. E. Montross' firm, for example, says only "Works of Art."[27] That the selling of American art seems almost invisible in such historical records has contributed to the false impression that there was no market at all.

The growing demand for pictures existed everywhere, and art dealers were hardly confined to New York. In cities ranging from the booming industrial centers of Cleveland and Chicago to towns too small to have a listing in the *American Art Annual*, art dealers — many of whom sold American art — were part of the local business community. Macbeth exchanged information and traded paintings with such firms as M. Scott Thurber, Albert Roullier, and Henry Reinhardt in Chicago; William Taylor and Sons in Cleveland; and scores like them across the country. In addition, many dealers — including Frederick Keppel and the Vose family of Boston's Vose Galleries — went out on the road for months at a time, often setting up exhibitions in a hotel reception room, and both selling works and adding others to their inventories. Although Macbeth combined vacations with trips in search of pictures and made day-long excursions to nearby exhibitions, like the Pennsylvania Academy annuals, he did not make it a practice to travel on business for longer periods of time.[28] Hence it was to compete in this expanding market that in 1896 he inaugurated *Art Notes*, a unique magazine published roughly four times a year by the Galleries, and sent free to his clients and anyone who cared to write and ask to be put on the mailing list. While Macbeth's letters formed an important link with many collec-

tors, not all of his clients were frequent correspondents. *Art Notes* allowed him to communicate on a regular basis with clients both in and out of New York.

In the publication, Macbeth promoted his coming exhibitions and works by artists currently in the Galleries' stock and frequently advised his readers about the wisdom of investing in art by young artists:

> Instead of bewailing lost opportunities for purchasing, at trifling prices, pictures by Mauve, Corot, Daubigny, Rousseau, Millet, and other artists now famous, let them look about them for the young artists of promise who are today repeating the struggles of great men of their days. They could in this way not only relieve many an anxiety but find opportunities for purchasing pictures that in a few years would be worth many times their cost. The man who does not want a picture until the fame of the artist so enhances its value that he cannot afford it, does not deserve a good picture and ought to confess that he does not know one when he sees it. Too many measure by dollars and not by quality.[29]

Macbeth did not focus solely on his own firm's activities. His reports on other New York art events — such as the opening of the National Academy of Design's exhibitions, shows at clubs and even other commercial art galleries — as well as national art events clearly attest to his mission not merely to sell art, but to educate the art-buying public. His comments on the state of the art world were occasionally convoluted rather than definitive. For the collector in Portland, Oregon, or Webb City, Missouri, for whom *Art Notes* provided the sole link with the New York art scene, such evaluations as Macbeth offered on art at the 1901 Pan-American Exposition must have made the process of collecting art seem more, rather than less, confusing:

> In spite of the fact that there were a good many canvases that had no excuse for existence, much less for being present in such an exhibition, the average quality was very high. That it was not higher was probably not wholly the fault of the

management, for, somehow, bad pictures do crawl into most exhibitions in spite of resolutions to suppress them. Juries are human and poor artists are usually "good fellows."[30]

Interspersed with such enigmatic judgments were Macbeth's characteristically low-key but very clear reminders that American art constituted a far better investment value than European art, as well as oft-repeated and unambiguous statements about "our" best artists and specific works of art available at the Galleries. Finally, each issue had several quotes from great authors and artists, ranging from Goethe to Sir Joshua Reynolds to Ralph Waldo Emerson, that in some vague way reinforced the dealer's ideas about truth and beauty. Overall, Macbeth cultivated the role of a dignified but diplomatic dealer, never too pushy, but above all persistent and committed to championing American art and artists.

Greater insight into the daily life of the Galleries can be found in the voluminous correspondence that has been preserved. In the course of the first twenty years of the Galleries existence, over 10,000 letters were received from artists, collectors, critics, other art dealers, museum officials, and the general public. In some cases, Macbeth engaged in a long and protracted correspondence with an individual; Connecticut landscape painter and gallery artist Charles H. Davis wrote almost 200 letters about his aspirations, the progress in his work, arrangements for it to be shipped to exhibitions, and letters introducing other artists.[31] More often the art dealer received fewer letters from an individual, and they related more specifically to business at hand, be it a show for an artist, paintings that were of interest to a collector, a request for information from a museum, or an inquiry about receiving *Art Notes*.

Although Macbeth's letters before 1910 are missing, we know from the artists' responses that he wrote encouraging letters about their work and even included suggestions for development. A young Charles Sheeler was disappointed that Macbeth criticized his work, "You say you hope it is only an experiment — every one who is sincerely trying to solve the enormous difficulties of artistic expression is an experimenter." Another Philadelphia artist Alice Mumford reported, "I am painting in the purgatory of pure color and I feel that

I am learning a great deal. When I get to Heaven and can handle the thing well there will be some results that will please you — at present things look very crude and unfinished especially as the rendering of textures is a frightful task."[32] Letters from frequent exhibitors discussed not only specific pictures but the art world and collectors: William Sartain, for example, wrote about Mr. and Mrs. H. O. Havemeyer, collectors whose holdings included almost exclusively European art, when he finally convinced them to buy one of his pictures. He also sent Macbeth quotes to use in *Art Notes*.[33] Artists often wrote with directives to send pictures from their stock at Macbeth's to shows around the country, such as the Carnegie annuals or the Pennsylvania Academy annuals, as well as to special showings at universities, clubs, or expositions. Artists' letters reveal Macbeth's reputation as a dealer who treated them with both fairness and respect. Longtime exhibitor J. Francis Murphy assured him in 1907, "You certainly shall have the first call in all of my work. I shall not let another New York dealer have a thing until you have passed judgment."[34] That Macbeth was held in high esteem is apparent as well in the many letters from artists who wrote on speculation, hoping to convince Macbeth to show their work. Aspiring artist Robert Hunter, who wrote in 1907 asking to send some paintings to Macbeth, commented, "I have heard so much about your broad views." Other artists wrote to Macbeth blindly; Nellie Burrell Scott, a San Francisco artist, admitted to the art dealer that she selected his name from the telephone book.[35]

From collectors, Macbeth received letters asking for advice on purchases; and when pictures were sent on approval, he often received the final decision in correspondence. Some collectors, like James Shepherd, President of The Peoples Coal Company in Scranton, Pennsylvania, became friends; when Shepherd was building a gallery for his own pictures in 1905, Macbeth sent him the latest information about the best options for illumination and encouraged his client to visit the new Albright Art Gallery in Buffalo to see a new concealed lighting arrangement. Shepherd wrote on June 3, 1905 saying, "I have written Mr. L. C. Holden, 1133 Broadway, my architect, regarding the Buffalo arrangement . . . but from what you say, it seems to me we will make no mistake by using the concealed effect."[36] Other letters to Macbeth reveal a professional distance between the

George LUKS, *The Spielers*, 1905. Addison Gallery of Art, Phillips Academy, Andover, Massachusetts.

dealer and the client. Certainly Macbeth's most thorough client was E. T. Webb of Webb City, Missouri, who in his first letter submitted a painstakingly detailed list of questions about a George Inness painting, which he had clearly heard about but not seen. Inquiring as to its subject, condition, and authenticity, he listed thirty-two questions which include "Any glow or gaudiness of colors, as in autumn?" and "Is this example fully up to, or above the average for Inness?" Determined to receive as full an account as possible, he closed by asking if there was "any other information about the picture or frame that you think I would desire to know?"[37] By 1908, Mr. Webb wrote in paragraphs, rather than lists, but he was no less demanding: "I would thank you to send me a catalogue of that exhibition (Feb. 19 to Mar. 7) with the sizes and prices of canvases marked. Also state what [sic] of them are sold, but give prices of those sold, too."[38] The meticulous Mr. Webb ultimately purchased seventeen paintings from Macbeth between 1906 and 1912.

Correspondence from museums, art clubs, and other dealers document the efforts Macbeth made to send art out on exhibit in other cities. Many newly founded museums needed not only works for exhibitions, but also advice about the authenticity of recent gifts, and suggestions as to purchases. Macbeth gave freely of his time and expertise in response to such requests, anticipating that he would later be able to use his influence to make some sales. An undated note from the paintings department at the Metropolitan Museum of Art inquired about the location of two works by Indian painter Carl Wimar — not a Macbeth exhibitor; and the Brooklyn Museum director, William H. Goodyear, mindful of Macbeth's background in prints, wrote to ask whether or not to accept the gift of a chromolithograph of Joseph Turner's "Rockets and Blue Lights" by Robert Carnick.[39]

Officials of new institutions outside New York more often wrote with questions concerning artists and requests for exhibitions. Hoping to have Arthur B. Davies' 1898 solo exhibition sent to Pittsburgh from the Pratt Institute, Carnegie Institute of Art Director John W. Beatty wrote to Macbeth as his contact: "I only offer this as a suggestion, and if possible, it may not be practicable for us to carry it out. I will be glad to have your view in reference to the matter."[40] In 1909, Cornelia B. Sage, Assistant Director of the Albright Art

Gallery, wrote: "Our exhibition calendar is nearly filled up now, but I should like to have some very stunning exhibition. Have you any in your mind that would answer that purpose?"[41] And from the Corcoran Art Gallery, Director Frederick B. McGuire wrote "to remind you of your promise to be on the lookout for other fine American pictures which you might be able to send us."[42]

In addition to fostering general goodwill toward the gallery and its artists, Macbeth's assistance in such matters was a contributing factor in sales. Among the institutions that made purchases from the Galleries in the years before 1914 were the Albright Art Gallery, the Art Institute of Chicago, the Brooklyn Museum, the Carnegie Institute of Art (Pittsburgh), the Corcoran Art Gallery (Washington, D.C), the Delgado Museum (New Orleans), the Memorial Art Gallery (Rochester, New York), the Metropolitan Museum, the Peabody Institute (Baltimore), the Rhode Island School of Design (Providence), the St. Louis Museum, and the Utah Art Institute (Salt Lake City).

One of Macbeth's most notable successes with new art museums was his prosperous relationship with the Worcester Art Museum, founded in 1896. From the spring of 1903 through 1907, at the request of John J. Heywood, the museum's manager, he visited numerous New York shows and sent marked catalogues indicating what works might be suitable for upcoming exhibitions. The correspondence from Macbeth, preserved by the museum, documents the generosity with which he seems always to have conducted business:

> I shall be very glad to make for you what suggestions I can on the catalogue of the Society of American Artists Exhibitions. . . .The Academy Exhibition is over. . . .I shall be able to add to my memorandum some things from this and the Philadelphia Academy which closed on Saturday.[43]

When he sent his list — along with a Lotos Club catalogue, also marked — he noted that "I have made some concessions to popular taste but I have not marked anything you need hesitate to show."[44] And Macbeth had ample opportunity to recommend artists who were

among his own exhibitors; of the Society of Painters in Landscape's show, he noted, "The best pictures are by Ochtman, Wiggins, and Swain Gifford."[45]

The investment in time spent — Macbeth refused when Worcester wanted to pay for his services — was rewarded in pictures later bought by the Museum from the Galleries. These purchases included *Holland Canal*, a painting by seventeenth-century Dutch master Jan Van Goyen, bought in 1904; and in 1909, the Museum spent $40,845 on four paintings, one each by J. Francis Murphy and Alexander Wyant, and two by James MacNeill Whistler, including his major work, *The Fur Jacket*. While none of Worcester's purchases reflect an interest in the more contemporary American art available through Macbeth at this time, they did include more progressive artists in their annual exhibitions: of The Eight, for example, Davies, Henri, Shinn, and Sloan all participated in Worcester's 1906 annual. Though the arrangements for this exhibition were not made by the Galleries, Macbeth's subtle persuasion may have affected the Museum's choices. Phillip Gentner, the Director, purchased a Davies drawing himself in 1909, and his partiality for the artist was reflected in his inclusion of Davies in a lecture on landscape painting, for which he asked Macbeth to provide a photograph so that he could make a lantern slide. Gentner described the work — he had forgotten its title — as "the landscape with the mountains in the distance, shown in the last Academy exhibition."[46] Macbeth, as usual, was happy to comply and sent a photograph of *Life Giving Sea*.

Macbeth and The Eight

Of the artists who participated in The Eight exhibition, six already had a fairly well-established association with the Macbeth Galleries. And Davies, Henri, and Prendergast — singled out as particularly promising talents — had been given solo exhibitions there. Only Everett Shinn, who sold his work in New York through Boussod-Valadon Company, which dealt in European painting but dabbled in selling American art, and William Glackens, who seems

not to have had an association with any New York gallery at the time, apparently had no contact with Macbeth prior to the 1908 show.[47]

Arthur B. Davies began his association with the Galleries just two years after it opened. In March of 1894, Macbeth took a chance on the young artist and included his work in "Figure Subjects by American Artists," an exhibition of twenty-seven works by seven artists, including National Academy of Design members Walter Shirlaw and Will H. Low. Although nothing by Davies sold while the exhibition was on view, Macbeth found buyers for three of his paintings by mid-May. And in October, Colonel Henry T. Chapman, a collector who had bought a nude figure by early nineteenth-century English painter William Etty the previous year, purchased his first two paintings by Davies. Chapman, a Wall Street banker who collected primarily European and Oriental art, bought two additional works by Davies from the Gallery in 1896.[48] Macbeth also persuaded other collectors to invest in Davies' work; by the end of 1894, he had sold fifteen paintings, each for under $100. Over the next twelve years, Davies had three solo exhibitions at Macbeth's, and his paintings sold on a steady basis for ever-increasing prices.

In 1895, backed by department store magnate and collector Benjamin Altman, who had recently bought Davies' *Young Artist* from Macbeth, the dealer sent the artist to Europe as his agent.[49] For Davies, this first trip abroad must have seemed a dream, for it allowed him to see great museums and collections without financial concerns. Davies' charge was to evaluate the worth of several collections of Dutch paintings for sale on the continent, by comparing their quality with that of examples in museums. From Amsterdam he wrote that "The Hobbema [that is for sale] is undoubtably genuine . . . about half the size of the largest Hobbema in the Rijks Museum and in quality very much like it and better than the other two."[50] His search took him to a number of European cities, though even in Italy his focus was on Dutch art. Reporting from Rome that the collections there were "far below those of England, Holland, and France," he promised to write again once he had evaluated the Jan Lievens that had evidently brought him there.[51] Relying on Altman's money and Davies' judgment, Macbeth spent almost $20,000 on Dutch art, which was shipped from Rotterdam in September.[52]

Ernest LAWSON, *An Abandoned Farm*, before 1908. National Museum of American Art, Smithsonian Institution. Gift of William T. Evans.

Over the next twenty years, the painter's missives to Macbeth indicate that the two shared a close friendship. Davies wrote a joyous letter to Macbeth on the occasion of the birth of his daughter Silvia in 1897, and sadly sent a telegram when she died eleven months later.[53] For a number of years, Davies also had a studio in the same building at 237 Fifth Avenue, so the artist and his dealer undoubtedly saw each other frequently.[54]

Like Davies, Henri had a long association with Macbeth, dating from 1897 when the artist was completely unknown in New York — as evidenced by an article in the December 9th *Commercial Advertiser*, which noted that "several paintings by a Frenchman named Robert Henri who has lately had an exhibition in Philadelphia" were on view at the Galleries.[55] The exhibition referred to was Henri's one-man show at the Pennsylvania Academy of the Fine Arts, held only the month before; Macbeth must have seen it and recognized in Henri a talent worthy of immediate introduction in New York. Artist and dealer stayed in touch when Henri went abroad in the fall of 1898; writing from Paris the following July, Henri reported the sale of his Paris Salon entry *La Neige* to the French government, "hoping that such an [sic] information will be of advantage to you in the managing of those pictures you now have of mine."[56] Despite Henri's new distinction, which Macbeth announced in *Art Notes*, the dealer had no luck in finding purchasers for the paintings he had in stock.[57]

If Macbeth believed in an artist, however, he was patient, even when their work was not of immediate interest to collectors or critics. As a member of the Society of American Artists and a teacher of growing acclaim, Henri was likely a safe bet for the dealer, who was rightly convinced that his works would eventually sell. Accordingly, Macbeth gave Henri a solo exhibition in April of 1902, despite the fact that in five years he had not sold a single painting by the artist. The show was praised by critics, and one painting — *Normandie Farm Houses* — was purchased by V. G. Fisher, an art dealer in Washington, D.C.[58] While Henri did not have another solo show at the Galleries until 1911, his work continued to be available through Macbeth and according to the press accounts of the changing displays in the Galleries, was occasionally on view. On January 3, 1903, for

example, an unidentified clipping in the Galleries' scrapbook notes that paintings by Henri could be seen along with the works of Jerome Myers, Arthur B. Davies, Ballard Williams, Alexander Wyant, George Inness, Homer Dodge Martin, and Winslow Homer.[59] And in 1906, a painting by Henri of Monhegan Island, Maine — on view with works by W. L. Lathrop, George Hitchcock, and W. S. Derrick — attracted the attention of one reviewer, who wrote that it was "gray in tone, interesting in subject."[60] While Macbeth's frequent rotations improved his chances of interesting reviewers and attracting clients, the technique failed to elicit sales of Robert Henri's works. Macbeth's faith in the artist would not be rewarded until 1908, when interest in The Eight show in general and Henri's work in particular finally translated into sales.

Maurice Prendergast's association with Macbeth dated to late 1899, when the dealer, who could have seen the artist's work at the 1898 New York Watercolor Club or at the 1898 and 1899 exhibitions of the Society of American Artists, wrote inquiring about the possibility of showing the Boston artist's work. The artist was in Europe at the time, but immediately upon his return, the two made plans for a solo exhibition. *Watercolors by Maurice Prendergast* opened on March 9, 1900, and during its two-week run Macbeth sold seven works. Despite the auspicious start, Prendergast's work did not prove popular among Macbeth's clients, although he continued to keep it in stock. For Boston-based Prendergast, the association with Macbeth's New York establishment was particularly significant; it served not only as an outlet for the artist's work but also as a place to meet other artists, see their work, and learn about upcoming events. While most of the artist's letters to Macbeth concern only business, their tone is cordial. Knowing of the artist's interest in sketching outdoor pageants, for example, Macbeth wrote to advise him of the upcoming Brooklyn Sunday Schools Anniversary parade in 1904, and the artist wrote to thank him.[61]

Ernest Lawson, like Henri, had works at Macbeth's for several years before making a sale through the Galleries. Macbeth had evidently purchased several of his paintings through a third party; a letter to the dealer dated January 17, 1903 thanks him for a check for $100, adding, "I do not know which canvases you have of mine but

I am glad you obtained them."[62] Macbeth seems not to have exhibited these works — they are not mentioned in reviews or in *Art Notes* — but rather to have kept them as part of his stock. The first sales by Macbeth of Lawson paintings occurred in 1907.

Macbeth frequently lent money to artists, accepting works of art as security. In an undated letter of circa 1908, Lawson blasted him for being "pitifully mean and small" over a disagreement about the balance that the artist owed the dealer. Noting that he was sending Macbeth a check, Lawson asked the dealer to return *Abandoned Farm*, which he claimed was delivered to the Galleries in error after an exhibition in Worcester. Lawson had found a potential buyer for the painting, prominent collector William T. Evans. Although Evans was a Macbeth customer and the painting had been exhibited in The Eight show, Lawson evidently did not want to share the commission with the dealer. As he wrote, "Evans never saw the canvas until it was sent up to [Henry Ward] Ranger's studio and it was I myself [who] approached him to buy it at this time."[63] Evans ultimately purchased the work, and Macbeth's records show no evidence of a commission. Such confusion was inevitable.[64] Paintings were in and out of the Galleries often, and the role that the dealer played in arranging a sale was often ambiguous, especially if the transaction took place at another location.

George Luks had works at Macbeth's by February 1905, when *The New York Times* noted that his *Child of the Slums* was on view.[65] An artist whose occasional bouts with drunkenness resulted in a reputation for erratic behavior, he seems to have had a perfectly tranquil relationship with Macbeth. Responding to the dealer's evident concern that the artist's late-night schedule might prohibit a morning visit to his studio, Luks commented, "I am afraid you have a mistaken idea of my habits — it matters not what time I retire — I'm up with the lark and after the usual preliminaries of all well-regulated homes I breakfast at 8:30 AM. I will be only too glad to show you the *Pawnbroker's Daughter* any morning you may see fit to call."[66] It was, of course, the rejection of this painting from the National Academy of Design's 1907 Annual that triggered The Eight exhibition. Although Luks' letter to Macbeth is undated, it is certainly possible that extensive publicity in the press and talk among the artists piqued the dealer's interest in this particular work.

Would-be purchasers were undoubtedly discouraged by the rather exorbitant prices Luks wanted for his paintings. In a June 3, 1907 letter to Macbeth, the artist set a figure of $1500 for both *The Boy with Parrot* and *The Girl with the Green Bowl*, offering a $500 discount if they were purchased together. In the same letter, he added "for *Dancing Girls* [*The Spielers*] I want $2000 for I am sure it will fetch that price and probably more later on."[67] Though Macbeth could not make money on art that did not move because of such high prices, he continued to represent Luks and in 1910 gave him a one-man show.

John Sloan, like Glackens, never sold a painting at Macbeth's. In May 1907, thinking he had a purchaser for *Dust Storm*, which he would have seen at the National Academy of Design's Annual, Macbeth had Sloan send it to the Galleries along with *Nurse Girls, Madison Square*.[68] Neither work evidently sold. Yet the artist recorded numerous visits to Macbeth's in his diary, both to see the exhibitions and to meet other artists there. Indeed, the Galleries served as a kind of gathering place for many artists. Henri and Davies reportedly first met there at Davies' 1897 solo exhibition;[69] and Macbeth explicitly advertised that he welcomed all visitors.

Amused by the salesmanship involved in being a dealer, Sloan did an etching of Macbeth in action in 1911.[70] In the print, Macbeth is showing a painting to an elderly and distinguished client, who is seated before an elegantly framed landscape. The art dealer stands "purring into the ear of the victim" while Robert McIntyre — Macbeth's nephew and the third director of the Galleries — stands by, holding an alternative selection.[71] In the background, a cluster of gallery visitors watches this game of enticement, fascinated, as was the artist, by the different way the dealer behaved when an important client came to call. The emphasis is clearly on the art of salesmanship — Macbeth could be hawking shoes or carpets just as easily as pictures. H. H. Benedict, President of Remington Typewriter, is the client portrayed.[72] A regular Macbeth customer, he bought fifty-six

works of art in the twenty years between 1892 and 1912, including nine paintings by Arthur B. Davies.

The Eight Show

When the first exhibition of the Ten was about to open in 1898, William Macbeth announced the exhibition with evident enthusiasm to readers of *Art Notes*:

> As they are sure to put their best foot forward in this effort the exhibition is certain to be a good one and will attract wide attention. If the movement stimulates the parent Society to reach a higher average of merit in its exhibition the result of the much talked of succession [sic] will be good all round.[73]

Typically, Macbeth's statement showed no sign of jealousy that the Ten, some of whose members — Childe Hassam, for example — had been exhibiting at the Macbeth Galleries, would make its debut at the New York branch of the French firm Durand-Ruel. And he was clearly in sympathy with American artists' continued discontent over the selection practices of established exhibiting organizations, for he again addressed the subject in even greater detail in the April 1902 issue of *Art Notes*:

> That the Academy of Design and the Society of American Artists' annual efforts to display current works do not meet the aspirations of a large number of our artists is very evident. Although they do not entirely cut loose from these institutions there are a good many restless and discontented spirits aiming to get a hearing in other and new ways. We see groups of twelve, of ten, or seven and so on, flocking together to make little shows of their own. Although one may sometimes wonder what the tie is that holds the members of certain groups the prevailing discontent that creates them is not an unhealthy sign, and out of it will be likely to come some movement that will give us each year an exhibi-

tion in which will be found only the good artistic work of which there is no scarcity in this city. In such an exhibition names will have no potency, but the veteran and the youth will meet on equal footing. There are enough opportunities for exploiting the commercial side of art, and there is a large public so tired of that side that a cordial welcome and encouragement would surely be given to those who paint for the love of painting.[74]

In 1906, Macbeth moved his business from its modest and cramped quarters at 237 Fifth Avenue near 27th Street to 450 Fifth, just below 40th. While most art dealers were located in the 300s of Fifth Avenue — Knoedler's at 355, Montross at 372 — or nearby on cross streets — Durand-Ruel at 5 West 36th Street and Keppel's at 4 East 39th Street — Macbeth explained his move farther north by noting the unavailability of a building in which the Galleries could have skylights in his present neighborhood.[75] The move uptown was not simply a relocation to more spacious, well-lit quarters, but rather another step in an ambitious attempt to establish the Macbeth Galleries as a major power in the New York art world. As the city grew and businesses expanded, commerce moved steadily up the avenues; and though 450 Fifth was north of the art scene's commercial center, it was closer to the Fine Arts Building on 57th Street where both the Society of American Artists and the National Academy of Design held their exhibitions. And Macbeth's new address placed him just below the New York Public Library, then under construction on the land that had once held the massive Croton Reservoir. After the library opened in 1911, the Galleries used it as a landmark in advertising their location. Time would prove that Macbeth was ahead of his peers in moving uptown; over the next fifteen years, many more galleries would seek quarters farther up Fifth Avenue.[76]

Discussing the move in *Art Notes*, Macbeth stated, "The time has come when our own artists' pictures must be properly presented, where they, too may be seen to the best advantage."[77] At his original location, the exhibition room was narrow, and dark curtains hung from the ceiling along the walls.[78] The new top-floor Galleries had two octagonal galleries with skylights, plus storage rooms and offices. Walls were covered with green fabric above decoratively carved

wainscoting, and one of the galleries had a narrow carved shelf about seven feet from the floor for the display of small decorative arts, pottery.[79] Visitors to Macbeth's establishment also found that the building was equipped with one of the hallmarks of progress: an elevator.[80]

When Henri and his associates decided in the spring of 1907 to organize an independent show, Macbeth's new galleries were an obvious candidate for the location. Though it was not Henri's first choice — he initially approached and was turned down by the American Art Association's Director, William Kirby — once the connection with Macbeth was secured by group member Arthur B. Davies, the artists were pleased.[81] On May 14, 1907, Henri would note in a letter, "Macbeth's Gallery is now — his new place — the best gallery on Fifth Avenue for such an exhibition."[82]

One wonders why Macbeth was not approached first. The American Art Association primarily held art auctions and did not promote a specific type of art.[83] Perhaps Henri feared that Macbeth might try to exert some control over the show. Forthright about the commercial nature of his business, he had never before allowed a group exhibition that he had not organized to use his galleries. Even after Davies reported to the group that Macbeth was willing, Sloan, Henri, Glackens, and Shinn continued to look for alternative spaces where they might set up their own gallery.[84] Ultimately, fears about the art dealer's interference proved groundless. Of the actual negotiations, however, we know little. The existing Macbeth records make no note of them, and Henri's diary for 1907 is lost. The resulting arrangement, that the artists would put up a guarantee of $500 for the exhibition, was recorded in Sloan's diary.[85]

To the public, The Eight show appeared to be another Macbeth Galleries exhibition. While the artists' substantial effort at promotion made it one of the most widely anticipated exhibitions held up to that time in New York, Macbeth noted the upcoming show in *Art Notes* without indicating that it was in any way an unusual event for the Galleries:

From inquiries frequently made in regard to the coming exhibition of the work of a group of eight artists in my galleries, it is evident that a large audience, at any rate, is assured for these men. The exhibition will be held in February. The following compose the group: Messrs. Davies, Glackens, Henri, Lawson, Luks, Prendergast, Shinn, and Sloan.[86]

Perhaps his comments were meant to reassure his more conservative clients that he was not hosting a revolution, but simply a group show.

Although the catalogue of the exhibition was solely the artists' responsibility, it too reinforced the idea that this was simply another show at the Macbeth Galleries. Sloan and Davies took over responsibility for the publication, gathering the material, selecting the type, and designing the format.[87] (Sloan himself made many of the photographs used in the publication.) Just like any other Macbeth catalogue in format, typeface, and style, the cover of the catalogue for The Eight show simply said "Exhibition of Paintings" and listed the eight artists, the date, and the gallery. The stapled booklet itself, however, was twenty pages long, much more substantial that the usual two-to-eight page booklets produced by the Galleries. Printed by the Gilliss Press, whose imprint appears on the last page, the catalogue was 7 ¾ by 5 ½ inches, larger than most Macbeth catalogues, which measured roughly 7 by 4 ½ inches. Inside the taupe-colored booklet, the text was printed on coated paper to make the photographs reproduce well. Each artist had a two-page spread with the list of works exhibited on the left and a reproduction of a painting on the right.

When the exhibition opened on February 3, the catalogues disappeared quickly as visitors poured into the Galleries. For Macbeth, business went on as usual despite the crowds. *Path Through the Woods*, a watercolor by Macbeth regular Henry Ward Ranger, was the first work sold during The Eight show: the purchaser was A. R. Kohlman of Indianapolis, who had purchased a painting by Leonard Ochtman from Macbeth's the previous year. Several days later Macbeth sold two bronzes by Abastenia St. Leger Eberle: one to Mrs. John Hannah, a new client, and the other to William A. Pardee, a regular

Arthur DAVIES, *Unicorns (Legend—Sea Calm)*, 1905. The Metropolitan Museum of Art, Bequest of Lizzie P. Bliss, 1931.

customer who later that year bought Henri's *Laughing Boy*. Mrs. I. E. Cowdin, a collector whose purchases from Macbeth were almost exclusively works by Davies — her first in 1894 — purchased two works from the exhibition, Davies' *A Mighty Forest — Maenads* and Henri's *Coast of Monhegan, Maine*. A second Davies painting in the show, *Autumn Bower*, sold to Mrs. Henry Hardon just as the exhibition closed. A first-time buyer, most likely drawn to the show by the extensive publicity, Mrs. Hardon proved to be the sort of contact who confirmed the exhibition's success for Macbeth; in the next four years she would purchase four more paintings by Davies from Macbeth, spending a total of $5450.

By far the most notable purchaser at the exhibition was Gertrude Vanderbilt Whitney, the sculptor and arts patron who bought four paintings: Luks' *Woman with Goose*, Henri's *Laughing Child*, Lawson's *Floating Ice*, and Shinn's *Revue*, as well as a Chester Beach bronze, *Breath of the Pines*. Undoubtedly, Macbeth followed up on this new client with a letter and put her on the mailing list for *Art Notes*; although Mrs. Whitney did not become a regular client, Macbeth was helpful to her and her assistant Juliana Force when they began to organize exhibitions themselves in 1914, just as he had helped numerous arts clubs and museums in the past.[88]

Happily for Macbeth, the notoriety of the exhibition did not deter his regular clients, a number of whom made purchases later that February, after the rush of The Eight show had subsided. A. C. Humphreys purchased Charlotte Buell Coman's *Fall of the Year* on February 26; and that same day, James G. Shepherd purchased two Alexander Wyant paintings, *In October* and *Near Williston, Vermont*, a major picture which cost the collector $5000. To distant collectors like E. T. Webb, Macbeth sent clippings about the show, obviously proud of the attention that it had received, and hoping to spark further interest in the artists.[89]

The paintings in The Eight show were all images (or types of images) with which Macbeth was familiar, with one exception: the new work of Maurice Prendergast. When the exhibition was arranged in the spring of 1907, Prendergast was preparing to leave for France; during the summer and fall abroad, he produced brighter, more abstract paintings and watercolors whose dizzying effect of bright colors were described by some critics as "an explosion in a color factory" and "the result of too much cider drunk at St. Malo."[90] These St. Malo scenes marked a significant departure from his earlier work, which more closely paralleled the urban scenes of Glackens and Sloan. Indeed, the painting reproduced in the exhibition catalogue, *The Fete* of 1905, depicting a group of women beneath a canopy of trees, bore little resemblance to the St. Malo paintings that Prendergast featured in The Eight show. The development in his style away from that of his co-exhibitors actually strengthened Henri's assertion that the group of artists were unalike, but it also meant that the Boston artist was repeatedly singled out in reviews. Despite the perplexed comments by the press, and the total lack of sales, however, Macbeth continued to stock and show Prendergast's paintings.

With the next Macbeth exhibition, *Forty Selected Paintings by Living American Artists*, Macbeth resumed his standard exhibition format, and reviews in the press likewise returned to less dramatic commentary. "The tones are usually subdued and it is sane and real," reported one critic.[91] Although the exhibition generally focused on paintings that were "calmer" and cooler in tonality than those of The Eight, it was not without a painting that startled the reviewers: Bryson Burroughs' *Fortune and the Blind Man* depicts a naked woman asleep, while a blind man, unaware of her presence, walks by with his dog, who is portrayed as enjoying the spectacle. Yet voyeurism apparently was less shocking than bright colors and bravura brushstrokes.

So marked a contrast between the paintings by The Eight and the more conservative American work that was most often seen at Macbeth's calls the dealer's taste into question. Many of the works Macbeth exhibited seem dull today — tonal paintings that lack an adventurous approach to design. John Sloan recorded in his diary a revealing conversation with Macbeth about the work of Paul Dougherty, the Academy member whose work Macbeth frequently exhibited and whose special exhibition preceded The Eight Show there. Sloan reported that Macbeth shared his dislike of the paintings in Dougherty's January 1908 exhibition. "Pot-boilers — 'Leather,' Macbeth called it. And people buy these things."[92] Yet Macbeth had to make a living, and by 1908 he knew the market — and his clients'

interests — well. In his published statements, he was invariably careful with his words, although it is clear that he sought very subtly and discreetly to challenge the status quo. He was critical of the arts establishment, but not too critical. He commented in *Art Notes* on the poor taste of collectors or museum trustees, but so vaguely that their anonymity was assured. Yet his commitment to such artists as The Eight cannot be doubted; and of the artists of their generation who came to maturity before the Armory Show, his choices now seem sensible. Several whom Macbeth championed with repeated praise in print as well as with frequent showings — George Inness, Homer Dodge Martin, Alexander Wyant, Arthur B. Davies, Theodore Robinson, and Robert Henri — have remained important figures in the history of American art. And Macbeth's willingness to continue to give artists exposure even when their works rarely sold is a further indication of his determination to expose his audience to work he considered worthwhile, not merely work that would sell.

Indeed, had The Eight organized a second show, Macbeth would probably have been willing to host it. Henri had discussed the idea of a follow-up show with Glackens and Sloan in December 1908, but when he approached Macbeth, he learned that the Galleries were already scheduled for the winter.[93] Macbeth continued to show the same members of the group whom he had represented in the past, leaving only Glackens, Sloan, and Shinn to exhibit their work elsewhere. In February 1909, the Galleries held a solo show of Davies' paintings — which that year were selling like "hotcakes," as the dealer wrote to his nephew.[94] Later in the winter, Henri and Luks were included in an exhibition with Blandon Campbell, Charles W. Hawthorne, and Kenneth Miller. Prendergast was included in "An Exhibition of Paintings by a Group of Boston Artists," also held that winter season. Macbeth gave George Luks his first solo exhibition in April 1910; and although no paintings sold, the show in fact made Luks' reputation. It received great positive attention from the press, who were impressed, as one review noted, by the "masterly verity and the invariable skill with which they are done."[95] Of the show-stopping canvas, *The Wrestlers*, another reviewer astutely commented, "Few men would care to live with the picture for it would be about as suitable to the average parlor as a brace of fighting Visigoths to a Louis Quinze sofa . . ."[96] Knowing the decor of the average parlor, Macbeth might well have predicted that no paintings would sell from the show.

Macbeth had better success with works by Lawson and Henri in the years following The Eight show. Though Lawson did not have a solo show, four works sold in 1912; the purchasers included Dr. Albert C. Barnes, who bought *High Bridge* in November. Henris were sold to a number of new clients, including the Brooklyn Museum, which bought *Laughing Girl* in 1912, and Lillie P. Bliss who bought *In the Cathedral Woods* in 1911. In future years Miss Bliss became a major patron of Arthur B. Davies, purchasing works first through the Macbeth Galleries and later directly from the artist.

As William Macbeth grew older, his son Robert began to take a larger role in the operation of the business. Born in 1884, Robert graduated from Columbia University in 1906 and joined his father's business in 1909.[97] From that date until the death of the senior Macbeth in 1917, it is difficult to determine who was setting policy for the Galleries; but it is clear that its trendsetting days had passed. Robert's taste was similar to his father's in that he championed American Impressionism and other styles that had been avant-garde in the 1890s, but he seems to have had less charitable feelings toward much of the art that he felt strayed too far from realism. The more radical work of Prendergast, and even Davies, was soon seen at such galleries as Montross and the newly founded Daniel Gallery.

Before the Armory Show, few galleries were on the cutting edge of contemporary American (or European) art. Only Stieglitz at 291 truly advocated a more avant-garde art, and yet his roster of artists was highly exclusive. The growth of the art market and the emergence of a new generation of galleries in the mid-1910s gave younger artists, especially those whose work tended toward abstraction, greater options in seeking commercial outlets. In addition to Stieglitz's 291, Montross, and Daniel, were a number of newly founded galleries like the Carroll Galleries, which took advantage of the growing market for modern European and American art. In comparison, the Macbeth Galleries continued to fill a niche for more traditional art, catering to clients who preferred realist painting and championing artists who went against the tide that was pushing art

78

John SLOAN, *Easter Eve*, 1907. Collection of Edward and Deborah Shein.

toward abstraction. Commenting on the Armory Show in 1913, William Macbeth noted with predictable grace:

> To me, personally, the exhibition was positively the most stimulating of the very many it has been my fortune to see. On first entering, the arrangement and whole air of the place, regardless of any individual exhibits was uplifting. The freshness and freedom of the show was a delight. On examining the pictures through several visits my pleasure was in no measure marred because I found a few score of them to be utterly absurd, and from my point of view to bear no relation to art, except possibly in some cases as decorations of a certain disagreeable sort.[98]

Yet at his own establishment, William Macbeth hosted the *Annual Exhibition of The Women's Art Club*, which opened on the same day as the famous international exhibition. A conservative group, the New York-based Women's Art Club offered prizes each year for the best landscape painting, figure painting, and sculpture, as well as a National Art Prize for the best work overall. Prize winners in the 1913 exhibition of 36 artists were Helen M. Turner, Florence Francis Snell, Clara Weaver Parish, and Annetta J. St. Gaudens. In his own more subtle way, Macbeth was still championing the more marginal artists — in this case women — whose work might not have been seen to as great advantage elsewhere.

The Myth of The Eight

In his summary of the history of the Galleries in the April 1917 issue of *Art Notes*, William Macbeth began by noting the difficulties facing American artists in the late nineteenth century as prominent collectors focused their attention on European art. He went on to tell the story of the founding of his gallery, and his early struggles in the poor economic climate of the 1890s. Omitting the fact that the Galleries sold European art to ensure its survival, he highlighted instead such accomplishments as his visit to Winslow Homer's studio at Prout's Neck, Maine and his efforts to promote the

work of Homer Dodge Martin.[99] There is no mention of The Eight show, however, and of the eight artists, only Davies is discussed; when first exhibited at the Galleries in 1894, his paintings suddenly made him "perhaps the most talked about artist in town."[100]

William Macbeth died later that year and the business continued under Robert Macbeth. *Art Notes* became increasingly a house organ, primarily informing clients of shows at the Galleries. And almost every issue included a piece that emphasized the gallery's importance in the history of American art. An article in the June 1927 issue added The Eight exhibition to the long list of achievements that the Galleries were proud to promote, asserting that "the exhibition was generally regarded as an important contribution to art history."[101]

In 1938, prompted by the Whitney Museum's 1937 *New York Realists* exhibition, which included six of the original eight artists in the nine-man show, the Macbeth Galleries held a thirty year anniversary show of the 1908 show. Helen Appleton Read, in her essay for the Whitney catalogue, stressed the American roots of these artists, asserting that although they had been eclipsed by the generation that came after them, they had "sowed the seeds for integration of art and society" that was important to the American Scene painters of the 1930s.[102] The writer of the brief unsigned essay in the Macbeth Galleries brochure — likely Robert Macbeth or Robert McIntyre — reinforced the ideas of the Whitney essay and gave even greater focus to the revolutionary aspect of the exhibition. In contrast to William Macbeth's low-key summary of the show in the April 1908 issue of *Art Notes*, which stressed that the artists were not out to stage a revolution, the 1938 writer altered the facts to make the group seem more like outcasts in a hostile arts establishment. He noted:

> "Men of the Rebellion," they were termed by one art writer when "The Eight" held their First Annual Exhibition in our gallery thirty years ago. The name was apt for they were rebellionists all, some actively fighting the then current vogue of the "pretty picture," some content to let their work record a silent protest.[103]

After discussing the painting style of each member of the group the writer continued:

> The men, personally, were as little alike as their art. Except that they uniformly objected to the type of picture popularly approved, and that, for the most part, they would not submit their work to exhibition juries, they had little in common. Henri, Davies, Sloan, and Glackens were probably responsible for getting the exhibition together, but the group, as such, never had a meeting and the First Annual Exhibition, after its showing here and later in Philadelphia by special invitation, was also its last.[104]

With this exhibition, which included only three works from the original show, the myth of The Eight's great rebellion began to take shape. Reviewers — as well as Lawson, Shinn, and Sloan, the three members of the group still living — failed to point out that these artists had actually shown in Academy shows and had met frequently to plan their independent exhibition; no one mentioned the show's subsequent nine-city tour, a traveling circuit that clearly demonstrated a far more receptive climate for American art than histories have usually acknowledged.

In 1943, The Brooklyn Museum further codified The Eight as a group with an exhibition and catalogue that included reminiscences of group member Everett Shinn. While noting accurately that "The grievance that gnawed at The Eight was the intolerance of their own profession," Shinn reinforced the idea of how strongly and singularly The Eight had fought against the prevailing trends in art.[105] Against the tide of falseness and self-deceit in turn-of-the-century New York, these eight artists alone had fought for truth. In Shinn's essay, the artists grew in stature, and their fight against the Academy became a holy fight against a false society. Never admitted were their less idealistic but more basic, mundane, and prosaic motives: recognition and, ultimately, sales. Yet it is the revisionist story, sparked by the Macbeth Galleries in 1938, that to the present day informs the numerous exhibitions centering on The Eight. The artists' work is often hung together in permanent museum displays, and collectors have come to prize owning a work by each of The Eight. The interwoven myths of the uniqueness of The Eight and the dismal state of American art in the first decade of the twentieth century set the stage for the need for a revolution.

In reality, The Eight show could not have happened without the growth of the art market and the receptivity of the public that had developed in the first sixteen years of the Macbeth Galleries' existence. Only then was it possible to create an event that would attract crowds of visitors and result in the sale of paintings. William Macbeth helped to make the public accept the idea of The Eight show as a reasonable alternative exhibition, rather than a call for revolt. His successors at the Galleries, with the benefit of hindsight and the knowledge that the show would be followed by even more dramatic events in the art world, could re-invent it for their audience thirty years later as a rebellion. And it is that later version of the story that has come down to us today. Thus, this one step in the fight for a change in art exhibition practices has come to be seen as a great event in the history of American art, and eight artists who exhibited as a group only once are always remembered as part of The Eight.

❧

1. *Art Notes*, no. 35 (March 1908), 545-46. My work on the Macbeth Galleries and its role in popularizing American art was begun with a grant from the Henry Luce Foundation to the Herbert F. Johnson Museum of Art, Cornell University, Ithaca, New York, which allowed me to devote seven months of concentrated research to the Macbeth Gallery Papers in the Archives of American Art, Smithsonian Institution (henceforth abbreviated AAA). Sales records and dates of exhibitions come from a compilation made in my research on the early history of the gallery. I am grateful to the Luce Foundation for their support of my long-term project as well as to the staff of the Archives, particularly Richard Wattenmaker, Garnett McCoy, and Judy Throm, and to the library staff at the National Museum of American Art. John Davis and Debora Rindge made important contributions as research assistants; far beyond simply recording information, both have helped me to better understand the complete picture of the Galleries' operation. Elizabeth Milroy and the advisers to this exhibition, Elizabeth Johns and William Innes Homer, have also helped to further my research and my thinking on American art in this period.

2. William Macbeth's establishment was called at various times the "Macbeth Gallery," "Galleries of William Macbeth," "William Macbeth, Inc.," as well as the "Macbeth Galleries," which was the name in use at the time of The Eight show. For simplicity, I use that name throughout my essay.

3. Diary of William Macbeth, Macbeth Gallery Papers, AAA.

4. Sales Receipt from Frederick Keppel, Rare Engravings and Artistic Framing, 15 March 1875, W. A. Leonard Papers, AAA.

5. Diary of William Macbeth, Macbeth Gallery Papers, AAA.

6. *Art Notes*, no. 63 (April 1817), 1016. Keppel may have been aware of Macbeth's interest in founding his own firm focusing on American art and may even have encouraged him to do so, as Macbeth's departure in 1892 does not seem to have caused any rift in the personal and professional relationship between the two men. See the letters from Frederick Keppel to William Macbeth, Macbeth Gallery Papers, AAA.

7. "Announcement," Macbeth Gallery Scrapbooks, Macbeth Gallery Papers, AAA.

8. The Macbeth Gallery Papers were the gift of Robert McIntyre, from 1955 through 1966, with additional material coming from the Macbeth family in 1974. Most of the correspondence has been microfilmed, as have the scrapbooks and *Art Notes*. The ledgers are not microfilmed.

9. William Dean Howells, *A Hazard of New Fortunes* (New York: Dutton, 1952), 23.

10. *Art Notes*, no. 1 (October 1896), 2.

11. See Linda Henefield Skalet, *The Market for American Painting in New York: 1870-1915* (Ph.D. diss., The Johns Hopkins University, 1980) for an overview of the market in this era. Skalet's well-organized study gives information on each gallery and club showing American art as well as useful details about prominent collectors.

12. Sales were noted in the Galleries' "Charge Books." All names of purchasers, artists, prices, and dates of sales have been compiled and sorted by the author from the "Charge Books" now in the Macbeth Gallery Papers, AAA. The material has not been microfilmed.

13. *Art Notes*, no. 63 (April 1917), 1018.

14. Ibid., 1027.

15. *New York Recorder*, 12 June 1892, Macbeth Gallery Scrapbook, Macbeth Gallery Papers, AAA.

16. Winslow Homer to William Macbeth, 3 August 1892, Macbeth Gallery Papers, AAA.

17. Thomas Hovenden to William Macbeth, 23 August 1893, Macbeth Gallery Papers, AAA.

18. Thomas B. Clarke to William Macbeth, 12 October 1893, Macbeth Gallery Papers, AAA.

19. Artists in this first exhibition were William Gedney Bunce, Mrs. Van Cleef Dodgshun, Will H. Drake, L. C. Earle, Charles Warren Eaton, C. Harry Eaton, Harry Farrer, William C. Fitler, Ben Foster, W. Hamilton Gibson, R. Swain Gifford, Albert Herter, Mrs. Claude Ragout Hirst, Winslow Homer, Miss Clara T. McChesney, Robert C. Minor, J. Francis Murphy, Leonard Ochtman, W. H. Ranger, F. K. M. Rehn, William T. Richards, H. M. Rosenberg, and Louis C. Vogt.

20. Rose Durfee to William Macbeth, n.d., Macbeth Gallery Papers, AAA. This undated letter to Macbeth is written on his own stationery.

21. Information about the loans that Macbeth received is vague and must be pieced together from various existing letters and ledgers.

22. Everett Shinn, "Recollections of The Eight," in "The Eight," (Brooklyn: The Brooklyn Museum, 1943-44, 11.

23. "Statistics" ledger (unfilmed material), Macbeth Gallery Papers, AAA.

24. *American Art Annual* (1898), 536-37 and *American Art Annual* (1905-6), 522-24. The 1907-08 edition of the *American Art Annual* no longer listed all the art dealers nationwide, as presumably the city-by-city list had grown too long to fit comfortably in this multi-purpose directory. Instead, the book's index cited only those firms that were advertisers; of the nine advertisers in New York, three—Macbeth, Montross, and Louis Katz—promoted themselves as selling American art.

25. See Skalet, Appendix B, 287-324, for a compilation of exhibitions of American art at New York galleries in this era. Many dealers stocked American art even when no works by Americans were included in their schedule of special exhibitions.

26. *Art Notes*, no. 19 (April 1902), 294.

27. *American Art News* (8 February 1908), 7-8.

28. Macbeth may have originally intended to travel with his art as he went to Pittsburgh on business in the fall of 1892, just six months after he opened his gallery. While he was away, however, two of his three children became gravely ill; his daughter Jessie died on October 25 and his son William died on November 6, 1892. It seems likely that Macbeth, in reaction to the pain of losing two children, may have decided not to be away from his family more than was absolutely necessary. See the Diary of William Macbeth, fall 1892, Macbeth Gallery Papers, AAA.

29. *Art Notes*, no. 3 (January 1897), 36.

30. *Art Notes*, no. 17 (November 1901), 258.

31. Charles Davis to William Macbeth, letters dating from 1892 to 1917, Macbeth Gallery Papers, AAA.

32. Charles Sheeler to William Macbeth, 26 September 1910; Alice Mumford to William Macbeth, n.d. [1906], Macbeth Gallery Papers, AAA.

33. William Sartain to William Macbeth, letters dating from 1902 to 1912, Macbeth Gallery Papers, AAA.

34. J. Francis Murphy to William Macbeth, 10 July 1908, Macbeth Gallery Papers, AAA.

35. Robert Hunter to William Macbeth, 23 July 1907; Nellie Burrell Scott to William Macbeth, 26 May 1896, Macbeth Gallery Papers, AAA.

36. James G. Shepherd to William Macbeth, 3 June 1905, Macbeth Gallery Papers, AAA.

37. E. T. Webb to William Macbeth, 17 January 1903, Macbeth Gallery Papers, AAA.

38. E. T. Webb to William Macbeth, 2 March 1908, Macbeth Gallery Papers, AAA. In the case of Mr. Webb, we even know what Macbeth thought of his client; in a 1909 letter to Robert McIntyre, then visiting collectors for the Galleries, William Macbeth says of Mr. Webb, "I have before me a long letter from Mr. Webb. He tells me how he has distinguished himself by his purchases and wants to know if they will increase in value etc. Queer duck" (William Macbeth to Robert McIntyre, 5 November 1909, Macbeth Gallery Papers, AAA.)

39. P. J. O. to William Macbeth, n.d.; William H. Goodyear to William Macbeth, 18 May 1905, Macbeth Gallery Papers, AAA.

40. John W. Beatty to William Macbeth, 17 January 1898, Macbeth Gallery Papers, AAA.

41. Cornelia B. Sage to William Macbeth, 19 November 1909, Macbeth Gallery Papers, AAA.

42. F. B. McGuire to William Macbeth, 1 December 1906, Macbeth Gallery Papers, AAA.

43. William Macbeth to John J. Heywood, 2 March 1903, Worcester Art Museum Archives.

44. William Macbeth to John J. Heywood, 20 April 1903, Worcester Art Museum Archives.

45. William Macbeth to John J. Heywood, 23 April 1903, Worcester Art Museum Archives.

46. Benjamin H. Stone (Assistant to the Director) to William Macbeth, 21 January 1910, Macbeth Gallery Papers, AAA.

47. For information on Boussod-Valadon, see Skalet, 213 and 293. The casual tone of Shinn's sole letter to Macbeth written before 1914 — which is about picking up a frame — and the offhand comments about the Galleries in Ira Glackens' memoir of his father certainly give no impression of ill-feeling toward Macbeth. See Everett Shinn to William Macbeth, n.d., Macbeth Gallery Papers, AAA; and Ira Glackens, *William Glackens and the Ashcan Group* (New York: Crown Publishers, 1957), 77-79.

48. For a profile of Chapman, see Skalet, 172-73.

49. Davies was not the only artist who evaluated European art for Macbeth; Henry Ward Ranger also bought Dutch watercolors and oils in Europe for the dealer. See Henry Ward Ranger correspondence, Macbeth Gallery Papers, AAA.

50. Arthur B. Davies to William Macbeth, 5 August 1895, Macbeth Gallery Papers, AAA.

51. Arthur B. Davies to William Macbeth, 28 September 1895, Macbeth Gallery Papers, AAA.

52. Invoice from the Netherlands American Steam Navigation Company, 26 September 1895; and note in "Charge Book, no. 1," Macbeth Gallery Papers, AAA. Apparently the New York critics questioned the authenticity of some of the Dutch Old Masters in the collection that Davies helped to obtain. See Arthur B. Davies to William Macbeth, 22 February 1896, Macbeth Gallery Papers, AAA.

53. Arthur B. Davies to William Macbeth, 1 July 1897 and 4 June 1898, Macbeth Gallery Papers, AAA.

54. Despite this close friendship, there is no indication that Macbeth knew of Davies "secret life" as David A. Owen and husband of Edna Potter. For Davies, double life see Brooks Wright, *The Artist and the Unicorn* (New City, New York: The Historical Society of Rockland County, 1978), 43-47.

55. *Commercial Advertiser*, 9 December 1897, Macbeth Gallery Scrapbooks, Macbeth Gallery Papers, AAA.

56. Robert Henri to William Macbeth, 14 July 1899, Macbeth Gallery Papers, AAA.

57. *Art Notes*, no. 11 (November 1899), 162-63.

58. Diary (12 April 1902), Robert Henri Papers, AAA. Curiously, the sale does not appear in the Macbeth Galleries' Charge Book. The painting may have been traded to Fisher with no money changing hands.

59. Macbeth Gallery Scrapbooks, Macbeth Gallery Papers, AAA.

60. Undated clipping from unknown newspaper [*American Art News*?], Winter 1906, Macbeth Gallery Scrapbooks, Macbeth Gallery Papers, AAA.

61. Maurice B. Prendergast to William Macbeth, 5 June 1904, Macbeth Gallery Papers, AAA.

62. Ernest Lawson to William Macbeth, 17 January 1903, Macbeth Gallery Papers, AAA.

63. Ernest Lawson to William Macbeth, n.d., Macbeth Gallery Papers, AAA.

64. In another undated letter to Macbeth about *Abandoned Farm*, Lawson says that he will give the dealer the commission if Evans buys it. Ernest Lawson to William Macbeth, n.d., Macbeth Gallery Papers, AAA.

65. *The New York Times*, 20 February 1905, Macbeth Gallery Scrapbooks, Macbeth Gallery Papers, AAA.

66. George Luks to William Macbeth, n.d. [1907?], Macbeth Gallery Papers, AAA.

67. George Luks to William Macbeth, 3 June 1907, Macbeth Gallery Papers, AAA. *Boy with Parrot* sold in 1909 for $800 and despite repeated showing at the Macbeth Galleries as well as in other exhibitions, *The Spielers* remained unsold until at least 1916.

68. See John Sloan's diary entry for 1 May 1907, in *John Sloan's New York Scene*, ed. Bruce St. John (New York: Harper & Row, 1965). Hereafter cited as *Sloan's New York Scene*.

69. Wright, 49. Henri's first letter to Macbeth upon returning from Europe in 1900 closes with "Will you kindly remember me to Mr. Davies?" Robert Henri to William Macbeth, 10 September 1900, Macbeth Gallery Papers, AAA.

70. *Sloan's New York Scene*, 24 January 1911.

71. The comment about "purring in the ear of the victim" was inscribed on the proof sold to John Quinn in 1911. See John Sloan, *New York Etchings (1905-1949)*, ed. Helen Farr Sloan (New York: Dover Publications, Inc, [n.d.]), plate 16.

72. Robert Macbeth to Jessie Walker Macbeth, June 1935, Macbeth Gallery Papers, AAA.

73. *Art Notes*, no. 7 (March 1898), 99.

74. *Art Notes*, no. 19 (April 1902), 301. Though he did not mention it in his article, Macbeth's comments may have been prompted by the first Photo-Secession exhibition then on view at the National Arts Club. And while none of the independent shows to date had been held at Macbeth's, the art dealer had clearly positioned himself as a supporter of alternative exhibitions.

75. *Art Notes*, no. 30 (April 1906), 464.

76. Among the significant galleries which soon moved uptown were Seligmann and Company to 705 Fifth in 1913, E. Gimpel and Wildenstein's to 647 Fifth in 1917, and M. Knoedler and Company to 546 in 1918. See Kate Simon, *Fifth

Avenue: A Very Social History (New York: Harcourt Brace Jovanovich, 1978), 237-38.

77. *Art Notes*, no. 30 (April 1906), 463-64.

78. A view of the gallery at 237 Fifth Avenue was published in the *New York Tribune* on 9 February 1902. Macbeth Gallery Scrapbooks, Macbeth Gallery Papers, AAA.

79. Photographs of the new galleries were published in the *New York Tribune* on 13 January 1907. Macbeth Gallery Scrapbooks, Macbeth Gallery Papers, AAA.

80. I have been unable to determine how many floors were in the building at 450 in 1906. Sometime in the 1910s, the Galleries took over the next floor down from their top floor space, giving them two floors, each with two galleries.

81. *Sloan's New York Scene*, 9 April 1907.

82. Robert Henri, 14 May 1907, quoted in William Innes Homer, *Robert Henri and His Circle* (New York: Hacker Art Books, 1988), 129.

83. Skalet, 199-200.

84. *Sloan's New York Scene*, 15 April 1907. In John Sloan's diary, Jerome Myers is recorded as having originally been a party to a number of early discussions about the proposed exhibition. Macbeth was promoting Myers' work heavily at this time; his work had been on view at the Galleries beginning in 1902, and he was often mentioned in *Art Notes*. Henri, for personal reasons, may not have wanted Myers in the show and feared that Macbeth would insist that he be included. Macbeth did give Myers a solo show in January 1908, perhaps to make up for the fact that he was not included in The Eight.

85. *Sloan's New York Scene*, 3 May 1907.

86. *Art Notes*, no. 34 (December 1907), 537. New artists were identified in *Art Notes* with their full name; the fact that all of The Eight, even those who had not shown at the Galleries in the past, were mentioned by last name only suggests that Macbeth felt that his readers *should* be familiar, if they were not already, with these men.

87. *Sloan's New York Scene*, 18 January 1908. Not all the artists were pleased with the catalogue; Sloan recorded in his diary that "Henri is very much disappointed with the reproduction of his work in the catalogue and it is not very good — but as usual in these affairs, one or two do the work and the rest criticize" (*Sloan's New York Scene*, 31 January 1908).

88. Avis Berman, *Rebels on Eighth Street* (New York: Atheneum, 1990), 114-15.

89. Webb writes back that while he is sorry not to have seen the exhibition, paintings by J. Alden Weir and Henry B. Sness [*sic*] in the next Macbeth show are of greater interest to him. E. T. Webb to William Macbeth, 2 March 1908, Macbeth Gallery Papers, AAA.

90. Arthur Hoeber, "Art and Artists," *Globe and Commercial Advertiser* (9 February 1908); James B. Townscend, "The Eight," *American Art News*, 17 (9 February 1908).

91. "Native Art Shown in Forty Paintings," undated clipping, Macbeth Gallery Papers, AAA.

92. *Sloan's New York Scene*, 20 January 1908.

93. Robert Henri diary, December 13-14, Robert Henri Papers, AAA. Henri's approach to Macbeth seems somewhat half-hearted, as he would certainly have been aware that the art dealer made up his schedule much further in advance.

94. William Macbeth to Robert McIntyre, 5 November 1909, Macbeth Gallery Papers, AAA.

95. Joseph Edgar Chamberlin, "A Splendid Picture by George Luks," *The Evening Mail* (18 April 1910).

96. "Mr. Luks 'Wrestlers' Gripping Realism," *New York Herald* (19 April 1910).

97. *A Memorial Exhibition of Paintings as a Tribute to the late Robert Macbeth, Renowned Dealer in American Art* (Utica, New York: Munson-Williams-Proctor Institute, 1941), n.p.

98. *New York Herald*, 4 May 1913, Macbeth Gallery Scrapbooks, Macbeth Gallery Papers, AAA (reprinted from *Art Notes*, April 1913).

99. *Art Notes*, no. 63 (April 1917), 1023-26.

100. Ibid., 1020.

101. *Art Notes*, no. 85 (June 1917), 1526.

102. Helen Appleton Read, *New York Realists: 1900-1914*, exh. cat. (New York: Whitney Museum of American Art, 1937), 6.

103. *"The Eight" (of 1908) Thirty Years After*, exh. cat. (New York: Macbeth Gallery, 1938), n.p.

104. Ibid.

105. Shinn, in "Recollections of The Eight," 13.

85

Installation view of the main gallery, 102nd Annual Exhibition, Pennsylvania Academy of the Fine Arts, 1907. Henri's painting *Asiego* can be seen just left of center. Courtesy of The Pennsylvania Academy of the Fine Arts.

Robert HENRI, *Salome*, 1909. Mead Art Museum, Amherst College, Amherst, Massachusetts.

The Legacy of The Eight:
Independent Exhibitions and the "National Salon"

The Macbeth Galleries exhibition and national tour inserted The Eight into leadership roles within the New York arts community and beyond. Celebrated for having defied convention, the artists enjoyed sustained publicity and patronage. The Eight demonstrated that the independent exhibition was a viable forum for self-promotion well within the reach of any artists' group. And they proved that the American public, so long maligned as uninterested in the visual arts, would indeed attend an art exhibition if its curiosity was whetted by a well-orchestrated and pervasive publicity campaign.

It is no surprise then that The Eight exhibition also initiated the decline of the National Academy of Design as the primary sponsor of contemporary American art shows in New York. Over the next ten years, centralization gradually gave way to even greater diversification of exhibitions and their settings. Instrumental in that development were several former members of The Eight. Between 1908 and 1917, Arthur Davies, William Glackens, and John Sloan would join Robert Henri as influential advisers to and participants in significant exhibitions of contemporary art in New York and other American cities.[1] And though these men never again exhibited together as The Eight, their prominence sustained memories of that association among many observers in the New York arts community. Despite their original solidarity, however, these newly influential leaders would ultimately and ironically betray divided opinions on the proper "progressive" alternative to the traditional juried Academy show. The search for a fair and modern "National Salon" continued unabated, though now directed by a younger generation.

Notwithstanding the anti-Academy rhetoric of their pre-exhibition publicity, the primary aim of The Eight had been to reform the Academy, not destroy it. Initially, in fact, the Academy annuals retained their preeminence in New York because they provided artists with the benefits of comparative study and the general public with an extensive, if not yet comprehensive sampling of work from the local arts community. Indeed, even as The Eight exhibition left New York on its national tour, Davies, Henri, Sloan, and Lawson sent paintings to the National Academy's 83rd Spring Annual and Lawson was awarded the Hallgarten prize for landscape. Davies, Glackens, and Lawson would exhibit at the 1908 Winter exhibition; and a year later, Glackens would serve as a member of the Winter exhibition selection jury.

But reform proved unattainable. Limitations on membership prevented younger innovative artists from joining the Academy's ranks in significant numbers (though George Bellows was elected an Associate in 1909 and an Academician in 1911). Moreover, senior Academicians continued to envision its role as that of premier arts society and chief administrator of the long-awaited municipal "art trust," to be realized once a central exhibition facility was constructed. "Even Richmond, Indiana has a better art exhibition than New York," lamented Academy president John White Alexander in 1910, in reference to the inadequacy of exhibition space in the city. "We have got to such a pass now that the remedy is difficult to find. All we artists can do is to try to educate public opinion and we do try."[2]

The Academy administration accordingly made several new attempts to secure midtown Manhattan property. But the announcement in 1909 that a deal had been struck with the city to build in Central Park met with fierce public opposition.[3] Community groups argued that city parks were small enough without granting valuable space to a private organization that already owned land in the city. Fearing a precedent that would make the parks in all five boroughs vulnerable to invasion, labor unions joined the Parks and Playgrounds Association to fight the plan. "This conspiracy, hatched in mystery and suddenly sprung on the public with the names of some hitherto blameless citizens attached to it, must be defeated," a *Times* editorial announced; "It may be true that the wealthy people do not care as much for Central Park as they used to before the era of the automobile. But for the poor, for the people of small means or none at all, it must be preserved as a park."[4] The Central Park plan was tabled. When a proposal to build in Bryant Park sparked equal protest, the Academy abandoned its plans for partnership with the city.[5]

Undaunted, it tested the "art trust" idea again in 1911. Proposals were sent to eight New York-based arts institutions, inviting them to form a "National Academy Association" to administer a

central building housing all nine organizations. The plan called for construction of a building large enough to house a joint annual exhibition encompassing all of the arts of design. During the rest of the year, member associations could hold smaller exhibitions rent-free, with proceeds benefiting the association. This plan too had to be tabled when efforts to find a suitable site again failed.[6]

The Academy was rapidly losing credibility. As its members vainly searched for new quarters and a revitalized role in the community, they neglected the very exhibitions they hoped to improve. Many in New York doubted the Academy's ability to serve the general public or to properly represent the city's artists, and even staunch conservatives remarked upon the declining quality of Academy annuals. After viewing the especially mediocre 85th Annual in the spring of 1910, Frank Jewett Mather wondered whether the Academy could or should continue to operate. "Only two dignified courses are open. Shut up shop, retaining the organization as an honorary institution; or move forward and make a bold attempt to catch the curiosity of the town."[7]

One year after The Eight exhibition, Mary Fanton Roberts wrote that it was the National Academy's responsibility to "estimate, appraise and judge what of our art means growth and what atrophy, for upon them alone can we depend for the real encouragement and the practical help which means a rapid flowering of art (or the contrary) in America." If the present "superannuated" Academy administration was overly wary of innovation, then younger men should be put in charge. "It would be interesting to see an exhibition of three hundred and thirty-eight pictures, with Glackens, Henri and Shinn on the hanging committee," Roberts commented.[8]

Indeed, with the Academy's search for a new site continually in the news, the time seemed ripe to launch a second independent exhibition, and throughout 1909 Henri and Sloan discussed organizing a large show that would highlight the work of younger artists. "The works shown to be invited by the Eight, and subject to their judgment so that the shows will be expressive of their judgment," Sloan noted in his diary, revealing that he still thought of The Eight as a viable political entity.[9] Yet discussions among Henri, Sloan, and

their associates continued indecisively, with questions of patronage and the selection of contributors unresolved.[10]

Significant progress was made only in early 1910, when Henri and Sloan were approached by Walt Kuhn, who also wanted to organize a large group exhibition open to all artists. A painter and illustrator who had taught with Henri at the New York School of Art in 1908 and 1909, Kuhn was best known at the time for cartoons in such magazines as *Puck*, *Life*, and *Judge*. The two older men welcomed his idea and, with Davies, agreed to contribute seed money. Because Sloan and Henri had already done most of the spadework, the exhibition was realized in record time. Working with Kuhn, Guy Pène du Bois, Rockwell Kent, and Stuart Davis, all of whom were ex-students of Henri, they rented an empty house on West 35th Street, assembled artworks, and opened the Exhibition of Independent Artists within a month.[11]

Demonstrating that grand new facilities were unnecessary for an effective display, the exhibition featured over two hundred and sixty oil paintings, twenty-two sculptures, and more than three hundred drawings and prints. Patterned after the 130 Salon des Indépéndants in Paris, it had no jury: artists who wished to participate simply paid an entrance fee based on the number of works submitted. The organizers did, however, invite some submissions from selected artists in an effort to discourage the participation of "men whose conservative conventionalism has retarded the progress of American art." Oil paintings and sculptures were installed alphabetically by artist in first- and second- floor galleries; works on paper were hung on the third floor. Scheduled to run concurrently with the Academy annual, the exhibition tellingly undermined that institution's semblance of authority in the New York arts community. On opening day, over twenty-five hundred visitors packed the three-story house.[12]

Like The Eight exhibition, the Independents was promoted with extensive and colorful advance publicity. As art critic for the New York *American*, participant Guy Pène du Bois promised his readers an exhibition of modern art "entirely independent of all that is accepted and practically all that is conventional in art." Works on view would include paintings by "the realists, the impressionists, the

men who, with Matisse followed the theories of Cézanne, the followers of the geometrical art of Picasso and by men whose art, purely personal is directly connected with no concerted movement."[13] Reviewers could not help but describe the show as an American "Salon des Réfusés," especially since several works — most notably Henri's *Salome* — were known to have been rejected by the Academy jury that year. But as others justifiably pointed out, several of the dominant exhibitors were members of the Academy, including Associates Glackens, Lawson, and George Bellows, and full Academician Henri.[14]

Reviewers praised the joint participation of well-known artists and their younger or less celebrated colleagues. And notwithstanding references to the European avant-garde, many noted in particular the eminently "American" spirit of the exhibitors and their work. "Certainly they have managed to fashion a most inspiring kind of romance out of the fabric of our contemporary local conditions and have got into their work the multitudinous aspect of our metropolis as none of their forerunners succeeded in doing," declared the *Times*.[15] "Naturally there are many 'extreme' things," noted Joseph E. Chamberlin in *The Evening Mail*; "No matter; there is also a great deal of good and very promising work, from artists now unknown, whose work may some day be famous."[16] "Distinctly more amusing than the Academy ever is," wrote Mather in *The Evening Post*. "Much of this work is vigorous. It represents us in certain human realities; it is idiomatic, and it tends to offset the impression made by much official art that we are chiefly wearers of good clothes and wanderers in green fields."[17]

While press reaction to The Eight show had alluded to the Civil War in reporting the artistic secession, reviews of the Independents exhibition mixed rhetoric derived from the French avant-garde with uniquely American terms borrowed from current federal politics and the intrigues of Capitol Hill. The exhibitors, for example, were nicknamed "Insurgents," the name given a maverick bipartisan coalition led by freshman Republican Senator Robert LaFollette of Wisconsin. Just as these congressmen were fighting protectionism and the influence of big monied interests in government, so too the artists were fighting the "art trust" controlled by the Academy.[18]

Noting that "insurgency" seemed to be a condition of the times, almost to be expected in art as in politics, several reviewers, both progressive and conservative, viewed the Independents' Exhibition as reflecting "an appetite for change and innovation in the arts."[19]

Such an emphasis in critical response clearly drew upon Robert Henri's carefully constructed comments on the show. Rather than rely upon the press to quote him at length from interviews as he had done for The Eight show, Henri this time published his own lengthy commentary on the Independents exhibition in *The Craftsman*. There he reiterated the nationalist program he had first articulated in 1908, ultimately pleading for public recognition and appreciation of the artist in American society. Henri explained that the exhibitors had come together to promote "freedom to study and experiment and to present the results of such essay, not in any way being retarded by the standards which are the fashion of the time, and not to be exempted from public view because of such individuality or strangeness in the manner of expression." While denying that these "independent" exhibitors possessed a specific political agenda, Henri yet made it very clear that they viewed creative freedom and political freedom as equal. He likened the artists' challenge to academic standards and conventions with the aims of America's founding fathers:

> Not one of these men will talk to you of their technique or of any organization they are interested in, or of any effort to form a society. They will tell you that they want independence for their ideas, independence for every man's idea. Why, this country was founded with the idea of independence, with the idea of man's right for freedom. We do not think much about this, and yet it was the first idea that caused people to fight under the leadership of such a man as Patrick Henry.[20]

It cannot have been coincidence that Robert *Henri* selected Patrick *Henry* as his Revolutionary model.

Although Henri in fact downplayed opposition to the Academy, other reviewers continued to highlight it. Guy Pène du Bois

called the Academy "bourgeois" and cheered the Independents Exhibition as "a vital, manly — if artistically vulgar — record of a living, seeing, breathing set of human beings whose hands and visions are not warped into inefficiency by the conventional aesthetics or the philistinism of art."[21] George Bellows' *Stag at Sharkey's* was singled out by several reviewers as emblematic of the anti-academic struggle. "How the 'Art Rebels' of America Are Shocking the Older Schools by Actually Putting Prize Fights on Canvas and Picturing Up-to-Date Life as It Really Is Here and Now," Henry Tyrell headlined in *The World*.[22] Similarly, critics made special mention of Henri's boldly brushed *Salome*, noting that it had been rejected by the Academy and praising it for "astonishing lifelikeness and vigor."[23]

In spite of good attendance, under a dozen works were sold from the Independents exhibition. And few of the unknown artists who had paid their dues and submitted works saw their hopes for publicity realized, for the majority of critics predictably focused on familiar names — Henri, Sloan, Bellows, Kent, and others, most of whom were identified as belonging to Henri's circle — and dismissed the majority as "amateurs." Nonetheless, high attendance at the Independents and the growing number of smaller club exhibitions in New York indicated that the general public was more likely to be attracted to diverse, even controversial shows than to the predigested displays selected by an Academy jury.

Although seven of The Eight exhibited in the Independents exhibition — Luks declined to participate — only Henri, Sloan, and Davies were directly involved in its organization. Nevertheless the press assumed that the group collectively masterminded the exhibition, an impression reinforced by Henri's dominant role as spokesman.[24] Henri insisted on full credit for the show's conception despite Kuhn's initiative and input. Defending his adamance to Sloan, Henri argued that Kuhn was an unknown, whereas he, with a reputation as a leading "Revolutionist" in New York, could more easily attract needed publicity.[25]

In truth however, The Eight had already ceased to exist as a cohesive association. After the success of their 1908 exhibition, contact among the artists declined as each returned to his own now dramatically enhanced career path. Although they individually supported the concept of free exhibitions, they increasingly distanced themselves from Henri. Even Sloan, Henri's closest friend for almost twenty years, began to spend less time with his former mentor.[26] When Sloan attempted to initiate a fall 1911 exhibition reunion at the Macdowell Club, Shinn and Prendergast agreed to participate, while Henri, Luks, and Davies declined, the latter commenting that he wished to be free from the "dreadful thought of an exhibition." Maintaining the integrity of The Eight as a group was apparently no longer important to Sloan as well, for he next invited Walt Kuhn and landscape painter Elmer Schofield. The exhibition, which finally opened in January 1912, was a motley gathering. Shinn, Prendergast, Lawson, Glackens, and Sloan were joined by Ernest Fuhr and James Preston, Schofield having withdrawn at the last minute. By this time, Sloan was tiring of exhibition projects. Following the lead of his wife Dolly, he became increasingly involved in Socialist politics, eventually joining the staff of the radical weekly *The Masses* as an editor and illustrator in December of 1912. When Henri informed him of his election to the Macdowell Club late in 1911, Sloan was unenthusiastic, "but I suppose it is my duty to pay my dues."[27]

Though the artists of The Eight were still considered "progressive," it was becoming increasingly difficult to maintain a radical stance as they entered the ranks of the establishment. In 1910, John Beatty, director of the Carnegie Institute — who a decade before had apologized to Arthur Davies because a submitted piece did not pass the jury — invited him to exhibit in the museum's annual, assuring the artist there would be no need for a jury review of his submission.[28] And a year later, Davies returned in triumph to Chicago, where he had studied and more recently exhibited regularly, with a retrospective exhibition at the Art Institute. Prendergast and Glackens temporarily renounced exhibition politics to concentrate on their art. In Paris in 1909, Prendergast reacquainted himself with the work of the Fauves and refined his adaptations from Cézanne. Glackens, who spent 1906 in France, returned in 1911 as the agent and adviser to Philadelphia collector Albert C. Barnes. He had by then effected a radical revision of his painting style, abandoning the dark palette of Manet for the brighter pastels and feathery brushstroke of Renoir. Everett Shinn, awarded a commission in 1911 for mural

decorations at the City Hall in Trenton, New Jersey, subsequently left New York for Hollywood to become a set designer. Following the success of a 1910 one-man show at Macbeth's, George Luks became a fashionable albeit eccentric portraitist. And Ernest Lawson, by then a National Academy regular, would exhibit his paintings at that institution regularly until his death.

Of The Eight, only Henri maintained a strong commitment to smaller shows organized by self-selected groups of artists. Beginning in 1910, he tested this small group exhibition concept at the Macdowell Club, a facility founded that year specifically to provide exhibition space for "direct presentation of the artists to the public." The club's galleries were available for a small fee to any group ranging in size from eight to twelve members. Membership in the club was not a requirement and there was no jury because the artists came as self-selected groups. "The aim of the Club is to make its gallery as nearly as possible an open field for expression of the various movements in art whether old or new." The presence of Academy president John White Alexander among its directors (and exhibitors) is evidence of the club's nonpartisan agenda.[29] Nor did Henri shun participation in shows that he himself did not control. In 1911, for example, he exhibited in an "Insurgents" show of works by James Preston, Edith Dimock Glackens, May Wilson Preston, Walt Kuhn, Rockwell Kent, George Bellows, and Max Weber, as well as Glackens, Davies, Luks, Shinn, Lawson, and Prendergast, which, thanks to the perspicacity of Fine Arts Committee chairman and National Academician Harry Watrous, was hosted by the venerable Union League.

That same year, however, Henri refused to contribute to a show assembled by Rockwell Kent because Kent initially insisted that contributors sever all ties to the National Academy. Kent criticized Glackens, Lawson, and Bellows in particular as "down on their knees to the Academy each exhibition after the bad treatment of the previous occasion." Defending his colleagues, Henri noted: "I hope it is 'youth,' and that he may see as he grows old that the great thing is to give your views and then let people decide for themselves."[30]

But the proliferation of small shows and progressive exhibiting organizations like the MacDowell Club did not satisfy the belief still shared among many artists in New York that the city needed a "National Salon" with which to assert its position as the American arts capital. Even Henri had misgivings about the adequacy of small exhibitions alone. As early as 1907, while organizing The Eight show, he had described his own plan for an ideal exhibition space in words that clearly recall the National Academy's goal of establishing a centralized exhibition building:

> I should like to see just such group shows and also larger shows where the groups combine — say twenty or thirty together but the gallery space is wanting in New York . . . I should like to see this movement grow and I do not believe it would be long before a large gallery would be possible where the groups could have more extended personal exhibitions or united hold larger exhibitions, still continuing with the idea of several pictures by each man and possibly hung together — at any rate well hung.[31]

Indeed, the Independents exhibition, to which Henri lent his considerable support, was less an absolute rejection of the Academy than a demonstration of what it could and should exhibit were it to liberalize its membership and jurying policies. Nevertheless, Henri felt strongly that large exhibitions did not do justice either to the artist-exhibitors or their audience, a conviction that ultimately and ironically contributed to his marginalization in the events that would soon transform the New York art scene.

New Yorkers suffered pangs of inadequacy when reports arrived of innovative contemporary art exhibitions produced in other cities. "To have the important foreign works that reach this country diverted to the West so frequently as they are is a misfortune that we only recently have begun to appreciate," a *Times* editorial observed late in 1911; "An acute critic says pertinently of our adventurous Western public: 'It is so eager to catch up that it will get ahead.'"[32] It was not enough to organize large exhibitions of American art: New York had to demonstrate its ability to host a groundbreaking *international* gathering. Heretofore in New York, new developments in

European art were displayed almost exclusively at commercial galleries. The mandate of the National Academy required that it display only American work, while the Metropolitan Museum was then focusing its exhibiting and collecting energies in the Renaissance. The best-known, indeed most notorious of contemporary art galleries in New York was Alfred Stieglitz's 291. It was Stieglitz who had hosted the first exhibitions of work by Picasso, Cézanne, and Matisse in the United States. And his magazine *Camera Work* was a major source for news and analysis of the European avant-garde. But he showed few Americans in the gallery, restricting his support to a small circle of protégés.

Within little more than a year after the *Times* editorial appeared, a group of New York artists met the challenge of the "West" and soundly defeated it. On February 17, 1913, "the most complete art exhibition that has been held in the world during the last quarter century," opened in the 69th Regiment Armory on Lexington Avenue at 25th Street. Over twelve hundred paintings, sculptures, and graphics were on view, four times as many works as could be seen at any Academy show. Four thousand visitors walked through the octagonal-shaped temporary exhibition spaces on the first day alone. They discovered there a carefully orchestrated history of modern art, the latest chapters of which were represented by works that challenged the very foundations of representational painting and sculpture.

The exhibition had been organized by a corporation of twenty-six artists who called themselves the Association of American Painters and Sculptors. Founded by painters Walt Kuhn, Henry Fitch Taylor, Jerome Myers, and Elmer MacRae, its aim was to "lead public taste in art rather than follow it," through the medium of an exhibition displaying the work of "progressive and live painters, both American and foreign — favoring such work usually neglected by current shows and especially interesting and instructive to the public."[33]

Arthur Davies was elected president of the association. Familiar with exhibition logistics, he also had a coterie of powerful patrons who could provide financial backing, including Lillie Bliss

and John Quinn, who was also legal counsel for the Association. Perhaps even more significantly, Davies belonged to no artistic clique. Well-known and respected within Henri's circle, he was also a close friend and patron of Alfred Stieglitz, Henri's chief rival in the New York arts community. A reserved, indeed secretive man whom many dismissed as shy and unassuming, Davies proved a masterful administrator, "a creature of driving energy, incisive command, organizational ability, and authoritarian attitude."[34] Davies supervised the organization of an exhibition that was the most heavily promoted and publicized art event in New York history. And it was Davies, together with Kuhn and Walter Pach, a painter and critic living in Paris, who assembled the works by European avant-garde artists which riveted the attention of the American press and public.[35]

The fact that seven of The Eight were members of the Association of American Painters and Sculptors — only Shinn, preoccupied with the Trenton murals, declined involvement — and that Davies and Glackens, who was chairman of the American Selection committee, held positions of authority led some commentators to mistakenly credit The Eight with the Armory Show's conception, as had happened with the Independents exhibition. Certainly the younger artists who had initiated plans for the show did turn to members of The Eight for guidance. But as the final structure of the Association's leadership indicates, former members of The Eight no longer acted in concert. The seven who joined the Association or contributed to the Armory Show did so with varying degrees of enthusiasm.

A lesson learned from The Eight exhibition and effectively exploited for the Armory Show was the value of publicity: dramatic and extensive. Advance press notices were distributed to newspapers and magazines across the country a month before the show opened.[36] Throughout its run in New York, and later in Chicago and Boston, press coverage was constant and vociferous, focusing particularly on works by the European "ultra-moderns," as they were nicknamed. To the familiar terms "revolutionist" and "insurgent" were now added such labels as "cubist" and "futurist." Even Stieglitz, who had hitherto limited his editorializing to the pages of his own publications,

reviewed the show for the popular press. Not coincidentally, he also scheduled a concurrent exhibition of his own photographs at 291.[37]

Davies and his colleagues conceived the Armory Show as a didactic event. Visitors were treated to a history of modernism from its beginnings, in the works of Ingres, Delacroix, and Goya, through its ascendancy in the paintings of Manet, Degas, Gauguin, Van Gogh, and Cézanne, to the achievements of the younger generation in Europe and America. Confronted by the new language of abstraction in works by Picasso, Duchamp, Matisse, and others, the American public reacted variously with anger, enthusiasm, or simple bewilderment. Chicago critic Harriet Monroe called it an exhibition of "Freak art," best suited for display in an insane asylum. Academician Kenyon Cox deemed Cubism "nothing else than the total destruction of the art of painting," the logical outcome of the decadent rebellion that had begun with Manet and Whistler. For painter Stuart Davis, however, who was a contributor to the show and former student of Henri, the Armory Show represented his teacher's ultimate vindication. "The Armory Show was the greatest shock to me — the greatest single influence I have experienced in my work," he recalled; "Here indeed was verification of the anti-Academy position of the Henri School, with developments in undreamed of directions."[38]

Ranging between these extremes were the reactions of the general public. Newspaper cartoons lampooned the apparent incomprehensibility of "cubism" and "futurism." Marcel Duchamp's *Nude Descending a Staircase* was a favorite target of parody as press and public endeavored to decipher the subject of Duchamp's energized design. When a reduced version of the show was put on view at the Art Institute of Chicago in March 1913, the Illinois legislature appointed a commission of inquiry to investigate the "depravity" of cubism.[39] Doubtless many people visited the Armory Show simply to satisfy their curiosity; but they came, and they left with changed attitudes. As Frank Jewett Mather tellingly observed: "In a half hour's visit to the sixty-ninth Regiment Armory, one may meet with ridicule, rage, helpless questioning, and savage enthusiasm, but not with indifference." The genteel chatter of the typical art exhibition was here replaced by "interest, discussion, and the slashing of prejudices."[40]

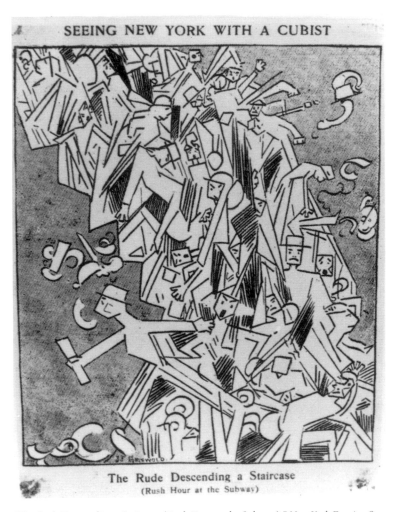

"The Rude Descending a Staircase (Rush Hour at the Subway)," *New York Evening Sun*, 20 March 1913. Courtesy of the Whitney Museum of American Art.

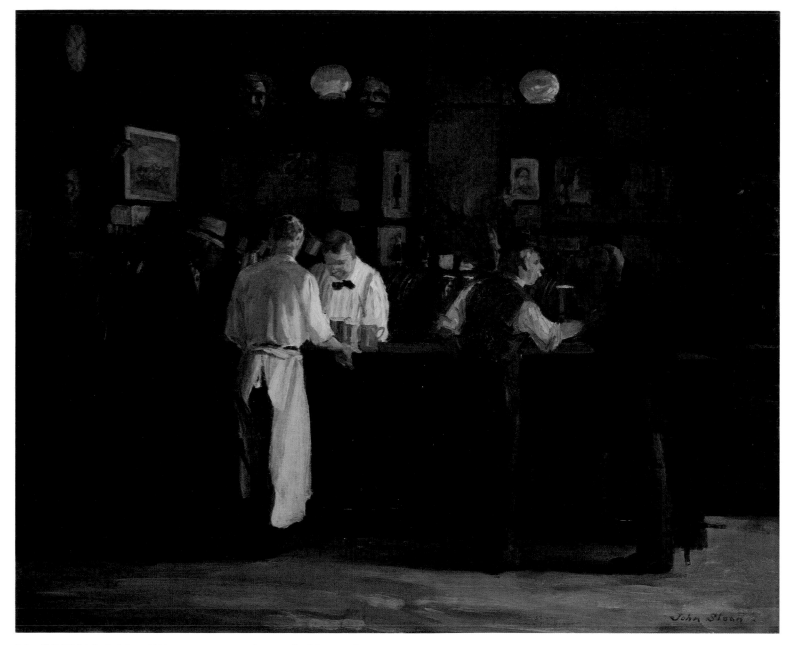

John SLOAN, *McSorley's Bar*, 1912. Detroit Institute of Arts, Gift of the Founders' Society.

Walt Kuhn described the Independents' exhibition as a cry for help, the Armory Show as an answer to that call.[41] With its realization, Arthur Davies and the AAPS achieved what the National Academy had only envisioned — a "national" Salon that would reassert New York's pre-eminence as the artistic capital of the United States. In the wake of the Armory Show, art dealers and commercial galleries specializing in the work of the avant-garde proliferated in New York and throughout the country. And exhibitions of American and European "ultra-moderns" toured to cities across the country.[42]

Offsetting the success of the Armory Show were some familiar criticisms. Some Association members criticized the range and quality of the European selections; Davies and Kuhn were accused of having monopolized this component of the exhibition in their efforts to assemble the exhibition in record time. And despite the professed desire of the founders to forego jurying procedures, this intent proved impractical for the American section. As chairman of the American selection committee, William Glackens made a valiant effort to achieve some equitability but was criticized nonetheless. Plans by the Association to produce a second exhibition were blocked by fiscal mismanagement and internal squabbling, which led finally to the dissolution of the organization in the early summer of 1914. By fall, war in Europe temporarily ended any plans for a large-scale art organization or exhibition project.[43]

Yet the dream of the big exhibition persisted, encouraged by many artists' continuing belief that only large shows could attract public attention. By 1916, an unlikely coalition of artists and patrons had gathered in New York to produce just such an exhibition. Veterans of The Eight William Glackens, Maurice Prendergast, and John Sloan joined forces with Armory Show organizer Walter Pach, exiled Europeans Marcel Duchamp and Francis Picabia, and a coterie of avant-garde patrons including John Quinn, Katherine Dreier, Gertrude Vanderbilt Whitney, and Louise and Walter Arensberg to create the Society of Independent Artists. Their stated aim was to revive the "no jury — no prizes" spirit of the Salon des Indépendants, suspended in 1914 because of the war. Their unspoken ambition, however, was to seize credit once and for all from the National Academy for an annual national salon in New York.

In April 1917, the first annual exhibition of the Society of Independent Artists opened at New York's Grand Central Palace. With some twenty-five hundred works of painting and sculpture by twelve hundred American and European artists, the exhibition was almost twice the size of the Armory Show. Rockwell Kent called it the "Big Show," a nickname quickly appropriated by the press. There was no selection committee. As with the Paris Indépendants, any artist who paid the one dollar initiation fee and five dollar annual dues could participate. On the suggestion of Marcel Duchamp, the installation was organized alphabetically, starting from the randomly selected letter "R."[44]

The Society enjoyed a distinct advantage over previous organizations in that its members had access to a large exhibition hall. The Grand Central Palace, designed as part of the Grand Central Terminal complex by teamed architectural firms Reed & Stern and Warren & Wetmore, had opened in 1912 on Lexington Avenue between 46th and 47th Streets. A vast multi-story atrium on the main floor provided an exciting alternative to the more utilitarian (and expensive) Madison Square Garden. Because of the scale of these galleries, the Society exhibition was able to accommodate an even wider range of artworks than had the Armory Show. Hence the Society of Independent Artists' inaugural exhibition "presented a thorough cross section of the various currents in modern American art in one of the most crucial periods of its development."[45]

Participants in this first annual ranged from the liberal academic to the radical avant-garde. Works exhibited included Gertrude Whitney's eighteen-foot male figure designed as the *Titanic Memorial*, Constantin Brancusi's *Princess X*, John Covert's *Temptation of Saint Anthony*, and Dorothy Rice's five-by-six foot double portrait of *The Claire Twins*, which one critic described as "circus avoirdupois freaks." Society president William Glackens exhibited two canvases: *Girl Arranging Flowers* and a Bellport beach scene. Ernest Lawson sent two landscapes as did Maurice Prendergast. John Sloan exhibited a portrait and a study called *Blonde Nude*. None of the other members of The Eight participated in the Society's inaugural.[46]

Critical response focused on the success or failure of the "no jury" selection and installation. Robert Henri openly called it a "Salon" in an article for Mary Fanton Roberts' new magazine *The Touchstone*. Ironically he specifically criticized Society members for having dispensed with a hanging jury and called the alphabetical system "a disastrous hodge-podge." "If we resent dictation from a jury why should we not resent dictation from an alphabet?" So strongly did Henri disagree with the final exhibition installation that he tendered his resignation from the Society just before the exhibition opened. His sentiments were echoed by other observers, including Henry McBride, newly appointed art critic for the *Evening Sun*, who feared that the arbitrary installation might harm works of real quality.[47]

In a 1914 critique of the Armory Show, Henri had argued that large exhibitions were a disservice to the public: "In our jury selections we have over-protected our public, for, after all, it is that public, or some immeasurable part of it, which has overriden our judgements [*sic*] and declared for us our real masters of art."[48] Now three years later, he repeated that argument, claiming the "Big Show" concept perpetuated academic elitism, and reiterating his call for "persistent" small group shows presented throughout the year in a central exhibition hall. "The artist should exercise *his* judgement [*sic*] and *his* taste in the making of the picture, should be the one to determine when it is ready for the public, and just as nearly as possible should choose the manner of its presentation; how it should be hung and in what company." Once on exhibition, appreciation of

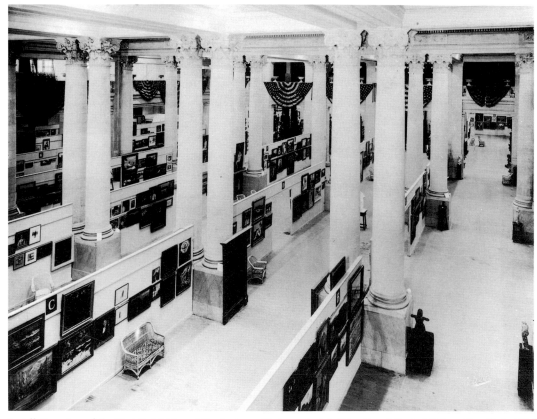

Installation view of the First Exhibition of the Society of Independent Artists, Grand Central Palace, New York, 1917. Collection of the Société Anonyme, Yale University.

this art then became the concern of the individual viewer, requiring a personal response to creative work.[49]

As Society president, William Glackens rebutted his former comrade-in-arms. Interviewed in the same issue of *The Touchstone*, Glackens admitted that smaller shows probably carried greater educational value, but pointed out that self-selection was equally vulnerable to cronyism. And he repeated the argument that a large-scale exhibition elicited more public attention. "The public in this country takes more interest in a big show and so the big show carries its own advertising," Glackens explained. "Such an exhibition once a year is looked forward to; it attracts attention and takes its place as an event . . . You cannot wake up the public with a series of the best small exhibitions ever seen. You have got to startle the people by volume or size or color." If the public wanted good art, it would encourage that art to be made, no matter what kind of exhibition was produced.[50]

The 1917 Society of Independent Artists exhibition represented the resolution of the conflicting ambitions and ideas of progressive American artists and the academic status quo. In size and scope, it fulfilled the longtime Academy dream of a national salon, while in structure and design, it realized the progressive model. But generational divisions appeared among the Society's founders even as the first exhibition was being installed. The Eight had conceived of their art in the traditional didactic sense, emphasizing the artist's role as a communicator. Theirs was a populist agenda, advocating that all who desired to communicate have access to an audience. But this cause presupposed an art comprehensible to that audience. In contrast, the stars of the Armory Show and the Society of Independent Artists' 1917 exhibition — the new heroes of progressive art in America — made images that often seemed inaccessible to American viewers. As the language of abstraction demanded that artists question the very structure of image and perception, innovation within the idiom of representation was no longer sufficient. Hence these two exhibitions thrust the one-time leaders of the "independent" revolution into the ranks of the reactionaries.[51]

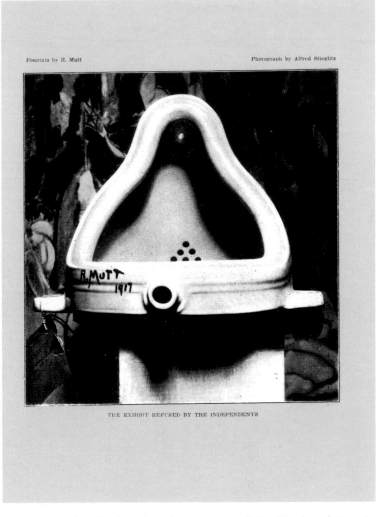

"The Exhibit Refused by the Independents": R. MUTT [Marcel Duchamp] *Fountain*, 1917. Photograph by Alfred Stieglitz, published in *The Blind Man*, no. 2, May 1917. Courtesy of the Philadelphia Museum of Art.

97

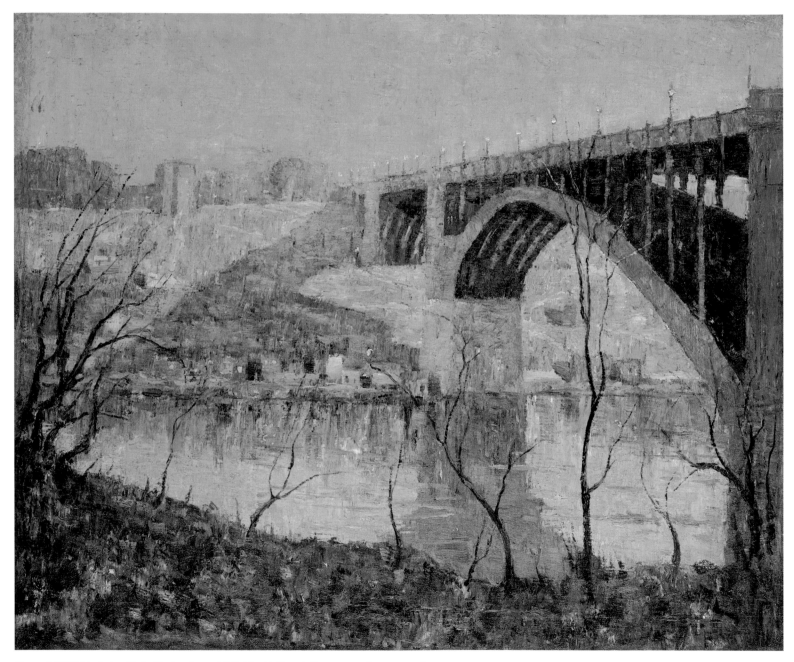

Ernest LAWSON, *Spring Night, Harlem River*, 1913. The Phillips Collection, Washington, D.C.

Despite his significant role in both the Armory Show and the 1917 Society inaugural, it is not surprising then that William Glackens expressed some reservations about the more extreme works on view. "If the public does not perceive any educational value in these big exhibitions it is not wholly the size; it is because certain modern artists elect to *disguise* rather than to *explain* their art . . . Of course every man has a right to paint just as he pleases, but one cannot get too far away from representation (which the modernists are so afraid of) with reacting into materialism. . . .I take it that art is something finer than a chance to bewilder the public." Chief among these incomprehensible works was a porcelain sculpture entitled *Fountain*, submitted by organizer Marcel Duchamp. The piece was in fact a mass-produced urinal, purchased from a plumbing supplier. Glackens and his colleagues, America's one-time champions of the "no jury — no prizes" exhibition, were flummoxed. Not having the authority of a selection jury, they could not reject the piece. Ultimately, however, *Fountain* was not exhibited. According to one report, as the executive committee pondered their next move, "nobody noticed [Glackens] leave the group and quietly make his way to a corner where the disputed *objet d'art* sat on the floor beside a screen. He picked it up, held it over the screen, and dropped it."[52]

❦

1. In 1909, the American Federation of the Arts, based in New York, was founded to assemble and circulate exhibitions of arts and crafts to communities throughout the country. In 1910, Henri participated in one such tour when he sent a painting to the "Indiana Circuit," comprising stops in Fort Wayne, Lafayette, Terre Haute, Muncie, Bloomington, Indianapolis, Richmond, and Louisville, Kentucky.

2. "Even Richmond, Ind. Has a Better Art Exhibition Than New York," *The New York Times*, 25 September 1910.

3. Although the Academy retained title to the Morningside Heights site, members voted overwhelmingly for a more central location.

4. "The Central Park Conspiracy," *The New York Times*, 12 March 1909. The American Scenic and Historical Preservation Society and American Society of Landscape Artists also challenged the Academy's right to alter the design of the landscape architect. Record attendence at the recent exhibition of work by the Spanish painter Joaquin Sorolla at the Hispanic Society on 155th Street in Audubon Park was cited to counter the Academy's expressed need for a midtown location: as long as a building was accessible by bus or subway, the public would show up. Moreover, as the sponsor of exhibitions of artworks available for sale, the Academy was a commercial enterprise. For years developers had attempted to inject commercial activities into New York's parks; setting a precedent for such an event was deemed too risky.

5. In the summer of 1910 the Academy also explored a site near the new Grand Central Station, but the increasing number of skyscrapers in this area presented problems: Academy administrators argued for construction of a building no more than one-story high — to provide skylit galleries and to accomodate the weight of sculpture exhibits — which would be overshadowed by higher structures. See "Plan Fine Arts Building," *New-York Daily Tribune*, 21 April 1910. The Central Park controversy points up the problems that faced semi-public cultural institutions in New York. Supporters of the Central Park plan pointed to the great "museum parks" in Europe as models, but unlike Berlin and Vienna for example, where the municipal governments owned 9.2% and 13.4% of city land respectively, very little land in Manhattan was actually owned by the City of New York. Cultural institutions such as the Metropolitan Opera and the New York Public Library as well as the National Academy were forced to turn to private philanthropy when they relocated to larger sites and expanded facilities. The major exception to this was the Metropolitan Museum, the trustees of which had agreed to turn over ownership of the museum building to the city in exchange for the privilege of building in Central Park (the trustees retained ownership and control of the museum collections). This arrangement, later copied by museums in Philadelphia and Chicago, was never repeated in New York.

6. Other organizations involved were the American Water Color Society, the New York Chapter of the American Institute of Architects, the Architectural

League of New York, the New York Water Color Club, the National Sculpture Society, the Society of Beaux-Arts Architects, the Society of Mural Painters, and the Society of Illustrators; see "Academy of Design Plans Home for Art," *The New York Times*, 1 April 1911. Charles De Kay argued that the Academy's proposals were too modest — that it should have lobbied for a large building complex to house exhibitions, not only of the fine arts but also "minor arts, as they are wrongly called"; see "The Problem of Finding a Suitable and Permanent Building for the Exhibitions of the National Academy of Design," *The New York Times*, 1 January 1911.

7. Quoted in "Academic Arteriosclerosis," *The Evening Sun* (New York), 19 March 1910. Ultimately, the Academy did not close shop. Nor did it build a grand new building. Not until the early 1940s would the Academy move from the temporary quarters on 57th Street to new school and exhibition facilities on 5th Avenue. See Eliot C. Clark, *History of the National Academy of Design* (New York: Columbia University Press, 1954), 219-22.

8. Mary Fanton Roberts [Giles Edgerton, pseud.], "What Does the National Academy Stand For?" *The Craftsman* 15 (February 1909), 530.

9. John Sloan, *John Sloan's New York Scene*, ed. Bruce St. John (New York: Harper & Row, 1965), 20 April 1909. Hereafter cited as *Sloan's New York Scene*. Carl Lichtenstein, who had assisted in organizing The Eight tour suggested that Henri and Sloan seek out rich patrons to finance the gallery scheme.

10. At the same time, the integrity of The Eight as an organizing body began to weaken. In December 1909, the painter A. W. Ullman approached Henri and Sloan with the idea of renting Madison Square Gardens for an exhibition of one hundred pictures by selected artists. Participants would be asked to donate five dollars apiece to defray expenses — the weekly rent for Madison Square Gardens was $9,000. When Henri showed no interest in this, Sloan and Ullman continued to talk of going it alone, renting gallery space, scheduling the exhibition, and only then asking others to come into the project as exhibitors or directors. They kept the plan secret and got only as far as finding a name, "The Associated American Artists," and starting a fund; see *Sloan's New York Scene*, 19 December 1909 and 26 January 1910.

11. Ibid., 10 March 1910; see also William I. Homer, *Robert Henri and His Circle* (Ithaca: Cornell University Press, 1969; revised edition, New York: Hacker Art Books, 1988), 151-54.

12. "The Independent Artists," *The Sun* (New York), 2 April 1910. The selection committee included sculptor James Fraser and Kuhn as well as Henri, Sloan, Lawson, Shinn, Davies, and Glackens. George Bellows, Du Bois, Kuhn, Fraser, and Sloan, the hanging committee, installed the exhibition on all three floors of the West 35th Street house.

13. Guy Pène du Bois, "Great Modern Art Display Here April 1," *New York American* (New York), 17 March 1910.

14. [Frank Jewett Mather], "The Independent Artists," *The Evening Post* (New York), 2 April 1910.

15. "Young Artists' Work Shown," *The New York Times*, 2 April 1910.

16. Joseph Edgar Chamberlin, "With the Independent Artists," *The Evening Mail* (New York), 4 April 1910.

17. "The Independent Artists," *The Evening Post* (New York), 2 April 1910.

18. The "Insurgent" movement was directed to Senate reform, specifically the election of senators by vote of the people rather than by appointment, as had been the practice. LaFollette attempted to put this reform on the Republican platform at the National Convention of 1908, but was defeated by a political coalition, "so obviously a machine as to excite the term of derision 'the steam roller.'" Perhaps not coincidentally, Rockwell Kent exhibited a painting entitled *Steamroller* at the Independents. See Robert L. Owen, "The True Meaning of Insurgency," *The Independent* 68 (30 June 1910), 1422. The Insurgents were later successful in engineering the bipartisan passage of a bill to have the Committee on Rules elected by the House rather than appointed by the Senate, thereby greatly lessening the power of the Speaker. For a full discussion of the interconnections between congressional and artistic politics at this time, see Marianne Doezema, *George Bellows and Urban America, 1905-1913* (Ph.D. diss., Boston University, 1989), 204-10.

19. Doezema, 205. Indeed, the *Herald* quoted a policeman, called to control the crowds on opening day: "You seem to be against the art trust and I'm with you." He may have been thinking of the recent Central Park controversy.

20. Robert Henri, "The New York Exhibition of Independent Artists," *The Craftsman* 18 (May 1910), 167.

21. Du Bois.

22. Doezema, 198.

23. Joseph Edgar Chamberlin, "With the Independent Artists." New York audiences would have been familiar with the controversial implications of the *Salome* theme: less than two years before, Richard Strauss' opera was closed on moral grounds after one performance at the Metropolitan.

24. "The revolutionary 'Eight' are in full force," noted Arthur Hoeber; see "Art and Artists," *The Globe and Commercial Advertiser*, 5 April 1910. James Townsend made the same assumption; see "The New Art Movement," *American Art News* 8

(23 April 1910), 4. Ironically George Luks, on whose behalf Henri had confronted the Academy jury in 1907 and who had yet to have a work accepted by the jury, declined to participate in the Independents. He did not want to draw attention away from his first one-man show, scheduled to open the same month at Macbeth's.

25. Sloan was taken aback by Henri's vehement refusal to his suggestion that Kuhn be given more credit. "If [Henri] said nothing there would be little notice taken of the show. And the reporters are bound to come to him on account of his record as Revolutionist. He is perhaps rather over-advertised but that cannot be stopped nor need it be, for his work stands on its merits" (*Sloan's New York Scene*, 16 March 1910).

26. The two men had become increasingly distant after Henri's second marriage in the summer of 1908 and as Sloan developed friendships outside of Henri's circle.

27. *Sloan's New York Scene*, 12 October 1911. In July 1909, Mary Fanton Roberts had introduced him to Irish painter John Butler Yeats, who encouraged Sloan to broaden his interests. After 1911, Sloan stopped painting almost altogether in order to devote his energies to editing and illustration work, but his work in illustration and later his encounter with European modernism at the Armory Show prompted the artist to reassess his aims as a painter. Sloan worked at *The Masses* until 1916, when he resigned in protest over editor Max Eastman's editorial policies. For Sloan's work at *The Masses*, see Rebecca Zurier, *Art for The Masses (1911-1917): A Radical Magazine and its Graphics* (New Haven: Yale University Art Gallery, 1985).

28. John W. Beatty to William Macbeth, 18 March 1910, Macbeth Galleries Papers, Archives of American Art.

29. Draft constitution, Macdowell Club, 1917. Henri Papers, Beinecke Rare Book and Manuscript Library, Yale University.

30. Henri diary, 5 February 1911. Collection of Janet LeClair. Kent finally removed the restrictions but Henri did not relent in his opposition. "An Independent Exhibition" opened in March 1911 and combined works by ex-Henri students Homer Boss, Glenn O. Coleman, Guy Pène du Bois, and Julius Golz, with works by artists from the Stieglitz circle, Marsden Hartley and John Marin, as well as Alfred Maurer, Davies, Prendergast, Luks, and Kent.

31. Henri to Albert Sterner, 18 May 1907. Julian Foss Estate. Copy on file, John Sloan Archives, Delaware Art Museum.

32. "Still Westward," *The New York Times*, 19 November 1911.

33. AAPS Minutes, 14 December 1911. Walt Kuhn Papers, Archives of American Art. See also Milton W. Brown, *The Story of the Armory Show*, rev. ed. (New York: Abbeville Press, 1988), 46ff.

34. Brown, 57.

35. In a letter to *The Times*, sculptor and AAPS member Gutzon Borglum explained that formation of the society had been motivated by "the full realization that the Academy was on the point of taking steps that would make it impossible to have a non-partisan building in New York" (quoted in Brown, 55). The first president of the AAPS was Julian Alden Weir, a founding member of "the Ten" and future president of the National Academy, who accepted the honor on the understanding that the society's only aim was to provide exhibition facilities for work crowded out of the Academy annual. Weir quickly rescinded his acceptance however, when newspaper reports appeared stating that the aim of the AAPS was to showcase the work of artists opposed to the Academy.

36. Clippings of these advance notices as well as exhibiton reviews are preserved in scrapbooks among the Walt Kuhn Papers, Archives of American Art.

37. Alfred Stieglitz, "The First Great 'Clinic to Revitalize Art,'" *New York American*, 26 January 1913.

38. See Monroe, "Critics of All Kinds at 'Freak Art' Exhibition," *The Chicago Daily Tribune*, 20 February 1913; Cox, "The 'Modern' Spirit in Art," *Harper's Weekly* 57 (15 March 1913), 10. Davis quoted in James Johnson Sweeney, *Stuart Davis* (New York: Museum of Modern Art, 1945), 9-10.

39. "Vice Probers Score Cubists," *The Evening Mail* (New York), undated clipping. Kuhn Papers, Archives of American Art. Homer suggests that Henri may even have painted the unusual full-length nude *Figure in Motion* for submission to the Armory Show in response to Marcel Duchamp's controversial *Nude Descending the Staircase*, 257.

40. [Frank Jewett Mather], "International Art," *Evening Post* (New York), 20 February 1913. Alert designers were quick to see new ideas: by March 1913, department stores were heralding the influx of cubist and futurist motifs in the summer season's fashions. "'Cubist' Art Wave Strikes Chicago," *Dry Goods Reporter* 43 (29 March 1913), 15. I am grateful to Joseph Siry for this reference.

41. Quoted by Gustave Kobbe, untitled clipping from *Sunday Herald*, 29 December 1912. Kuhn Papers.

42. See Judith K. Zilczer, "The Armory Show and the American Avant-Garde: A Re-Evaluation," *Arts* 53 (September 1978), 126-30.

43. For the dissolution of the American Association of Painters and Sculptors, see Brown, 223-33.

44. Francis Nauman, "The Big Show: The First Exhibition of the Society of Independent Artists. Part I," *ArtForum* 17 (February 1979), 34-6; see also Clark S. Marlor, *The Society of Independent Artists* (Park Ridge, New Jersey: Noyes Press, 1984); and Homer, 170-72.

45. Naumann, 34.

46. Though Henri would later relent: he sent paintings to the Society from 1919 until his death. Francis Naumann, "The Big Show; The First Exhibition of the Society of Independent Artists. Part II: The Critical Response," *ArtForum* 17 (April 1979), 50.

47. Robert Henri, "The 'Big Exhibition,' the Artist and the Public," *The Touchstone* 1 (June, 1917), 175; for McBride see Naumann, 49-50.

48. Robert Henri, "An Ideal Exhibition Scheme," *Arts and Decoration* 5 (December 1914), 49-52, 76.

49. Robert Henri, "The 'Big Exhibition.' "

50. [Mary Fanton Roberts], "The Biggest Art Exhibition in America and, Incidentally, War," *The Touchstone* 1 (June 1917), 164-210. Over 20,000 people attended the 1917 exhibition during its four-week run; however insufficient income was generated to cover expenses and Society treasurer Walter Pach was forced to solicit individual guarantors to make up the deficit. Naumann, I, 52.

51. By 1915, Guy Pène du Bois split members of The Eight into opposing stylistic camps. Henri, Luks, Lawson, and Glackens he labeled "radicals," independents who painted life and experience. Davies, by comparison, was a "new" reactionary, one among a group of artists who had done away with the representation of life in favor of "art, pure, unblemished, unadulterated by the slightest attention to the proportion of human form." In effect, du Bois made Davies an academic. Du Bois called this reactionary art "subjective or despotic art in its most virulent state." See "Despotism and Anarchy in Art," *Arts and Decoration* 5 (January 1915), 98, 114.

52. Ira Glackens, *William Glackens and the Ashcan Group* (New York: Crown Publishers, 1957), 188. The actual breaking of the piece may be apocryphal, for Glackens gives no specific source for this report, beyond stating that "everyone perhaps knows the story of the 'Fountain.' " According to Beatrice Wood, Rockwell Kent objected to the piece as obscene, while collector Walter Arensberg, a patron of the Society, defended the right of the artist to exhibit anything he chose, as long as his membership fee had been paid. Suppression of *Fountain* prompted Duchamp and Arensberg to resign from the Society in protest. See Beatrice Wood, "I Shock Myself: Excerpts from the Autobiography of Beatrice Wood," *Arts* 51 (May 1977), 135-36. Duchamp later told an interviewer that the urinal was simply hidden behind a partition for the run of the exhibition and that Arensberg later purchased it. Naumann, I, 51-52 and n. 21; see also Marlor, 5.

Artists' Biographies

Arthur Bowen DAVIES, *Sacramental Tree*, 1915. The Art Institute of Chicago, Mr. and Mrs. Martin A. Ryerson Collection.

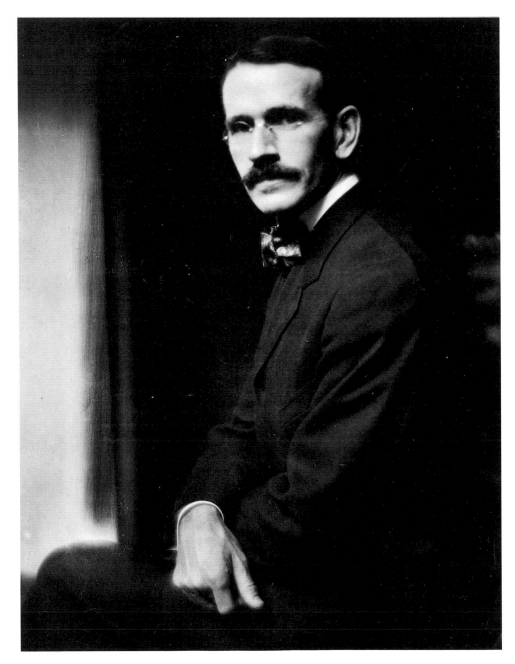

Gertrude Käsebier. Arthur Bowen Davies, 1907. Delaware Art Museum.

Arthur Bowen Davies, 1862-1928

The fourth child of a Methodist minister, Arthur Davies was born in Utica, New York, in 1862. Gifted with an active imagination, he is said to have had a recurrent dream of standing in a room hung with landscapes by George Inness after seeing an exhibition of that artist's work at the Utica Art Association in 1874.

Davies first studied painting in his hometown with Dwight Williams. When the family moved to Chicago in 1879, he enrolled in the Chicago Academy of Design but soon left the city for Colorado to improve his health. In 1880, he settled in Mexico City, where he worked as an engineering draughtsman until 1882. Upon his return to the United States, Davies studied briefly at the Art Institute of Chicago before moving to New York City in 1885 or 1886. There he took classes at the Art Students' League and worked as an illustrator. He was exhibiting paintings and works on paper by the early 1890s.

In 1892 Davies married Virginia Meriwether Davis, a staff physician at the New York Infant Asylum. The two purchased a farm in Congers, New York, where she established a successful general practice. Less satisfied with a rural existence, Davies commuted regularly to Manhattan. He traveled abroad in 1895 spending much of his time scouting pictures for William Macbeth, who had opened a commercial art gallery in 1892. Macbeth gave Davies his first one-man show in 1896, and the artist began to attract a small but devoted circle of patrons and collectors. The following year he again made a trip to Europe as Macbeth's agent.

By 1900 Davies was estranged from his wife, but they did not divorce and he continued to visit their two children in Congers. Unbeknownst to her as well as many close friends, Davies lived secretly in Manhattan with Edna Potter — the model for many of his pictures — as Mr. and Mrs. David Owen until the artist's death in 1928.

Inspired by French and German Symbolism and the work of fellow American Albert Pinkham Ryder, Davies invented fantasy landscapes populated by winsome rhythmic nudes. His work was shown sporadically at the National Academy of Design between 1893 and 1899, and after the turn of the century he exhibited regularly at the Pennsylvania Academy of the Fine Arts and the Art Institute of Chicago, as well as at Macbeth's gallery in New York, and Doll and Richards' in Boston. Although he was among the American painters featured at the important Comparative Exhibition of Native and Foreign Art assembled in 1904 at the Fine Arts Building galleries in New York, his nomination to National Academy membership was rejected in 1907.

Davies acted as adviser to several influential American collectors of modern art, including Lillie Bliss and John Quinn. Following the 1908 exhibition of The Eight, he became more actively involved in promoting progressive art. Elected President of the Association of American Painters and Sculptors in 1912, he spearheaded the organization of the landmark Armory Show in 1913. He subsequently experimented with the cubist idiom but in his late works returned to the lyricism that had first made his reputation. Early in his career Davies had gained some recognition as a printmaker; in 1916 he resumed printmaking and produced many of his most successful late works in etching and aquatint. Frequently abroad, he also explored such media as mural painting, glass, sculpture, and tapestry design, until his sudden death in Florence.

Gertrude Käsebier. William Glackens, 1907. Delaware Art Museum.

William Glackens, 1870-1938

William Glackens was born in Philadelphia in 1870 and attended Central High School during the same years as Albert Barnes and John Sloan. A precocious draughtsman, he was employed as an illustrator for the Philadelphia *Record* by the age of twenty-one. The following year, 1892, he joined fellow illustrators Sloan, Luks, and Shinn at *The Philadelphia Press*. Glackens and Sloan attended night classes at the Pennsylvania Academy of the Fine Arts, where they befriended Robert Henri, with whom Glackens shared a studio.

Glackens first exhibited a painting at the 64th Pennsylvania Academy Annual in 1894. The next year he accompanied Henri to Europe on a summer cycling tour through the Low Countries, visiting museums before returning to Paris. Settling in New York in 1896, he quickly established himself as an accomplished and prolific free-lance illustrator. By 1901, when he won a gold medal for drawing at the Pan-American Exposition, his drawings were appearing regularly in leading American magazines, including *McClure's*, the *Saturday Evening Post*, and *Scribner's*. That year he also sent paintings to the Allan Gallery exhibition in New York organized by Robert Henri. In 1904, the year of his marriage to artist Edith Dimock of Hartford, Connecticut, Glackens participated in the National Arts Club exhibition also organized by Henri; and he was awarded a silver medal for painting at the Louisiana Purchase Exposition in Saint Louis. Although he did not give up illustration altogether until 1914, his paintings, in the major genres of landscape, figure, and still life, sold well and generally attracted critical praise.

Following a 1906 trip to Spain and France, Glackens began to abandon the dark, Manet-like style he shared with Henri. Encouraged by Lawson and Prendergast, and inspired on a 1909 trip to France by the works of Impressionist master Auguste Renoir, he adopted a brighter palette. Summers spent at Bellport, Long Island from 1911 to 1916 resulted in a distinctive series of beach scenes. In 1912 he traveled again to Europe, this time as agent and artistic adviser to his childhood friend, the collector Albert Barnes.

Glackens participated in the Exhibition of Independent Artists in 1910 and was Chairman of the Domestic Selection Committee for the Armory Show. A founding member of the Society of Independent Artists in 1916, he served for a year as its first president. Later in his career, Glackens made frequent trips to Paris and the south of France. A year before his death, he received the Grand Prix for painting at the Paris Exposition of 1937.

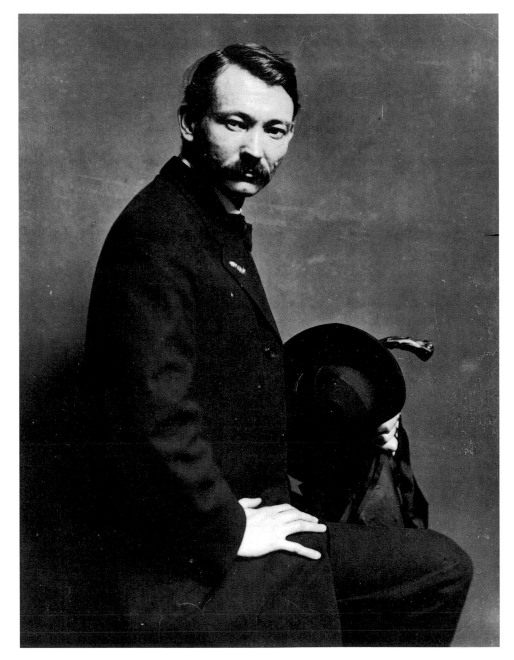

Gertrude Käsebier. Robert Henri, 1907. Delaware Art Museum.

Robert Henri, 1865-1929

Robert Henri was born Robert Henry Cozad on June 24, 1865 in Cincinnati, the son of John Jackson and Theresa Gatewood Cozad. A riverboat gambler who invested his winnings in land speculation, the elder Cozad moved his family to the new town of Cozad, Nebraska, when Robert was nine, and then in 1881 to Denver, where he hoped to exchange his Nebraska holdings for land in Colorado. But Cozad's ambitions were thwarted when, during a return trip to Nebraska, he shot a cowboy in self-defense. Fearful of arbitrary frontier justice, he and his family fled back to the east in disguise. John and Theresa Cozad became Mr. and Mrs. Lee, their older son adopted the artfully misspelled name Frank Southrn, and their second son latinized his name to Robert Henri (pronounced "Hen-rye").

Henri studied at the Pennsylvania Academy from 1886 to 1888, before studying in Paris for two years with William-Adolphe Bouguereau and Tony Robert-Fleury at the independent Académie Julian. Back in Philadelphia from 1891 to 1895, he taught at the Philadelphia School of Design for Women (now Moore College of Art) and became the mentor of several younger artists, including Glackens, Luks, Shinn, and Sloan. He took Glackens with him to Paris on his second trip in 1895. To date, Henri had been painting in a high-keyed impressionist style, but during this second European trip he altered his palette profoundly after discovering the work of seventeenth-century masters Frans Hals and Diego Velasquez, and reacquainting himself with the paintings of Edouard Manet. In Europe for a third time on his honeymoon from 1898 to 1900, Henri successfully submitted paintings to the liberal salons sponsored by the Société Nationale des Beaux-Arts. His painting *La Neige* was purchased by the French government in 1899.

Returning to New York with his first wife Linda in 1900, Henri henceforth made a concerted effort at self-promotion. Having already had a solo exhibition in Philadelphia in 1897, he circulated a second one-man show in New York and Philadelphia in 1902. He organized group exhibitions at the Allan Gallery in 1901 and at the National Arts Club in 1904. Invited by William Merritt Chase to teach at his New York School of Art in 1902, Henri gradually usurped Chase's popularity, prompting the older artist to resign from the faculty in 1907. Henri remained at the school until 1909, when he left to start his own art school.

As a member of the 1907 National Academy jury, Henri's well-publicized protests against the exclusionary decisions of fellow jurors sparked the planning of the independent exhibition of The Eight the next year. Henri was also an organizer and spokesman for the Exhibition of Independent Artists in 1910. But by this date his leadership was threatened by competition from such men as Alfred Stieglitz and Henri's own former associate Arthur Davies, who masterminded the 1913 Armory Show. Henri had no interest in the new language of abstraction or the European avant-garde, although after 1913 he did admit a wider range of colors to his palette: a change prompted by Hardesty Maratta's system of determining color harmonies analogous to musical scales and chords. Henri was also a student of Jay Hambidge's theory of dynamic proportion, which posited compositional formulae based on geometric ratios derived from Greek and Egyptian art. But he never relinquished his commitment to narrative representation.

During the 1910s, Henri found inspiration in the wilderness landscape and began to divide his time between Santa Fe, New Mexico, and "Corrymore," the house he and his second wife, Marjorie, owned on Achill Island off the west coast of Ireland. There Henri would spend half his days in the studio and half out in the open. His most important contributions in these later years were as a teacher. In 1923, his student Margery Ryerson published *The Art Spirit*, a compendium of quotations from Henri's lectures and essays. The book proved extremely popular and remains a favorite source for artists to this day. Henri died in New York in 1929.

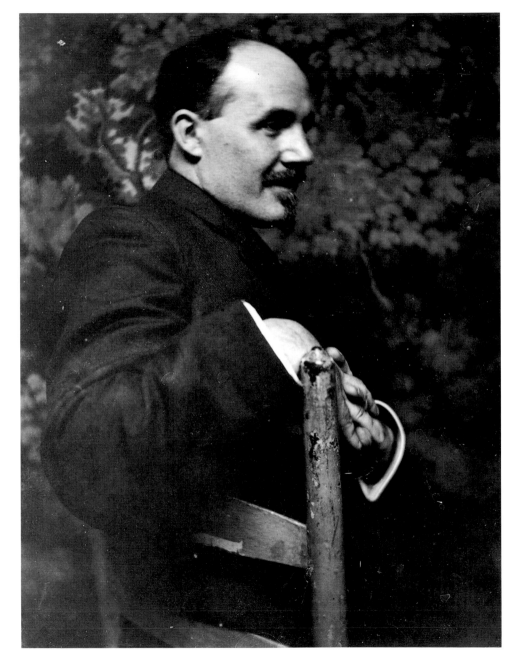

Gertrude Käsebier. Ernest Lawson, 1907. Delaware Art Museum.

Ernest Lawson, 1873-1939

Ernest Lawson was born in Halifax, Nova Scotia, in 1873. After a peripatetic youth, which included sojourns in Kansas City and Mexico, he arrived in New York and enrolled at the Art Students' League in 1891. There he studied with Julian Alden Weir and John H. Twachtman, whom he followed to Cos Cob, Connecticut, where they founded a school of landscape painting in 1892. Twachtman's gestural impressionism influenced Lawson greatly, and the two men worked closely until Twachtman's death in 1902.

In 1893, Lawson left for France, where he studied at the Académie Julian. Of greater consequence was his chance meeting at Moret-sur-Loing with Alfred Sisley, who confirmed Lawson's allegiance to the impressionist aesthetic. Returning from Europe in 1894, Lawson worked in various cities in the United States and Canada before settling in Washington Heights, on the outskirts of Manhattan. For the next fifteen years, he devoted himself to painting the fast-changing landscape of the Harlem and Hudson rivers.

Exhibiting frequently and widely throughout his career, Lawson moved easily between the liberal and conservative elements in the American artistic community. Identified as a member of Henri's "progressive" circle even before the 1904 National Arts Club exhibition, he alone of The Eight continued to exhibit his pictures at the National Academy until the end of his career. He also sent paintings to the Armory Show and in 1914 showed some three dozen works at the Galerie Levesque in Paris. The next year, Lawson was awarded a gold medal for painting at the Panama-Pacific Exposition in San Francisco. During the late teens, he painted in Spain and eventually taught in Kansas City and Colorado Springs. Financial reverses during the Depression, coupled with chronic alcoholism, caused a marked deterioration in Lawson's late work. He was found drowned on a Florida beach in 1939, a probable suicide.

Gertrude Käsebier. George Luks, 1907. Delaware Art Museum.

George Luks, 1866-1933

George Luks was born in Williamsport, Pennsylvania, in 1866, the son of German immigrants. A leading citizen of the town, Luks' father worked as a public health doctor and apothecary ministering to the local mill workers, coal miners, and their families. Luks enrolled briefly at the Pennsylvania Academy of the Fine Arts in 1884, but spent much of the rest of the decade touring with his brother as a vaudeville comedy team. During the 1890s, he made several trips to Europe, studying for a short time at the Dusseldorf Academy and making the requisite stops in Paris, London, and Spain. Returning to Philadelphia in 1894, he joined the staff of the *The Philadelphia Press* and soon struck up an acquaintance with fellow illustrators Glackens, Sloan, and Shinn, and their mentor Henri. By 1896, Luks had moved to New York, where he made his name as the illustrator of the popular comic strip "Hogan's Alley," for Joseph Pulitzer's New York *World*.

A small man who compensated for his lack of stature with a feisty attitude and a vaudevillian's sense of bohemian dress, Luks refined his picturesque image on a longer stay in Paris in 1902-3. Upon his return to New York, he became a popular, if notorious member of Greenwich Village bohemia. Abandoning illustration for painting, he exhibited at the Society of American Artists in 1903 and by 1906 was widely known for his richly painted renderings of the urban landscape and its picturesque denizens. The jury's rejection of a portrait by Luks in 1907 prompted Henri's protest against the National Academy and set the stage for The Eight exhibition.

After 1908, critical attitudes to Luks' imagery softened when the support of a series of New York dealers allowed him to pursue an independent course. Many contemporaries considered Luks a modern master: his facility with the brush and devotion to the portrayal of what were then considered suitably picturesque American character "types" were welcome alternatives to the deepening mysteries of modern art and abstraction. After 1915, he turned his attention to landscape as well as portraiture, working in watercolor and oils. In the 1920s, Luks produced a notable series of views of the mining communities of his native Pennsylvania. After teaching for a short time at the Arts Students' League, he started his own school, which John Sloan took over after Luks' death.

Luks' capacity for alcohol, which doubtless accounted for his flamboyant if uneven technical facility as well as his aggressive personality, was legendary; but it steadily took its toll on his work. Though he won a Corcoran Gold Medal in 1932, he was long past his prime as a painter. In 1933 he was found dead in a doorway on Sixth Avenue, apparently of injuries suffered in a speakeasy fight.

Gertrude Käsebier. Maurice Prendergast, 1907. Delaware Art Museum.

Maurice Prendergast, 1858-1924

The oldest member of The Eight, Maurice Prendergast was born in 1858 in Saint John's, Newfoundland, where his father ran a trading post. Ten years later the family moved to Boston; as a youth, Prendergast worked in a dry-goods store and later for a commercial art firm. He made at least one trip to Europe during the mid-1880s, but it was not until 1891 that he visited Paris expressly for professional training. While studying at Colarossi's atelier and the Académie Julian, Prendergast was befriended by a number of foreign students, notably the Canadian James Wilson Morrice, who introduced his American companion to the work of the Parisian avant-garde. Back in Boston between 1894 and 1898, Prendergast produced a substantial number of watercolors and monotypes, most often depicting city parks and boulevards, and holiday crowds along New England's beaches. By 1897, he was exhibiting these works in Boston and at the Watercolor Society in New York. The following year he left for an eighteen-month stay in France and Italy, where a visit to Venice resulted in some of his most memorable watercolors.

By the turn of the century, Prendergast was steadily expanding the schedule of exhibitions to which he sent watercolors and soon thereafter his first works in oil. He exhibited jointly with Hermann Dudley Murphy at the Art Institute of Chicago in 1900; a year later, Prendergast won a bronze medal for his watercolor *Stony Beach, Ogunquit* at the Pan-American Exposition in Buffalo. His first public contact with future members of The Eight came in 1904, when Henri invited Prendergast to contribute to the six-man National Arts Club exhibition.

Prendergast's bright palette and the decorative surfaces of his populous landscapes raised critical eyebrows in the United States. Intensely self-directed, the artist paid no heed: regular trips to Europe provided him with the necessary creative challenges. Like Henri, Prendergast was abroad during most of the planning stages of The Eight exhibition, reporting his excitement to a friend in Boston at seeing the work of the Fauves and an important Cézanne retrospective. His study of modernist trends in French art confirmed the direction in which his own work had been moving, and during the next decade he refined his idiosyncratic vision steadily closer to abstraction.

A semi-recluse who lived with his brother Charles in Boston until 1914, when they relocated to New York, Maurice Prendergast was nonetheless an active if indirect participant in the American arts community. Indeed, the diffidence he displayed in social situations was due in large part to severe deafness. A charter member of the Association of American Painters and Sculptors, he was the only member to sit on both the European and American Selection Committees for the Armory Show. Prendergast sent seven paintings to the latter exhibition; in 1914, he was included in the important exhibition of American "ultra-moderns" circulated by Montross Galleries; and six years later, he was among the first Americans to exhibit at the Venice Biennale. In 1923, the Corcoran Gallery of Art in Washington awarded Prendergast both its William A. Clark Prize and Bronze Medal. He died on February 1, 1924.

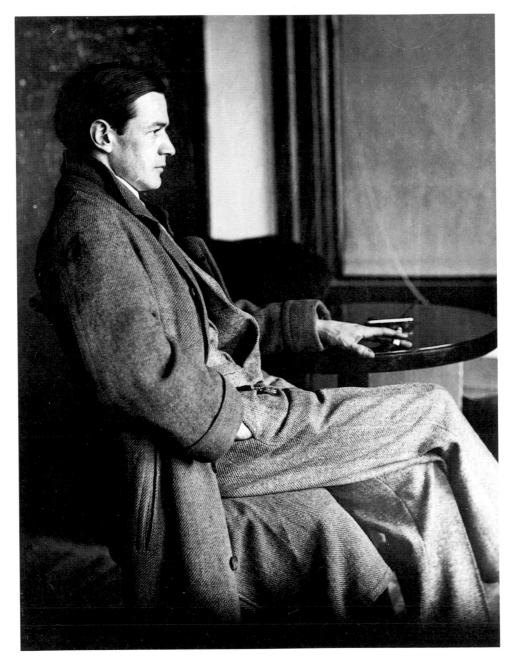

Gertrude Käsebier. Everett Shinn, 1907. Delaware Art Museum.

Everett Shinn, 1876-1953

Everett Shinn was born in 1876 in Woodstown, New Jersey, the youngest of eight children. He initially planned to pursue an engineering career and after two years at the Spring Garden Institute, worked for a gas fixtures company in Philadelphia from 1890 to 1893. Changing direction that year, he enrolled at the Pennsylvania Academy and later found a job with *The Philadelphia Press* as an illustrator. Blessed with a talent for rendering with speed and efficiency, Shinn excelled in his newfound career. He moved to New York in 1897 and became best known as an illustrator for *Harper's Weekly*, drawing the first full-color pictures for its center page. During the course of his free-lance career, he would illustrate twenty-eight books and over ninety magazine stories.

Thanks to his friendship with noted architect Stanford White, Shinn was given his first one-man exhibition of drawings at the Boussod-Valadon Galleries in 1899. He spent the next year in Paris, sampling its entertainments in the company of George Luks. At the time Shinn worked primarily in pastel, rapidly sketching the cul-de-sacs and alleyways of the inner city and recording the incidents and momentary confrontations that occurred there. He typically drew material for his magazine illustrations from these drawings.

Shinn was an inveterate theater-goer and amateur thespian. In 1907, he was commissioned to paint eighteen decorative panels for New York producer David Belasco's Stuyvesant Theater, and he later had a working stage installed in his studio at Waverley Place. By 1908, Shinn's paintings were almost exclusively of theater subjects, and many of his compositions derived from the café-concert paintings of French Impressionist Edgar Degas. Shinn's association with The Eight was strictly temporary. By 1913, he had stopped exhibiting his pictures with any regularity and had no interest in contributing to the Armory Show. From 1917 to 1923, he worked as a set designer and art director in Hollywood. Eventually moving back to New York, he continued to paint and illustrate scenes of the theater until his death in 1953.

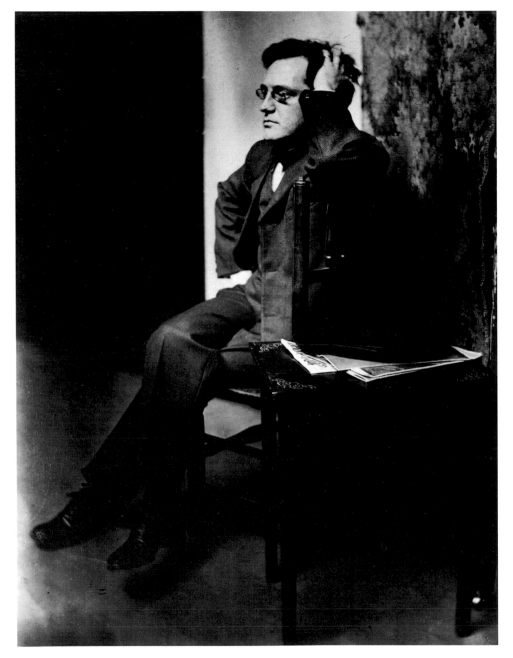

Gertrude Käsebier. John Sloan, 1907. Delaware Art Museum.

John Sloan, 1871-1951

John Sloan was born in 1871 in the lumber town of Lock Haven, Pennsylvania. The family moved to Philadelphia when he was five and he later attended Central High School with William Glackens, although the two were not then acquaintances. While working at Porter and Coates' bookstore, Sloan taught himself etching and began to make money from the sale of sketches and card designs. By 1891, he was working as a commercial illustrator and in 1892 had a full-time job as staff artist with the Philadelphia *Inquirer*.

Sloan had no facility for quick reportorial work, but newspaper editors liked his poster-style drawings and witty pictographs for the feature pages and Sunday supplements. It was while attending class at the Pennsylvania Academy in 1892 that Sloan met Robert Henri who, during informal sketching sessions at the student-run Charcoal Club, encouraged him and fellow illustrators Glackens, Shinn, and Luks to start painting. But while the latter three pursued their training abroad, Sloan stubbornly remained at home, having moved from his job at the *Inquirer* to *The Philadelphia Press*. The last to leave Philadelphia for New York, he continued on staff at *The Philadelphia Press* until 1903, by which time demand for original illustrative work had been all but supplanted by photography.

Sloan began to exhibit his paintings in 1900 and by 1908, was devoting most of his time to painting and teaching. Though critics did not as a rule praise his lively renderings of Lower Manhattan and its residents, he was recognized as a talented narrative painter. After the 1908 exhibition, he joined Henri as a leader of the "independent" movement, but by 1910, when he helped to organize the Exhibition of Independent Artists, Sloan had begun to move out of Henri's orbit and influence.

In 1912, Sloan joined the Socialist magazine *The Masses* as an art director, contributing many of his finest illustrations before resigning from the editorial staff as well as the Socialist Party in 1916. By 1914, having exhibited two paintings and five etchings at the Armory Show, he had resumed painting full-time and joined the faculty of the Art Students' League. Two years later he had a solo exhibition at Gertrude Whitney's Studio Club and began a long association with Kraushaar Galleries. And in 1918, he succeeded Glackens as president of the Society of Independent Artists.

During the mid-teens, Sloan abandoned the dark palette of his urban scenes for brighter hues and a broader tonal range. Studies of the female nude became a particular interest, as did landscape — summering in Gloucester, Massachusetts from 1914 to 1919, he devoted his time to painting *en plein air*. In 1919, Sloan and his wife Dolly visited Santa Fe, which soon became their second home. As were so many of his generation, Sloan was fascinated by the rituals of the Southwest Indians and the dramatic luminescence of the desert landscape.

By the early 1930s, many observers regarded Sloan as the dean of American painters. On the model of Henri's *Art Spirit,* he published his philosophy of art in *The Gist of Art* (1939), a compilation of comments and aphorisms derived from his lectures at the Art Students' League. He was assisted in this endeavor by Helen Farr, a former student whom he married in 1944 after the death of his first wife. In 1950, Sloan was awarded a gold medal by the American Academy of Arts and Letters. He died the following year in Hanover, New Hampshire.

Everett SHINN, *The Laundress*, 1903. Collection of James and Barbara Palmer, courtesy Babcock Gallery.

Exhibition Checklist

"We are of our time, and we as artists have as important things to say as statesmen, scientists, [and] inventors."

Robert Henri, 1910

The Eight came to prominence during a period of intense change in the presentation and marketing of paintings in the United States — change that would impact most profoundly on the interaction of artists with the American public. As this representative selection of exhibition pictures documents, each member of The Eight had established a secure exhibiting record in New York and nationwide well before the 1908 exhibition. And each approached the public exhibition circuit differently: Arthur Davies, Robert Henri, Ernest Lawson, Maurice Prendergast, and John Sloan sent paintings to the full range of museum, club, and commercial gallery shows; George Luks' works were first seen most often at club shows in New York; Everett Shinn worked almost exclusively through commercial dealers such as Boussod-Valadon and Knoedler, while William Glackens initially eschewed commercial galleries, preferring to send his exhibition pictures to the various museum annuals.

The effectiveness of The Eight derived in large part from their distinctly individual approaches to a shared set of thematic concerns. In very few of their exhibition paintings did these artists treat the seamier side of urban life. If their dark palettes conveyed a somber mood, their selection of picturesque views and incidents reflected the confident optimism of a new century.

Exhibitions held in the same year are listed chronologically when exact dates are known. All measurements are in inches. Due to their fragility, works on paper are shown at two venues only.

121

1

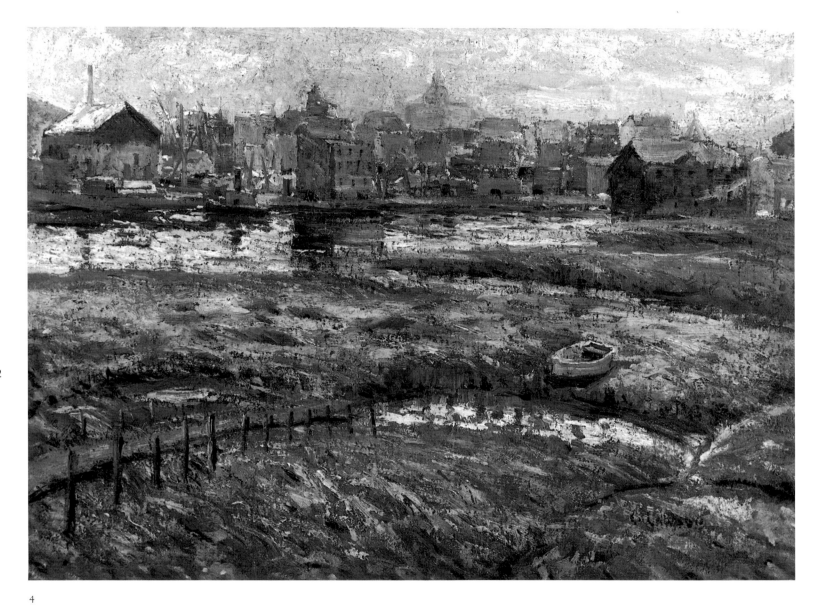

4

The Century Begins

Arthur Bowen DAVIES

1 *Arethusa*, before 1896
Oil on canvas, 27 x 22
The Butler Institute of American Art, Youngstown, Ohio

Exhibitions: Pennsylvania Academy of the Fine Arts, Sixty-Sixth Annual Exhibition, 1896; Macbeth Galleries, *Exhibition of Paintings by Arthur B. Davies*, 1897, no. 26; Art Institute of Chicago, *Special Exhibition of Paintings by Arthur B. Davies*, 1911, no. 15

William GLACKENS

2 *Figures in a Park*, 1895
Oil on canvas, 25 x 32
Kraushaar Galleries, New York

Robert HENRI

3 *14th of July*, 1899
Oil on canvas, 32 x 25 ¾
Sheldon Memorial Art Gallery Association, University of Nebraska, Lincoln, Nebraska. Nellie Cochrane Woods Collection

Exhibitions: Pennsylvania Academy of the Fine Arts, *Fellowship Exhibition* [Works by Robert Henri], 1902, no. 19; Pratt Art Institute, [One-man exhibition], 1902-3; Ardsley Studios, 1917; Macdowell Club, 1918; Knoedler's, 1918

Ernest LAWSON

4 *Low Tide*, ca. 1898
Oil on canvas, 20 x 28
William Benton Museum of Art, University of Connecticut, Storrs, Connecticut

Exhibitions: ?Carnegie Institute, Third Annual Exhibition, 1898, no. 197

3

6

125

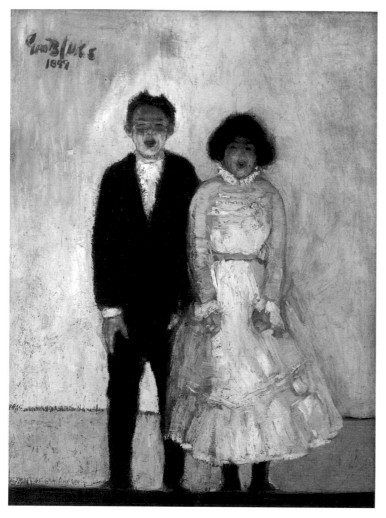

5

George LUKS

5 *The Amateurs*, 1899
Also called *The Vaudeville Singers*
Oil on canvas, 24 x 18
Private Collection

Exhibitions: Pennsylvania Academy of the Fine Arts, *Fellowship Exhibition*, 1901; *Exhibition of Paintings* [The Eight], 1908-9 tour, no. 29 (not shown in New York or Philadelphia), no. 31 (Newark); Macbeth Galleries, *An Exhibition of Paintings by George B. Luks*, 1910, no. 19

Maurice Brazil PRENDERGAST

6 *Siena*, ca. 1898-99
Watercolor and pencil, 12 ¼ x 20 ⅛
Collection of Rita and Daniel Fraad

Shown at Ottawa and Brooklyn

7 *Grand Canal, Venice*, 1898-99
Watercolor, 17 ⅝ x 14
Daniel J. Terra Collection. Terra Museum of American Art, Chicago, Illinois

Exhibitions: Boston Art Students' Association, First Annual New Gallery Exhibition of Contemporary American Art, 1900, no. 181; Macbeth Galleries, *Exhibition of Watercolors and Monotypes in Color by Maurice B. Prendergast*, 1900, no. 9

Shown at Milwaukee and Denver

Everett SHINN

8 *Spoiling for a Fight, New York Docks*, 1899
Pastel and watercolor, 22 x 29 ½
Milwaukee Art Museum, gift of Mr. and Mrs. Donald B. Abert and
Mrs. Barbara Abert Tooman, 1977

Exhibitions: ?Pennsylvania Academy of the Fine Arts, Sixty-Eighth
Annual Exhibition, 1899, possibly as *The Docks*; Saint Louis Exposi-
tion and Music Hall Association, Sixteenth Annual, 1899; Pennsyl-
vania Academy of the Fine Arts, *Exhibition of Pastels by Everett Shinn*,
1900, no. 11; Boussod-Valadon and Co., [One-man exhibition], 1900,
no. 11; ?Pennsylvania Academy of the Fine Arts, Sixty-Ninth Annual
Exhibition, 1900; ?Macdowell Club, 1909

Shown at Milwaukee and Denver

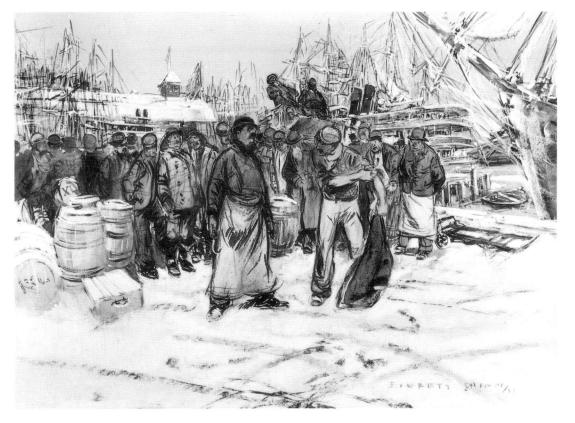

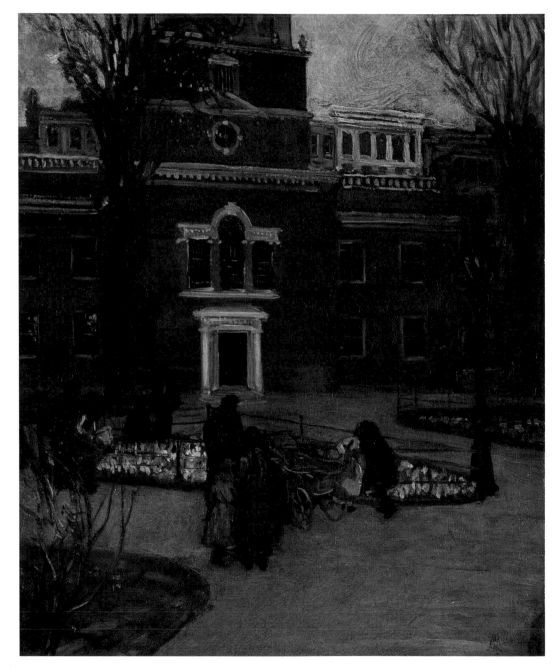

Everett SHINN

9 *Cafe Martin, formerly Delmonico's*, ca. 1908
Pastel, 17 ½ x 23 ½
Mint Museum of Art Collection, Charlotte, North Carolina. The
Harry and Mary Dalton Collection

Shown at Ottawa and Brooklyn

John SLOAN

10 *Independence Square, Philadelphia*, 1900
Oil on canvas, 27 x 22
Collection of Mr. and Mrs. Alan D. Levy, Los Angeles

Exhibitions: Carnegie Institute, Fifth Annual Exhibition, 1900, no.
227; Pennsylvania Academy of the Fine Arts, Seventieth Annual Ex-
hibition, 1901; Society of American Artists, Twenty-Third Annual
Exhibition, 1901, no. 162; Copley Society, Second Annual Exhibition,
1902, no. 152; Art Institute of Chicago, Sixteenth Annual Exhibition,
1903, no. 343; National Arts Club, *Loan Exhibition*, 1904; Louisiana
Purchase Exposition, 1904, Lewis and Clark Centennial Exposition,
1905; Pisinger's Modern Gallery, New York, 1906; Texas State Fair,
1906

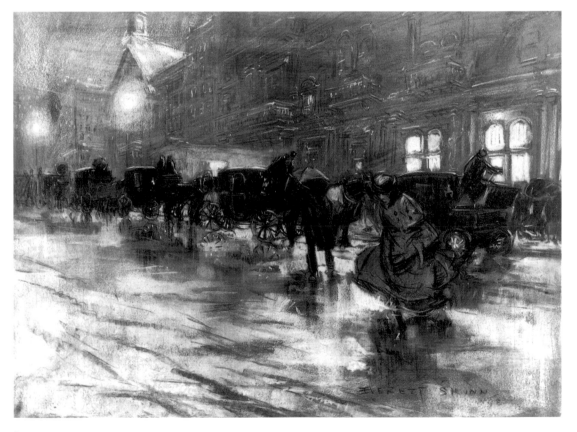

9

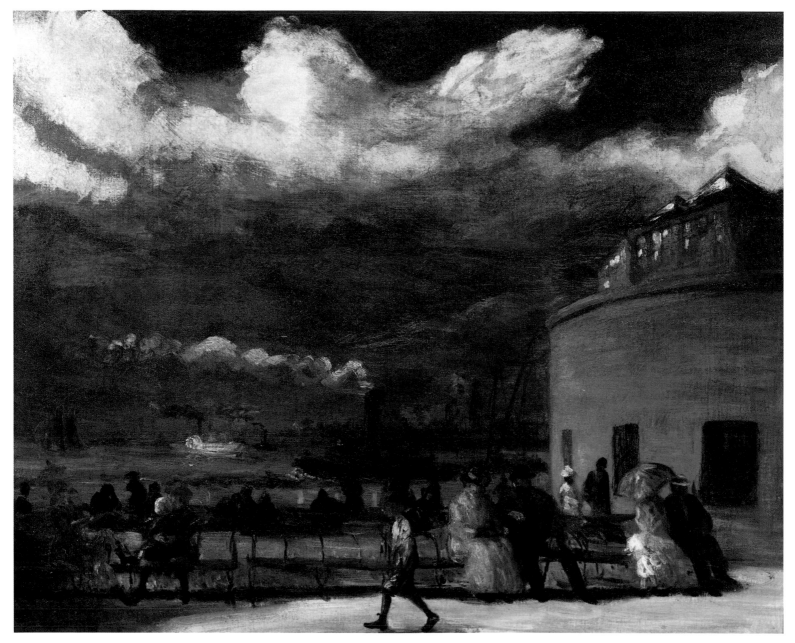

11

City Streets

William GLACKENS

11 *The Battery*, 1902-4
 Also called *Battery Park*
 Oil on canvas, 26 x 32
 Collection of Mr. and Mrs. Alan D. Levy, Los Angeles

 Exhibitions: ?Pennsylvania Academy of the Fine Arts, One Hundred
 and First Annual Exhibition, 1906, no. 782; illustrated in 1908 Mac-
 beth Galleries exhibition catalogue, but not in exhibition

Robert HENRI

12 *Street Corner*, 1899
 Also called *Down the Rue de Sèvres*
 Oil on canvas, 32 ⅛ x 26
 Milwaukee Art Museum, gift of Mr. and Mrs. Donald B. Abert

Ernest LAWSON

13 *Excavation — Pennsylvania Station*, ca. 1906
 Oil on canvas, 18 ⅛ x 24 ¼
 University Art Museum, University of Minnesota. Bequest of Hud-
 son Walker from the Ione and Hudson Walker Collection

 Exhibitions: Pennsylvania Academy of the Fine Arts, *An Exhibition of
 Paintings by Ernest Lawson*, 1907, no. 7

14 *Stuyvesant Square in Winter*, ca. 1907
 Also called *Evening New York City*
 Oil on canvas, 25 ⅛ x 30 ⅛
 Museum Purchase, 1907. In the Collection of the Telfair Academy
 of Arts and Sciences, Savannah, Georgia

 Exhibitions: New York School of Art, *An Exhibition of Paintings by
 Ernest Lawson*, 1907; Pennsylvania Academy of the Fine Arts, *An
 Exhibition of Paintings by Ernest Lawson*, 1907, no. 16 (as *Stuyvesant
 Square, Snow*)

George LUKS

15 *Hester Street*, 1905
 Oil on canvas, 26 x 35 ³⁄₁₆
 The Brooklyn Museum, Dick S. Ramsay Fund, 40.339

 Exhibitions: *Exhibition of Paintings* [The Eight], 1908, no. 37 (Mac-
 beth), no. 42 (Philadelphia) (as Street Scene)

Everett SHINN

16 *Paris Street #2*, 1902
 Oil on canvas, 10 x 12
 New Britain Museum of American Art, Harriet Russell Stanley Fund

 Exhibitions: ?Boussod-Valadon and Co., *Pastels of Paris Types by
 Everett Shinn*, 1901, no. 2 (as *Rue de Paris*) or no. 40 (as *Paris Street*);
 ?Pennsylvania Academy of the Fine Arts, *Fellowship Sketch Exhibition*,
 1901.

17 *Rue de l'Ecole de Medicine*, 1903
 Pastel, 18 x 28 ¼
 Sheldon Memorial Art Gallery Association, University of Nebraska,
 Lincoln, Nebraska

 Shown at Milwaukee and Denver

18 *The Laundress*, 1903
 Pastel, 26 x 21 ⅛
 Collection of James and Barbara Palmer, courtesy Babcock Gallery

 Exhibitions: ?Boussod-Valadon and Co., *Pastels of Paris Types by
 Everett Shinn*, 1901, no. 7 (as *La Blanchisseuse*)

 Shown at Ottawa and Brooklyn

131

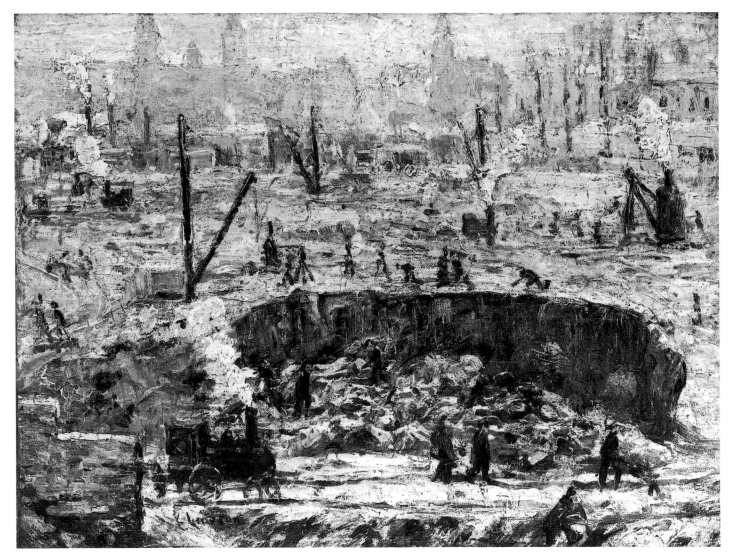

13

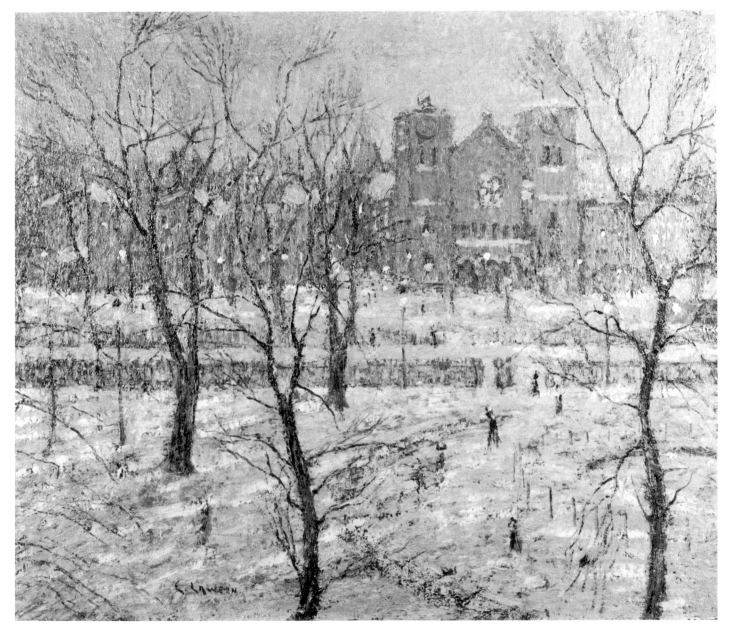

133

14

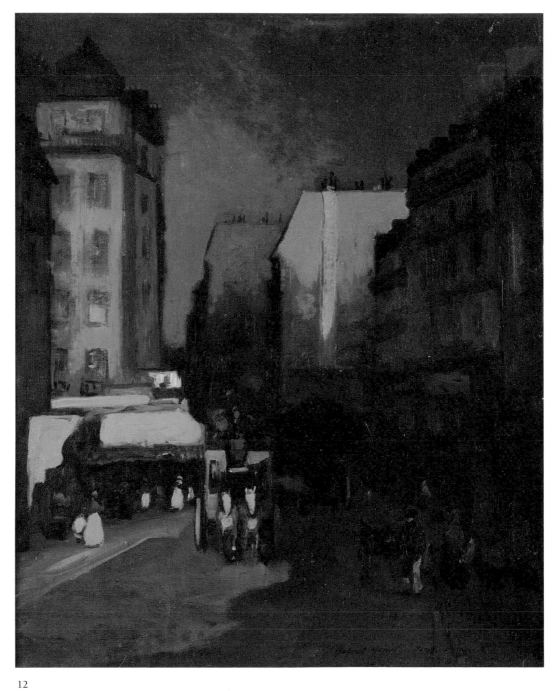

12

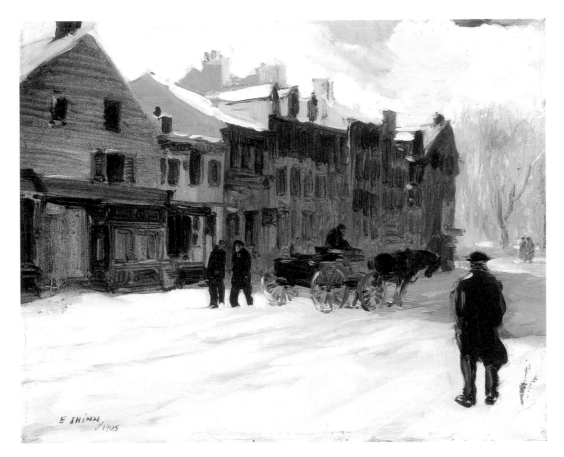

19

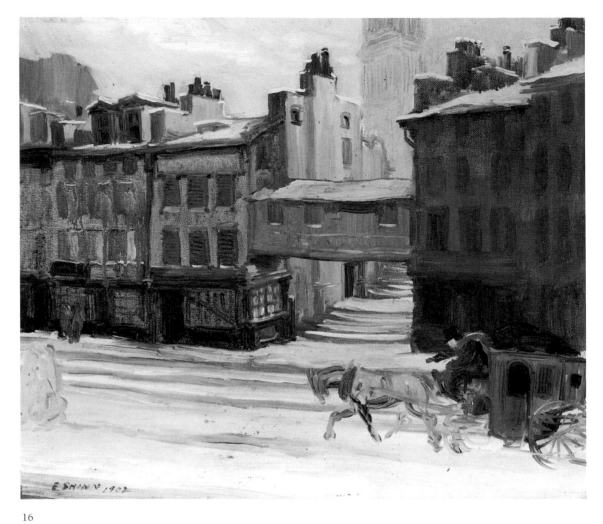

16

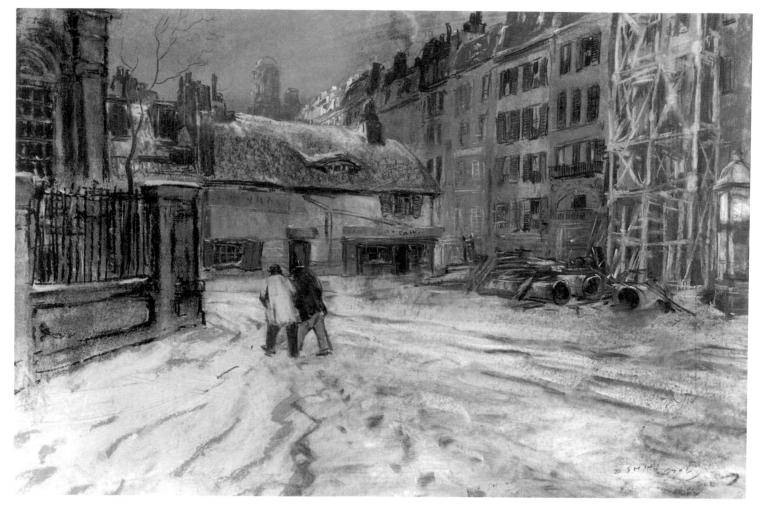

137

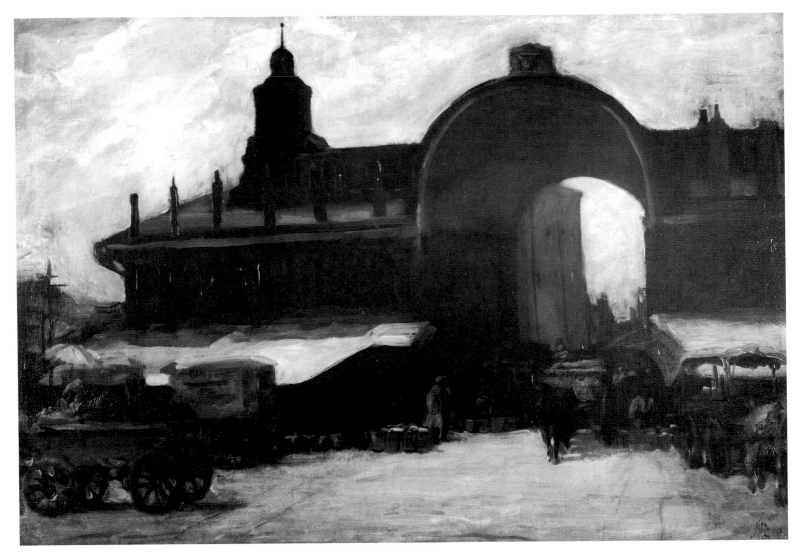

20

Everett SHINN

19 *Sullivan Street*, 1905
 Oil on canvas, 8 x 10
 Memorial Art Gallery, University of Rochester, Marion Stratton
 Gould Fund

John SLOAN

20 *Dock Street Market*, 1903
 Oil on canvas, 24 ¼ x 36 ¼
 Montgomery Museum of Fine Arts Association Purchase

 Exhibitions: Pennsylvania Academy of the Fine Arts, Seventy-Third
 Annual Exhibition, 1904, no. 81 (as *Dock Street*); Carnegie Institute,
 Ninth Annual Exhibition, 1904, no. 256; Art Institute of Chicago,
 Eighteenth Annual Exhibition, 1905, no. 314

21 *Easter Eve*, 1907
 Oil on canvas, 32 x 26
 Collection of Edward and Deborah Shein

 Exhibitions: *Exhibition of Paintings* [The Eight], 1908-9 tour, no. 13
 (Macbeth), no. 51 (Philadelphia), no. 62 (Newark), no. 63 (Chicago
 and remaining venues)

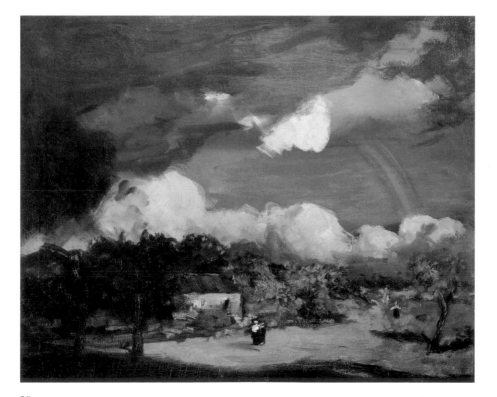

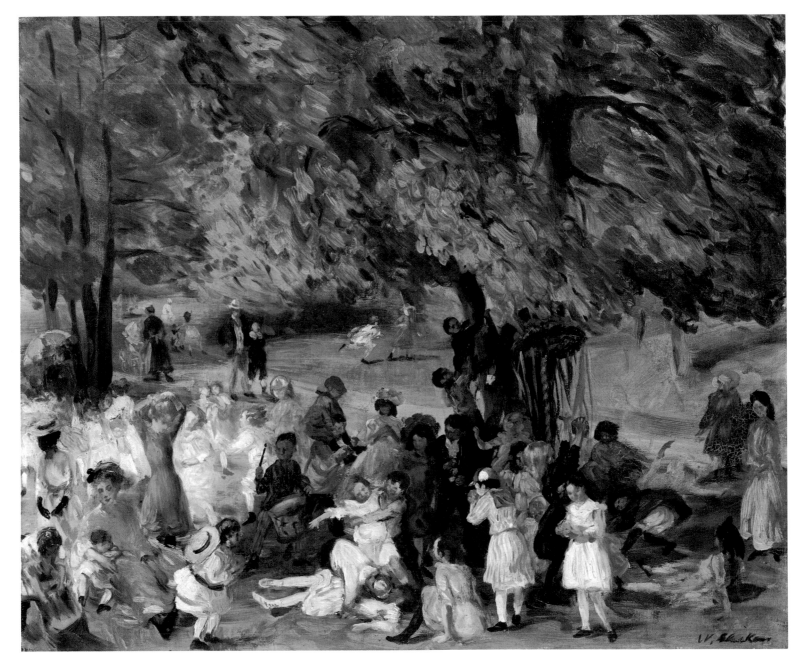

Parks and Promenades

William GLACKENS

22 *May Day, Central Park*, ca. 1905
Oil on canvas, 25 ⅛ x 30 ¼
The Fine Arts Museums of San Francisco, gift of the Charles Merrill
Trust with matching funds from the de Young Museum Society

Exhibitions: Pennsylvania Academy of the Fine Arts, One-Hundredth
Anniversary Exhibition, 1905, no. 335; Society of American Artists,
Twenty-Seventh Annual Exhibition, 1905, no. 346; Buffalo Fine Arts
Academy, Albright Art Gallery, First Annual Exhibition, 1906, no. 50;
Carnegie Institute, Eleventh Annual Exhibition, 1907, no. 182; *Exhibition of Paintings* [The Eight], 1908-9 tour (not shown in New York),
no. 55 (no. 10 at Newark)

23 *Central Park, Winter*, ca. 1906
Oil on canvas, 25 x 30
The Metropolitan Museum of Art, George A. Hearn Fund, 1921

Exhibitions: Pennsylvania Academy of the Fine Arts, One Hundred
and First Annual Exhibition, 1906, no. 774; Society of American
Artists, Twenty-Eighth Annual Exhibition, 1906, no. 420

Shown at Milwaukee, Denver, and Brooklyn

Robert HENRI

24 *Picnic at Meshoppen, Pennsylvania, 4 July 1902*, 1902
Oil on canvas, 26 x 32
Westmoreland Museum of Art, Greensburg, Pennsylvania. William
A. Coulter Fund

Exhibitions: Pennsylvania Academy of the Fine Arts, *Fellowship Exhibition* [Works by Robert Henri], 1902, no. 30; Pratt Art Institute,
[One-man exhibition], 1902-3

25 *Wyoming Valley, Pennsylvania*, 1903
Oil on canvas, 26 x 32
Milwaukee Art Museum, gift of Mr. and Mrs. Donald B. Abert in
Memory of Mr. Harry J. Grant

Maurice Brazil PRENDERGAST

26 *Central Park*, ca. 1900-3
Watercolor, 15 ⅛ x 19 ½
Blanden Memorial Art Museum, Fort Dodge, Iowa

Shown at Ottawa and Brooklyn

27 *Picnic, May Day, Central Park*, ca. 1901
Also called *The Picnic*
Watercolor, 15 ¾ x 22 ⅛
The Carnegie Museum of Art, Pittsburgh, gift of Mr. and Mrs. James
H. Beal

Shown at Milwaukee and Denver

28 *Salem Willows*, 1901-4
Oil on canvas, 26 x 34
Daniel J. Terra Collection. Terra Museum of American Art, Chicago,
Illinois

Exhibitions: ?Carnegie Institute, Sixth Annual Exhibition, 1901, no.
183; ?Society of American Artists, Twenty-Third Annual Exhibition,
1901, no. 339; ?Worcester Art Museum, Third Annual Exhibition,
1901, no. 169; ?Cincinnati Museum Association, Ninth Annual Exhibition, 1902, no. 222; ?Pennsylvania Academy of the Fine Arts,
Seventy-First Annual Exhibition, 1902, no. 4; illustrated in 1908
Macbeth Galleries exhibition catalogue, but not in exhibition; Copley
Gallery, Boston, *Exhibition of Paintings by Charles Hopkinson, Charles
Hovey Pepper, Maurice Prendergast*, 1911, no. 12

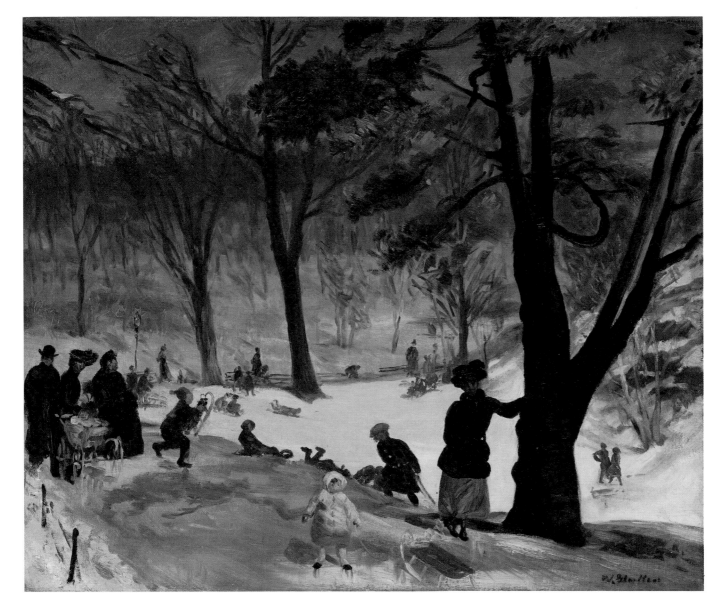

23

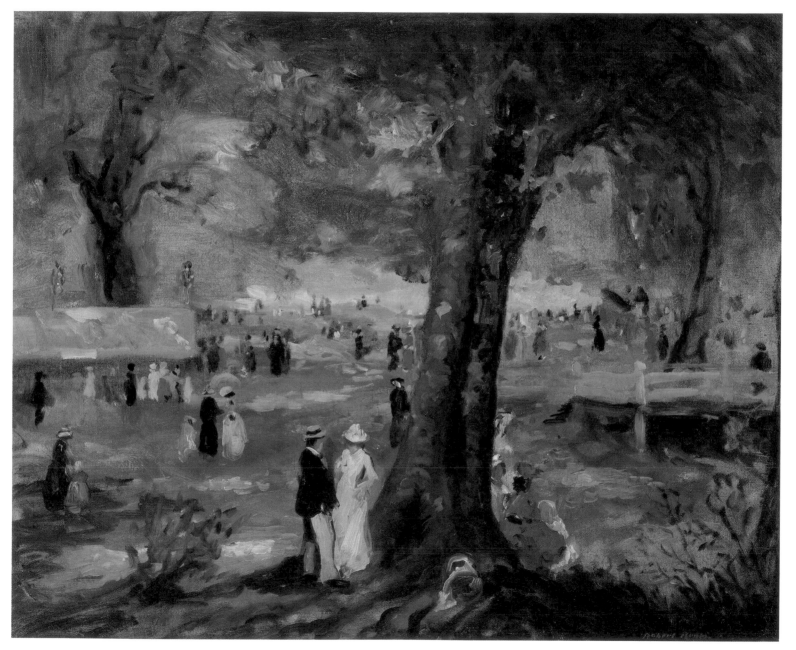

24

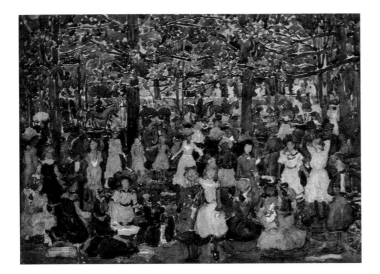

26

144

27

Maurice Brazil PRENDERGAST

29 *By the Seashore*, 1902-4
Oil on panel, 11 ¾ x 16
Mitchell Museum, John R. and Eleanor R. Mitchell Foundation,
Mount Vernon, Illinois

Exhibitions: ?National Arts Club, *Loan Exhibition*, 1904

30 *Saint Malo #1*, ca. 1907
Watercolor and pencil, 13 ½ x 19 ¼
Columbus Museum of Art, gift of Ferdinand Howald, 1931

Shown at Milwaukee and Denver

31 *Beach at Saint Malo*, 1907
Watercolor with oil, crayon, and pastel, 13 ½ x 19 ⅝
Hirshhorn Museum and Sculpture Garden, Smithsonian Institution,
gift of the Joseph H. Hirshhorn Foundation, 1966

Shown at Ottawa and Brooklyn

John SLOAN

32 *Nursemaids, Madison Square*, 1907
Oil on canvas, 24 x 32
Sheldon Memorial Art Gallery Association. University of Nebraska,
Lincoln, Nebraska. F. M. Hall Collection

Exhibitions: rejected for Carnegie Institute Eleventh Annual, 1907;
Exhibition of Paintings [The Eight], 1908-9 tour, no. 18 (Macbeth), no.
46 (Philadelphia), no. 61 (Newark), no. 62 (Chicago and remaining
venues); City Club, New York, 1911

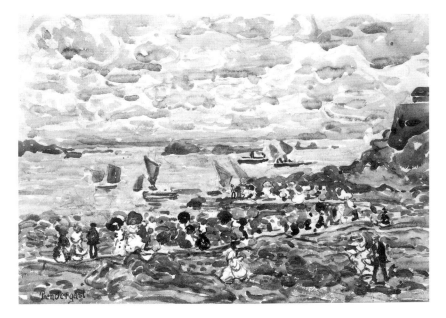

30

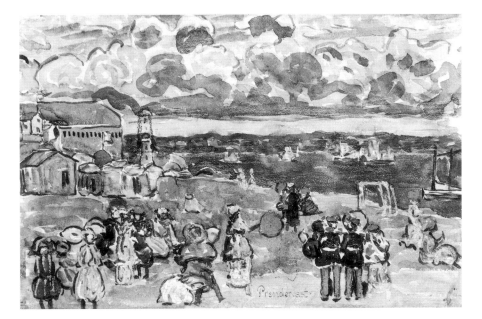

31

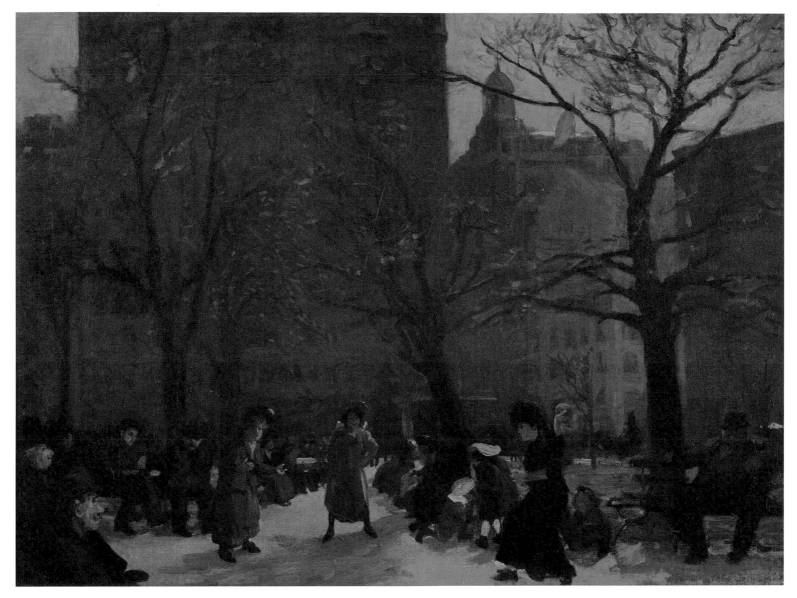

Manhattan Island

William GLACKENS

33 *East River from Brooklyn*, 1902
Also called *View of the East River from Brooklyn*
Oil on canvas, 25 ⅛ x 30
Santa Barbara Museum of Fine Arts, gift of Mrs. Sterling Morton

Exhibitions: National Arts Club, *Loan Exhibition*, 1904, no. 40

34 *Breezy Day, Tugboats, New York Harbor*, before 1908
Oil on canvas, 26 x 31 ¾
Milwaukee Art Museum, gift of Mr. and Mrs. Donald B. Abert and
Mrs. Barbara Abert Tooman

Robert HENRI

35 *East River Embankment, Winter*, 1900
Oil on canvas, 25 ¾ x 32 ⅛
Hirshhorn Museum and Sculpture Garden, Smithsonian Institution,
gift of Joseph H. Hirshhorn, 1966

Exhibitions: ?Pennsylvania Academy of the Fine Arts, *Fellowship
Exhibition* [Works by Robert Henri], 1902, no. 17

Ernest LAWSON

36 *Harlem River in Winter*, ca. 1907
Oil on canvas, 18 ⅛ x 24 ⅛
Hirshhorn Museum and Sculpture Garden, Smithsonian Institution,
gift of Joseph H. Hirshhorn, 1966

37 *Snowbound Boats*, ca. 1907
Oil on canvas, 24 ¾ x 29 ¾
National Gallery of Canada, Ottawa

Exhibitions: ?Carnegie Institute, Eleventh Annual Exhibition, 1907,
no. 269; ?National Academy of Design, Winter Exhibition, 1907-8, no.
301; Canadian Art Club, 1911, no. 32

John SLOAN

38 *Tugs*, ca. 1900
Oil on canvas, 24 x 32
Des Moines Art Center, Coffin Fine Arts Trust Fund, Nathan Emory
Coffin, 1959.33

Exhibitions: Pennsylvania Academy of the Fine Arts, Seventieth An-
nual Exhibition, 1901, no. 47; The Allan Gallery, 1901; Art Institute
of Chicago, Fourteenth Annual Exhibition, 1901, no. 317

39 *City from the Palisades*, 1908
Also called *Glimpse of New York from the Palisades*
Oil on canvas, 26 1/16 x 32 1/16
Santa Barbara Museum of Fine Arts, gift of Mrs. Sterling Morton

Exhibitions: rejected for National Academy of Design, Winter Exhibi-
tion, 1908; rejected for Pennsylvania Academy of the Fine Arts, One
Hundred and Fourth Annual Exhibition, 1909; Macdowell Club, 1912

33

35

151

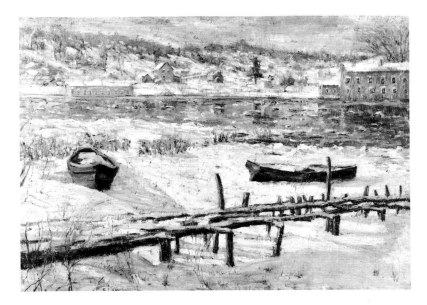

36

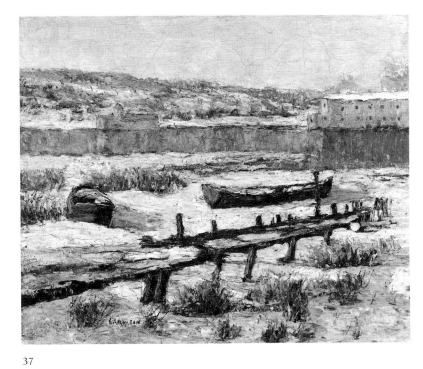

37

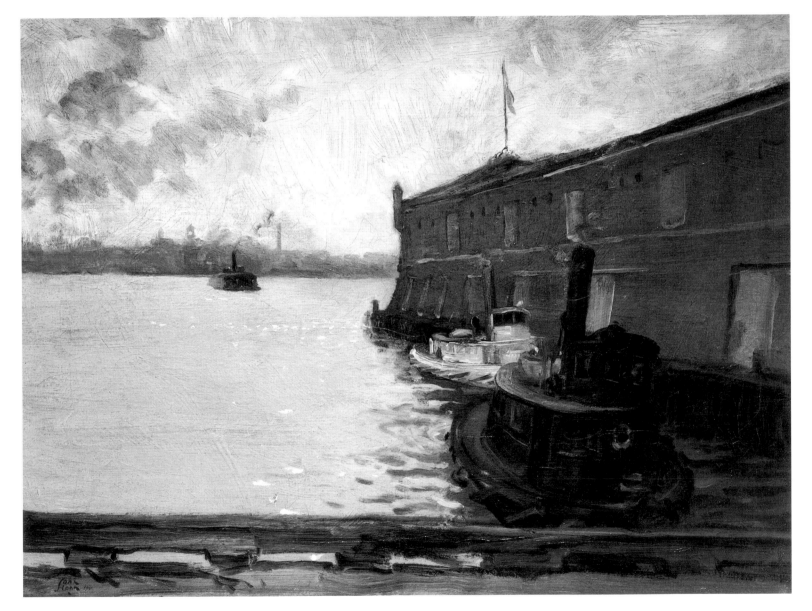

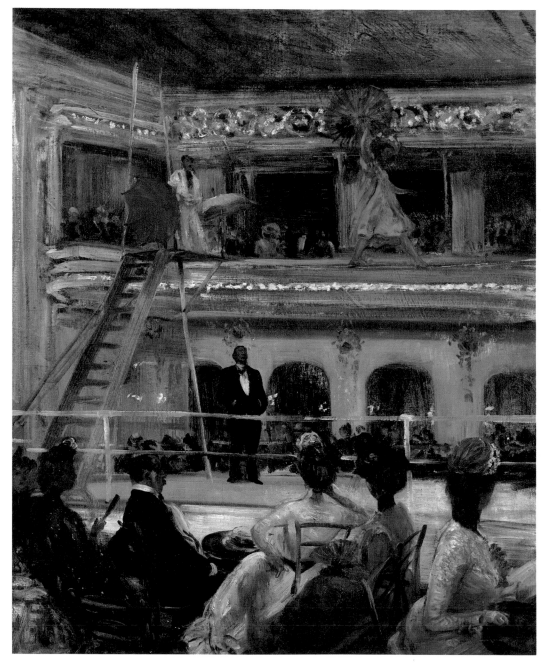

At the Theater

William GLACKENS

40 *Hammerstein's Roof Garden*, ca. 1901
 Oil on canvas, 30 x 25
 The Whitney Museum of American Art, New York

 Exhibitions: Society of American Artists, Twenty-Fourth Annual Exhibition, 1902, no. 90; Art Institute of Chicago, Seventeenth Annual Exhibition, 1904, no. 154

Everett SHINN

41 *Keith's, Union Square*, ca. 1906
 Oil on canvas, 19 13⁄$_{16}$ x 24 ⅛
 The Brooklyn Museum of Art, Dick S. Ramsay Fund

 Exhibitions: ?National Arts Club, *Special Exhibition of Contemporaneous Art*, 1908 (as *Outdoor Stage, France*)

42 *Theatre Box*, 1906
 Also called *Gaite Montparnasse*
 Oil on canvas, 16 ⅛ x 20 ⅛
 Albright-Knox Art Gallery, Buffalo, New York

 Exhibitions: *Exhibition of Paintings* [The Eight], 1908, no. 1 (Macbeth), no. 30 (Philadelphia)

42

156

43

The Mythic Vision of Arthur B. Davies

43 *Orchard Idyl*, 1896
Oil on canvas, 32 ½ x 26 ½
Babcock Galleries, New York

44 *Full-Orbed Moon*, 1901
Oil on canvas, 23 x 15 ¾
The Art Institute of Chicago, Mr. and Mrs. Martin A. Ryerson Collection

Exhibitions: *Pan-American Exposition*, Buffalo, 1901

45 *Unicorns* (*Legend — Sea Calm*), 1905
Oil on canvas, 18 ¼ x 40 ¼
The Metropolitan Museum of Art. Bequest of Lizzie P. Bliss, 1931

Exhibitions: ?Macbeth Galleries, 1905 (as *A Legend of the Sea*); National Academy of Design, Eighty-Third Annual Exhibition, 1908; *Exhibition of Paintings* [The Eight], 1908-9 tour, no. 3 (Chicago, Toledo, Detroit, Cincinnati, Pittsburgh); Women's Cosmopolitan Club, *Loan Collection of Paintings by Arthur B. Davies*, 1911-12, no. 6; Macbeth Galleries, *Loan Exhibition of Paintings, Watercolors, Drawings, Etchings and Sculpture by Arthur B. Davies*, 1918, no. 40

46 *The Flood*, before 1905
Oil on canvas, 18 ⅛ x 30
The Phillips Collection, Washington, D.C.

Exhibitions: ?Doll and Richards, Boston, 1905 (as *A Flood*); *Exhibition of Paintings* [The Eight], 1908 (shown only in Philadelphia), no. 61

47 *Sleep Lies Perfect in Them*, 1908
Oil on canvas, 18 x 39 ⅞
Worcester Art Museum, Worcester, Massachusetts, gift of Cornelius N. Bliss

Exhibitions: Society of Beaux-Arts Architects, *An Independent Exhibition of the Paintings and Drawings of Twelve Men*, 1911; Macbeth Galleries, *Exhibition of Paintings by Arthur B. Davies*, 1912, no. 48; Carnegie Institute, Eighteenth Annual Exhibition, 1913, no. 73; Art Institute of Chicago, Twenty-Sixth Annual Exhibition, 1913, no. 99; Detroit Institute of Art, First Annual, 1915, no. 94; Macbeth Galleries, *Loan Exhibition of Paintings, Watercolors, Drawings, Etchings and Sculpture by Arthur B. Davies*, 1918, no. 20

46

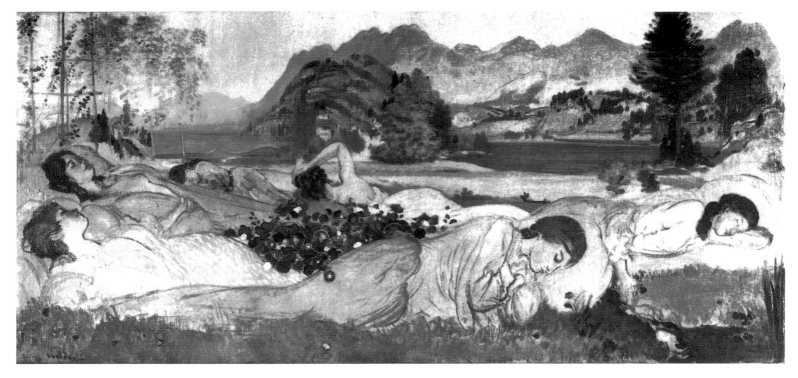

47

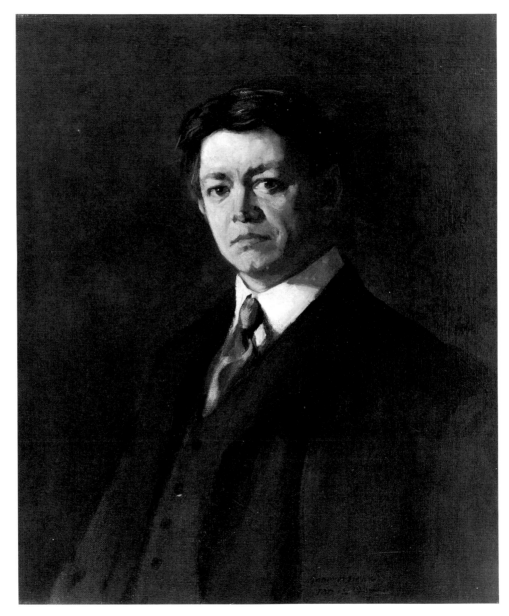

Portraits and Types

Robert HENRI

48 *Portrait of Frank Southrn*, 1904
Oil on canvas, 32 x 26
Sheldon Memorial Art Gallery Association, University of Nebraska.
Olga N. Sheldon Collection

Exhibitions: National Arts Club, *Loan Exhibition*, 1904; New York
School of Art, [One-man exhibition], 1904; Union League Club, *An
Exhibition of Portraits*, 1904, no. 19

49 *Portrait of George Luks*, 1904
Oil on canvas, 76 ½ x 38 ¼
National Gallery of Canada, Ottawa

50 *The Art Student, Portrait of Miss Josephine Nivison*, 1906
Oil on canvas, 77 ¼ x 38 ½
Milwaukee Art Museum, Purchase, 1966

Exhibitions: Society of American Artists, Twenty-Eighth Annual Ex-
hibition, 1906, no. 339; Worcester Art Museum, Ninth Annual Exhibi-
tion, 1906, no. 109; Art Institute of Chicago, Nineteenth Annual
Exhibition, 1906, no. 164; New York School of Art, 1907; McClees
Gallery, Philadelphia, 1907; Goldhandt Exhibition, Bethlehem, Penn-
sylvania, 1908; State Normal School, Westchester, Pennsylvania, 1908

51 *Dutch Girl, Laughing*, 1907
Also called *The Happy Hollander*
Oil on canvas, 32 x 26
Dallas Museum of Art, Dallas Art Association Purchase, 1909.2

Exhibitions: Philadelphia Art Club, 1908; Charleston, South Carolina,
[Exh. title unknown], 1909; Spartansburg, South Carolina, [Exh. title
unknown], 1909; Texas State Fair, 1909

49

50

George LUKS

52 *The Chess Players*, 1900
Also called *The Old Cosmopolitan Chess Club*
Oil on canvas, 25 ⅛ x 36
Yale University Art Gallery, New Haven, Connecticut

Exhibitions: Macbeth Galleries, *An Exhibition of Paintings by George Luks*, 1910; Folsom Gallery, 1912

53 *Whiskey Bill*, ca. 1901
Oil on canvas, 26 ⅛ x 18 ¼
Phoenix Art Museum, gift of Mr. and Mrs. Tom Darlington, Mr. and Mrs. James Beattie, Mr. and Mrs. Kenneth Watters, Jr., 1961

Exhibitions: Colonial Club, 1903; National Arts Club, *Loan Exhibition*, 1904, no. 12; Art Institute of Chicago, Seventeenth Annual Exhibition, 1904, no. 264

54 *The Spielers*, 1905
Also called *Girls Dancing*
Oil on canvas, 36 x 26
Addison Gallery of Art, Phillips Academy, Andover, Massachusetts

Exhibitions: Society of American Artists, Twenty-Seventh Annual Exhibition, 1905, no. 432; ?Macbeth Galleries, 1906; Macbeth Galleries, 1907; National Arts Club, *Special Exhibition of Contemporaneous Art*, 1908; Macbeth Galleries, *An Exhibition of Paintings by George Luks*, 1910, no. 6; Society of Beaux-Arts Architects, *An Independent Exhibition of the Paintings and Drawings of Twelve Men*, 1911; Albright Art Gallery, Sixth Annual Exhibition, 1911, no. 92; Folsom Gallery, 1912; Mrs. H. P. Whitney's Studio, *Modern Paintings by American and Foreign Artists*, 1916, no. 8.

Shown at Denver, Ottawa and Brooklyn

John SLOAN

55 *Stein, Profile*, 1905
 Also called *Foreign Girl*
 Oil on canvas, 36 x 27 ⅜
 Collection of Dr. and Mrs. Fouad A. Rabiah

 Exhibitions: Pennsylvania Academy of the Fine Arts, One Hundredth Anniversary Exhibition, 1905, no. 313; Art Institute of Chicago, Nineteenth Annual Exhibition, 1906, no. 282; rejected for National Academy of Design, Eighty-Second Annual, 1907; National Arts Club, *Special Exhibition of Contemporaneous Art*, 1908 (invited); rejected for Carnegie Institute, Thirteenth Annual Exhibition, 1909

51

52

165

58

The Macbeth Galleries Exhibition

Arthur Bowen DAVIES

56 *Many Waters*, ca. 1905
Oil on canvas, 17 x 22
The Phillips Collection, Washington, D.C.

Exhibitions: *Exhibition of Paintings* [The Eight], 1908 (shown only in New York and Philadelphia), no. 58; Art Institute of Chicago, *Special Exhibition of Paintings by Arthur Davies*, 1911, no. 21

William GLACKENS

57 *The Shoppers*, 1907
Oil on canvas, 60 x 60
The Chrysler Museum, gift of Walter P. Chrysler

Exhibitions: Carnegie Institute, Eleventh Annual Exhibition, 1907, no. 181; *Exhibition of Paintings* [The Eight], 1908-9 tour, no. 52 (New York), no. 57 (Philadelphia), no. 12 (Newark)

Robert HENRI

58 *Dutch Soldier*, 1907
Oil on canvas, 32 ⅝ x 26 ⅛
Munson-Williams-Proctor Art Institute, Utica, New York. Museum Purchase

Exhibitions: *Exhibition of Paintings* [The Eight], 1908-9 tour, no. 48 (New York), no. 34 (Philadelphia), no. 23 (Newark)

Ernest LAWSON

59 *An Abandoned Farm*, before 1908
Oil on canvas, 28 ⅞ x 35 ⅞
National Museum of American Art, Smithsonian Institution, gift of William T. Evans

Exhibitions: *Exhibition of Paintings* [The Eight], 1908, no. 10 (New York), no. 19 (Philadelphia)

George LUKS

60 *Mammy Groody*, ca. 1908
Also called *Old Mary*
Oil on canvas, 20 x 16
Milwaukee Art Museum, gift of Charles D. James

Exhibitions: *Exhibition of Painting* [The Eight], 1908, no. 42 (shown at New York only); ?Society of Beaux-Arts Architects, *An Independent Exhibition of the Paintings and Drawings of Twelve Men*, 1911 (as *Aunt Mary*)

Maurice Brazil PRENDERGAST

61 *Beach at Saint Malo*, ca. 1907
Oil on canvas, 17 ½ x 21
Collection of Lana and Ben Hauben

Exhibitions: ?*Exhibition of Paintings* [The Eight], 1908-9 tour, no. 25 or no. 36 (as *Beach, St. Malo*)

Everett SHINN

62 *The White Ballet*, ca. 1905
Oil on canvas, 25 ⅝ x 35 ⅞
Mr. and Mrs. Arthur G. Altschul

Exhibitions: *Exhibition of Paintings* [The Eight], 1908, no. 3 (New York), no. 26 (Philadelphia)

John SLOAN

63 *The Cot*, 1907
Oil on canvas, 36 ¼ x 30
Bowdoin College Museum of Art, Brunswick, Maine

Exhibitions: *Exhibition of Paintings* [The Eight], 1908-9 tour, no. 15 (New York), no. 48 (Philadelphia), no. 59 (Newark), no. 60 (Chicago and remaining venues); Carnegie Institute, Twelfth Annual Exhibition, 1908, no. 291; Society of Independent Artists, Second Annual Exhibition, 1918, no. 705

56

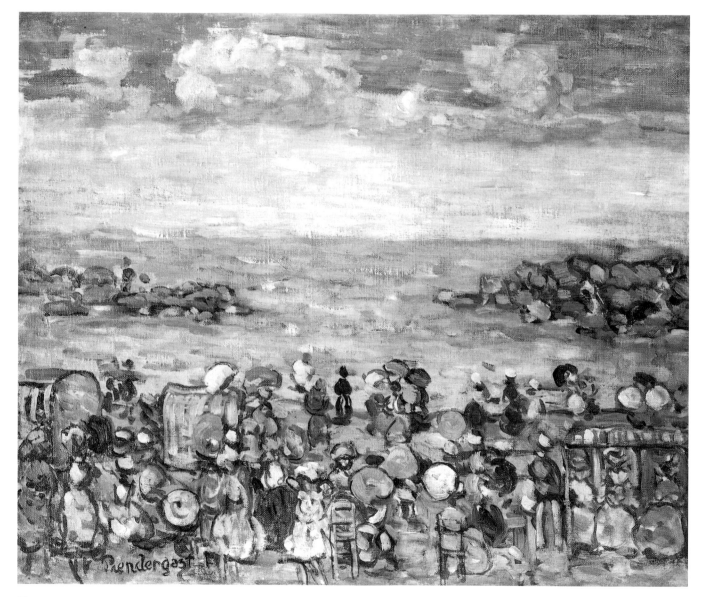

60

174

65

Aftermath: The Independent Movement

Arthur Bowen DAVIES

64 *Jewel-Bearing Tree of Amity*, 1912
Oil on canvas, 18 ¼ x 40 ⅜
Munson-Williams-Proctor Institute, Museum Purchase

Exhibitions: Macbeth Galleries, *Thirty Paintings by Thirty Artists*, 1913; Pennsylvania Academy of the Fine Arts, One Hundred and Ninth Annual Exhibition, 1914, no. 215; Albright Art Gallery, Tenth Annual Exhibition, 1915, no. 51

65 *Line of Mountains*, ca. 1913
Also called *Moral Law*
Oil on canvas, 18 x 40 ⅛
Virginia Museum of Fine Arts, gift of a Friend, Acc. No. 44.20.1

Exhibitions: Association of American Painters and Sculptors, *International Exhibition of Modern Art*, 1913, no. 924; Macbeth Galleries, *Loan Exhibition of Paintings, Watercolors, Drawings, Etchings and Sculpture by Arthur B. Davies*, 1918, no. 42

66 *Potentia*, 1913
Oil on canvas, 21 ½ x 43 ½
Indiana University Art Museum, Bloomington, Indiana

Exhibitions: Montross Gallery, New York, *Modern Departures in Painting* (traveled to Detroit, Cincinnati, and Baltimore), 1914, no. 3; Mrs. H. P. Whitney's Studio, *Modern Paintings by American and Foreign Artists*, 1916, no. 24

67 *Sacramental Tree*, 1915
Oil on canvas, 26 x 42
The Art Institute of Chicago, Mr. and Mrs. Martin A. Ryerson Collection

Exhibitions: Art Institute of Chicago, Twenty-Eighth Annual Exhibition, 1915, no. 94

William GLACKENS

68 *Nude with Apple*, 1910
Oil on canvas, 40 x 57
The Brooklyn Museum, Dick S. Ramsay Fund, 56.70

Exhibitions: *Exhibition of Independent Artists*, 1910

69 *Family Group*, 1910-11
Oil on canvas, 72 x 84
National Gallery of Art, gift of Mr. and Mrs. Ira Glackens, 1971

Exhibitions: Association of American Painters and Sculptors, *International Exhibition of Modern Art*, 1913, no. 853; Pennsylvania Academy of the Fine Arts, One Hundred and Ninth Annual Exhibition, 1914; *Panama-Pacific Exposition*, San Francisco, 1915, no. 2468

70 *Jetties at Bellport*, 1912
Oil on canvas, 25 x 30
Albright-Knox Art Gallery, Buffalo, New York. Evelyn Cary Rumsay Fund, 1935

71 *Beach Side*, 1913-14
Oil on canvas, 26 x 32
The Nelson-Atkins Museum of Art, Kansas City, Missouri (Bequest of Miss Frances Logan) 47-109

Exhibitions: Folsom Gallery, 1913

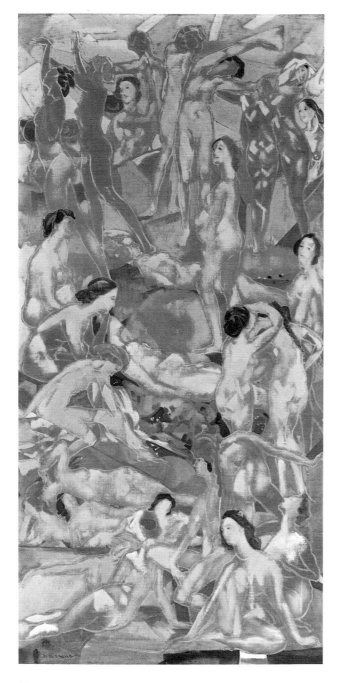

Robert HENRI

72 *Salome*, 1909
 Oil on canvas, 77 x 37
 Mead Art Museum, Amherst College, Amherst, Massachusetts

 Exhibitions: Texas State Fair, 1909; rejected by National Academy of
 Design, 1910; *Exhibition of Independent Artists*, 1910

73 *Dutch Joe*, 1910
 Oil on canvas, 24 x 20 ³⁄₁₆
 Milwaukee Art Museum, gift of Samuel O. Buckner

 Exhibitions: *Exhibition of Independent Artists*, 1910; Syracuse, [One-
 man show] 1910; Wm. Taylor & Son, Cleveland, *Special Henri Exhibi-
 tion*, 1912

74 *Figure in Motion*, 1912
 Oil on canvas, 77 x 37
 Daniel J. Terra Collection. Terra Museum of American Art, Chicago,
 Illinois

 Exhibitions: Association of American Painters and Sculptors, *Interna-
 tional Exhibition of Modern Art*, 1913, no. 835; Cincinnati Museum
 Association, 1916

75 *West Coast of Ireland*, 1913
 Oil on canvas, 26 x 32
 Everson Museum, Syracuse University

 Exhibitions: St. Mark's Gallery, New York, 1914

76 *Tam Gan*, 1914
 Oil on canvas, 24 x 20
 Albright-Knox Art Gallery, Buffalo, New York. Sarah A. Gates Fund,
 1915

 Exhibitions: Museum of History, Science and Art, Los Angeles, *Special
 Henri Exhibition*, 1914; Macbeth Galleries, [Exh. title unknown], 1914;
 State Normal School, Westchester, Pennsylvania [Exh. title unknown],
 1915; Gage Gallery, Cleveland, *Special Henri Exhibition*, 1915; Albright
 Art Gallery, Tenth Annual Exhibition, 1915, no. 79; City Art Museum,
 Saint Louis Tenth Annual Exhibition, 1915; Art Institute of Chicago,
 Twenty-Eighth Annual Exhibition, 1915, no. 171; Detroit Institute of
 Arts, Second Annual, 1916.

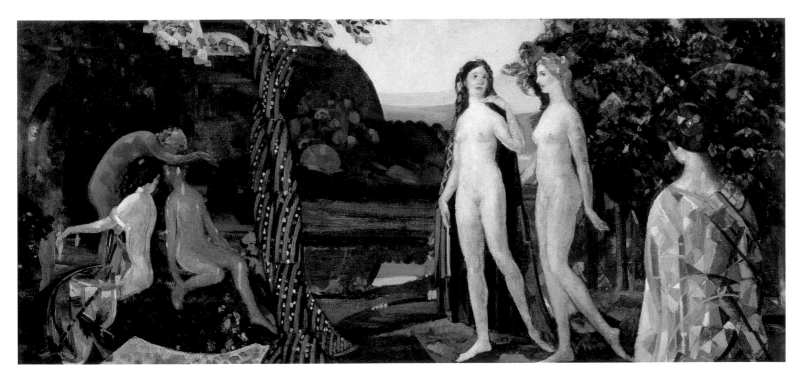

64

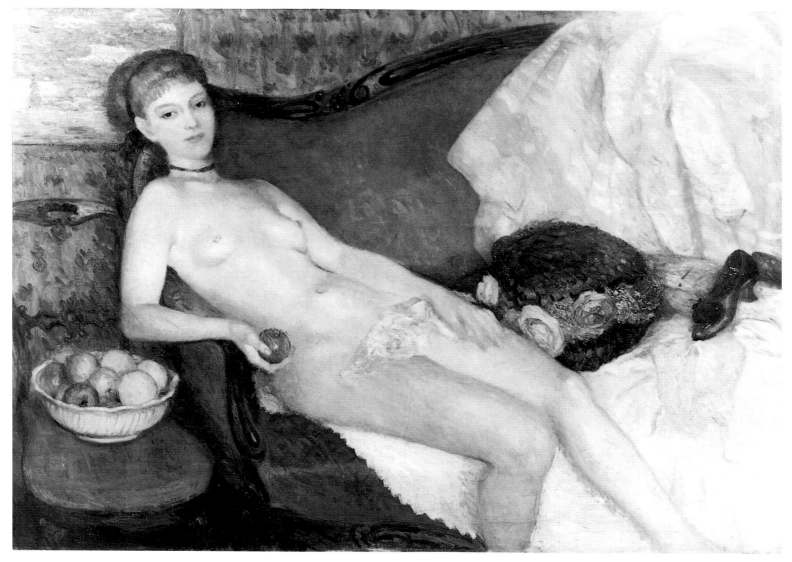

178

68

Ernest LAWSON

77 *Spring Night, Harlem River*, 1913
 Oil on canvas, 25 ⅛ x 30 ⅛
 The Phillips Collection, Washington, D.C.

 Exhibitions: Levesque Gallery, Paris, 1914, no. 19 (as *Le Grand Pont*)
 or no. 20 (as *Le Pont*)

78 *Boys on Canal Boat*, ca. 1914
 Oil on canvas, 25 x 30
 Ex-Collection John Quinn
 Collection of James and Barbara Palmer, courtesy Babcock Gallery

79 *The Garden*, 1914
 Oil on canvas, 20 x 24
 Memorial Art Gallery of the University of Rochester, gift of the
 estate of Emily and James Sibley Watson

80 *Boat Club in Winter*, ca. 1915
 Oil on canvas, 16 ⁵⁄₁₆ x 20 ¼
 Milwaukee Art Museum, gift of Samuel O. Buckner

George LUKS

81 *Roundhouse at Highbridge*, 1909-10
 Oil on canvas, 30 ⅜ x 36 ⅛
 Munson-Williams-Proctor Institute, Utica, New York

 Exhibitions: Kraushaar Gallery, 1914

82 *Holiday on the Hudson*, ca. 1912
 Oil on canvas, 30 x 36 ⅛
 The Cleveland Museum of Art

 Shown at Milwaukee and Denver

83 *Bleecker and Carmine Streets*, ca. 1915
 Oil on canvas, 25 x 30
 Milwaukee Art Museum, gift of Mr. and Mrs. Donald B. Abert and
 Mrs. Barbara Abert Tooman, 1976

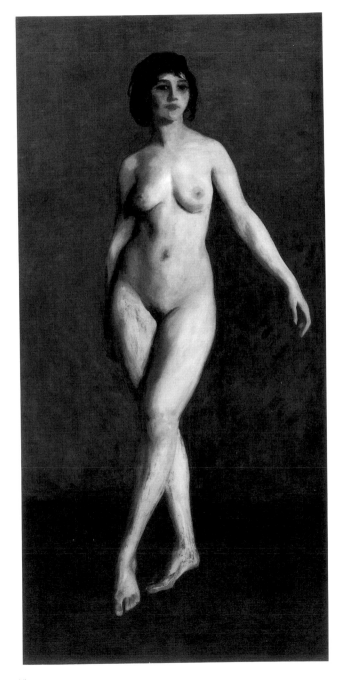

179

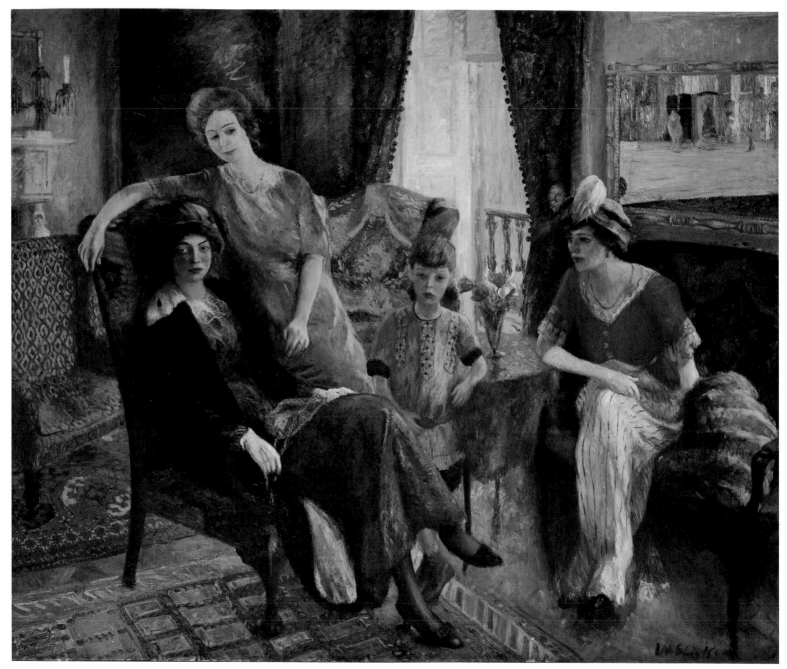

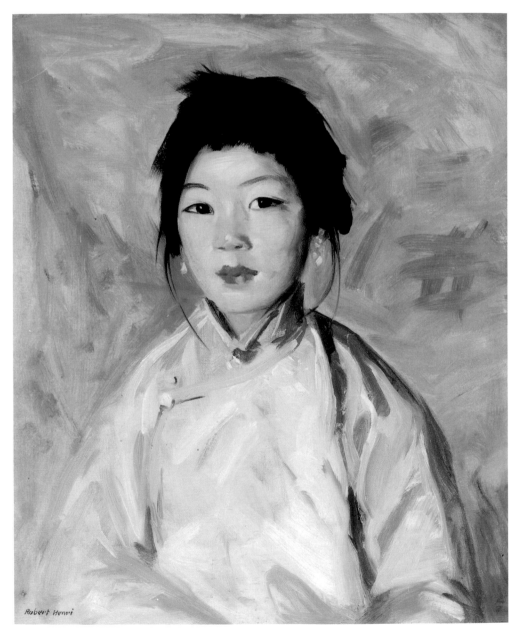

181

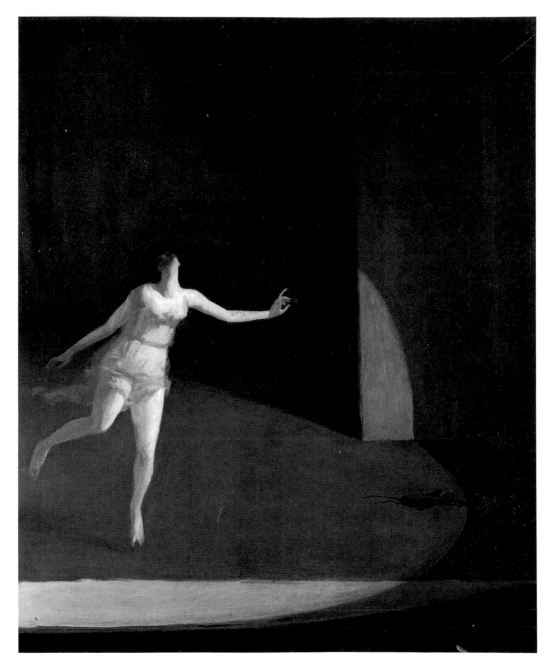

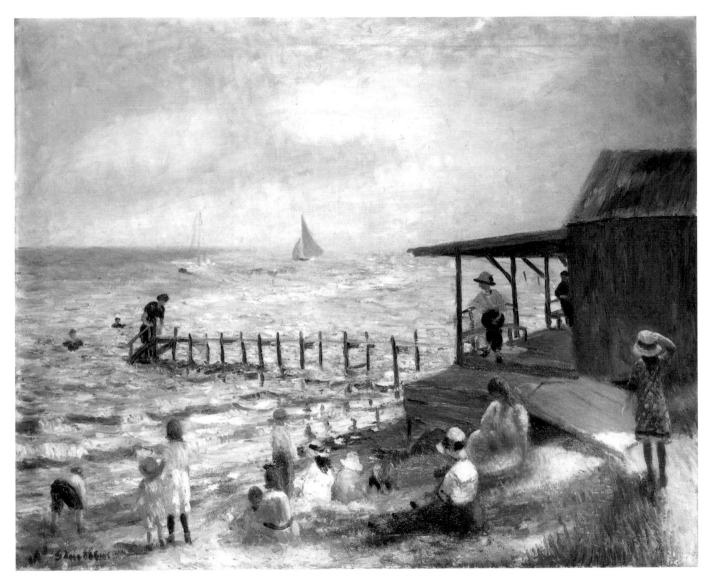

71

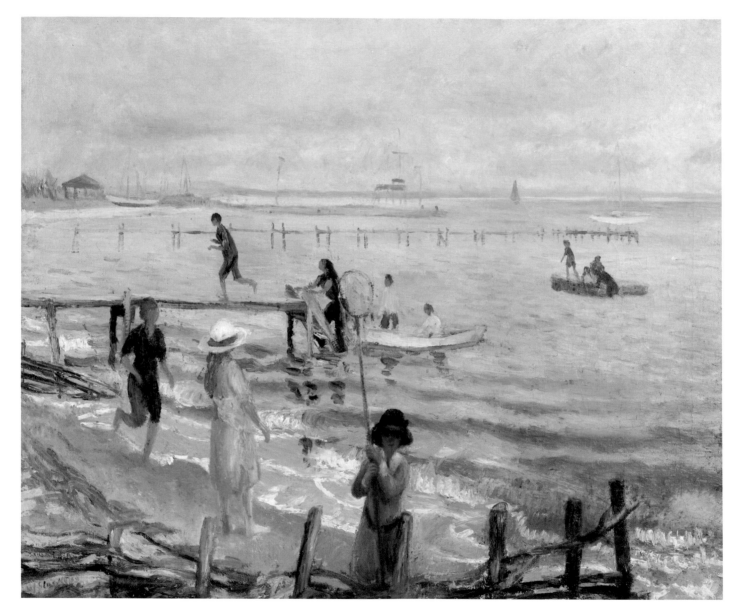

79

186

73

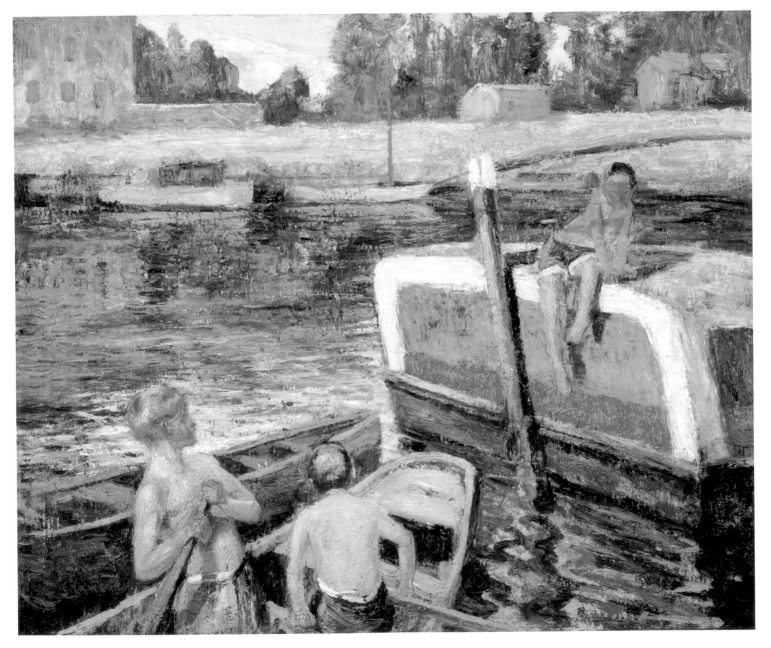

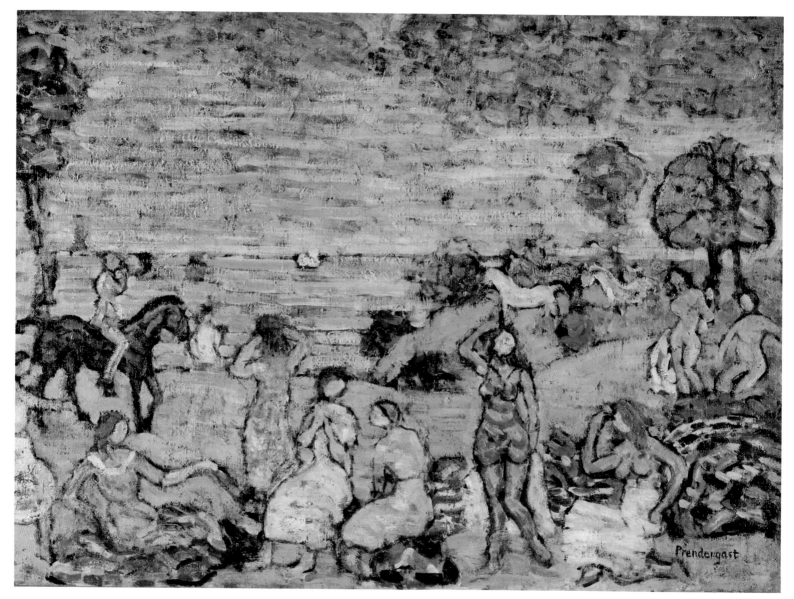

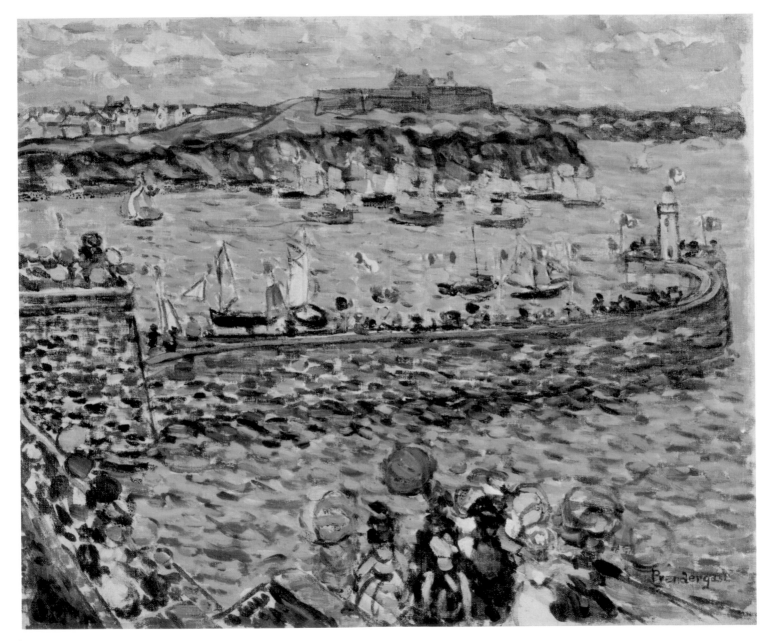

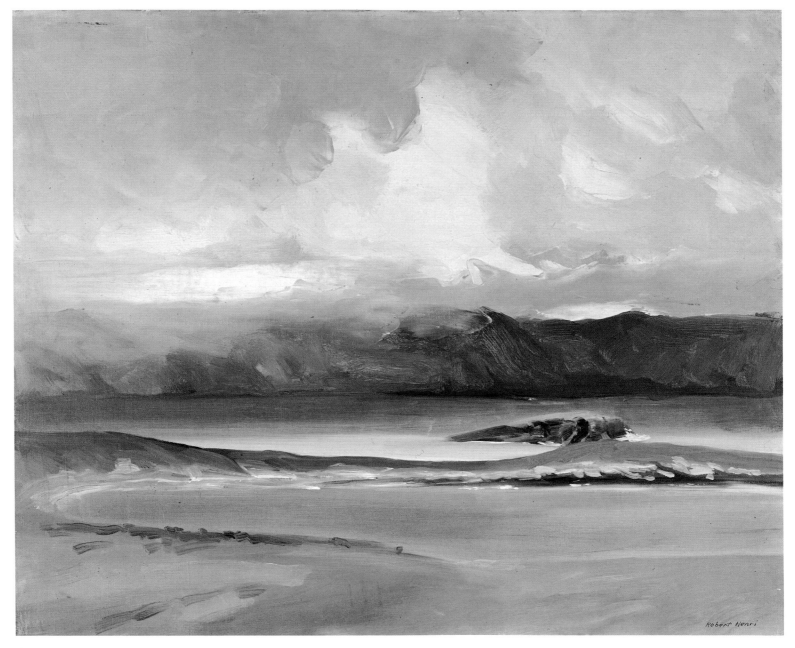

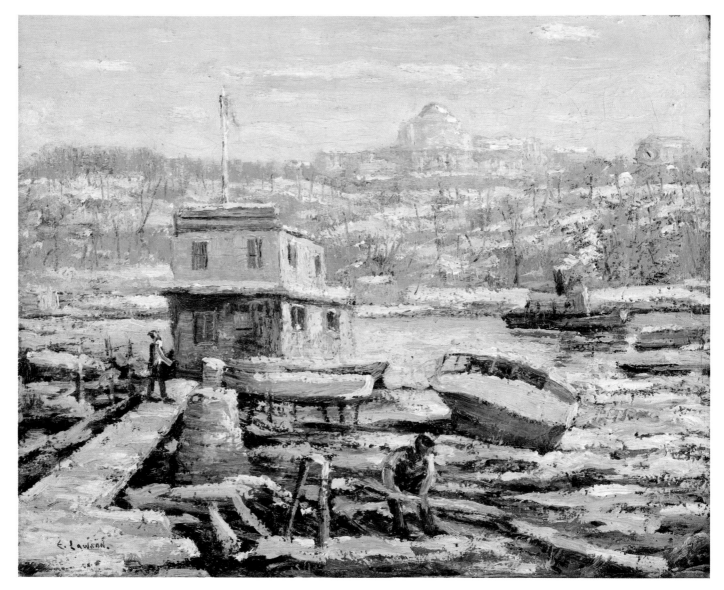

Maurice Brazil PRENDERGAST

84 *Lighthouse at Saint Malo*, 1909
Oil on canvas, 20 ⅛ x 24 ⅝
William Benton Museum of Art, The University of Connecticut, gift
of Mrs. Eugenie Prendergast

85 *Picnic by the Sea*, 1915
Oil on canvas, 24 ¼ x 32 ⅛
Milwaukee Art Museum, gift of the Family of Donald B. Abert in his
Memory

Exhibitions: ?Carroll Galleries, *Maurice B. Prendergast Paintings in Oil
and Watercolor*, 1915

John SLOAN

86 *Three A.M.*, 1909
Oil on canvas, 32 x 26
Philadelphia Museum of Art, gift of Mrs. Cyrus McCormick, 1946

Exhibitions: rejected for National Academy of Design, Eighty-Fifth
Annual Exhibition, 1910; *Exhibition of Independent Artists*, 1910; Mrs.
H. P. Whitney's Studio, *Paintings, Drawings and Etchings by John Sloan*,
1916, no. 11; Hudson Guild, 1916, no. 24

87 *Isadora Duncan*, 1911
Oil on canvas, 32 ¼ x 26 ¼
Milwaukee Art Museum, gift of Mr. and Mrs. Donald B. Abert

Exhibitions: rejected for Carnegie Institute, Fifteenth Annual Exhibi-
tion, 1911; Macdowell Club, 1912; Rand School, New York, 1915; Mrs.
H. P. Whitney's Studio, *Paintings, Drawings and Etchings by John Sloan*,
1916, no. 13

88 *McSorley's Bar*, 1912
Also called *McSorley's Ale House*
Oil on canvas, 26 x 32
Detroit Institute of Arts, gift of the Founders' Society

Exhibitions: Association of American Painters and Sculptors, *Interna-
tional Exhibition of Modern Art*, 1913, no. 907; Pennsylvania Academy
of the Fine Arts, One Hundred and Ninth Annual Exhibition, 1914;
Art Institute of Chicago, Twenty-Seventh Annual Exhibition, 1914, no.
284; Panama-Pacific Exposition, San Francisco, 1915; Denver [Exh.
title unknown], 1916

89 *Autumn Dunes*, 1914
Oil on canvas, 26 ¼ x 32 ¼
Milwaukee Art Museum, gift of Mr. and Mrs. Donald B. Abert

Exhibitions: *Panama-California Exhibition*, San Diego, 1915

194

81

Bibliography

Atlanta, High Museum of Art. *The Advent of Modernism*, 1986. (exhibition catalog)

BERRY-HILL, Henry and Sidney. *Ernest Lawson, N.A.: American Impressionist.* Leigh-on-Sea, 1968.

BROOKS, Van Wyck. *John Sloan, A Painter's Life*. New York, 1955.

BROWN, Milton. *The Story of the Armory Show* (new edition). New York, 1988.

CLARK, Carol et al. *Maurice Brazil Prendergast and Charles Prendergast: A Catalogue Raisonné*. Williamstown, Massachusetts, 1990.

CZESTOCHOWSKI, Joseph. *The Works of Arthur B. Davies* . Chicago, 1979.

DE SHAZO, Edith. *Everett Shinn, A Figure in His Time*. New York, 1974.

ELZEA, Rowland. *John Sloan: Spectator of Life*. Wilmington, Delaware, 1988.

FINK, Lois Marie. *American Art at the Nineteenth-Century Paris Salons.* Washington, 1990.

GLACKENS, Ira. *William Glackens and the Ash Can Group*. New York, 1957.

HENRI, Robert. *The Art Spirit*. Philadelphia, 1923.

HOMER, William Innes. *Robert Henri and His Circle* (revised edition). New York, 1988.

PERLMAN, Bennard. *The Immortal Eight: American Painting from Eakins to the Armory Show, 1870-1913*. Cincinnati, 1979.

SLOAN, John. *The Gist of Art*. New York, 1939.

———— . *John Sloan's New York Scene*. Edited by Bruce St. John. New York, 1965.

YOUNG, Mahonri Sharp. *The Eight: The Realist Revolt in American Painting.* New York, 1973.

WEINBERG, H. Barbara. *The Lure of Paris: Nineteenth Century American Painters and their French Teachers*. New York, 1991.

WRIGHT, Brooks. *The Artist and the Unicorn, the Lives of Arthur B. Davies.* Rockland County, New York, 1978.

ZURIER, Rebecca. *Art for The Masses (1911-1917) A Radical Magazine and its Graphics*. New Haven, 1985.

Articles and Reviews Concerning The Eight: 1907-1909

"Portrait Painters of Today. Robert Henri." *Vogue* (3 January 1907).

"Editorial." *The Evening Post* (New York), 9 March 1907.

"The 'Thirty' and Mr. Henri. Why the Painter Withdrew His Academy Canvases." *The Evening Post* (New York), 13 March 1907.

"National Academy Stirred." *The Sun* (New York), 14 March 1907.

[Gregg, Frederick James?]. "Academicians and Outsiders." *The Evening Sun* (New York), 14 March 1907.

"Jar in Jury of National Academy." *The World* (New York), 15 March 1907.

"A Varnishing Day Crush." *The Evening Post* (New York), 16 March 1907.

[Gregg, Frederick James?]. "That Tragic Wall." *The Sun* (New York), 16 March 1907.

Hartmann, Sadakichi. "The Academy. A Retired Critic's View of the Current Exhibition." *The Evening Sun* (New York), 16 March 1907.

"The Academy, Its Pride and Glory." *The New York Times*, 17 March 1907.

De Kay, Charles. "In the World of Art. Artists at Their Little Games." *The New York Times*, 17 March 1907.

[Huneker, James]. "George Luks." *The Sun* (New York), 21 March 1907.

[Townsend, James B.]. "The Henri Hurrah." *American Art News*, 23 March 1907.

"Two Admired of Mr. Robert Henri." *New York Herald*, 31 March 1907.

"George Luks. Former Newspaper Illustrator Wins Recognition as Painter of Rare Ability." *The National Advertiser*, 31 (1 April 1907).

"Protests Against Psychopathic Art." *New York Herald*, 5 April 1907.

"Academy Bars Noted Artists." *The Evening Mail* (New York), 11 April 1907.

"Door Slammed on Painters." *The Sun* (New York), 12 April 1907.

"Artists Stirred by Election." *The Evening Post* (New York), 12 April 1907.

"Mr. Henri Off 'Academy' Jury." *New York Herald*, 12 April 1907.

"National Academy Elects 3 Out of 36. 'Progressive' Painters Criticize the 'Conservatives' Who Are in Control." *The New York Times*, 12 April 1907.

"Art Topics of an Important Week. The Academy and Its Slaughter of Candidates." *The Sun* (New York), 13 April 1907.

Swift, Samuel. "Revolutionary Figures in American Art." *Harper's Weekly* 51 (13 April 1907).

"Art According to the Academy." *The World* (New York), 14 April 1907.

"The National Academy." *The Sun* (New York), 15 April 1907.

"Academy Can't Corner All Art." *The Evening Mail* (New York), 14 May 1907.

[Cortissoz, Royal]. "A New Art Group. Eight Painters Join to Give Annual Exhibitions." *New-York Daily Tribune*, 15 May 1907.

"Eight Independent Painters." *The Sun* (New York), 15 May 1907.

"New Art Salon Without a Jury." *New York Herald*, 15 May 1907.

"The Eight." *The Evening Sun* (New York), 15 May 1907.

"New York to Have a 'Salon.'" *Boston Evening Transcript*, 15 May 1907.

De Kay, Charles. "Wolves That Stalk the Academic Sheep Fold. Academy Threatened by a Realistic Eight." *The New York Times*, 19 May 1907.

"Wm. M. Chase Forced Out of N.Y. Art School: Triumph for the 'New Movement' Led by Robert Henri." *New York American*, 20 November 1907.

"Chase, Nettled, Leaves Art School He Founded." *The World* (New York), 21 November 1907.

"What Is Art, Anyhow?" *New York American*, 1 December 1907.

Chamberlin, Joseph Edgar. "Significant Exhibitions." *The Evening Mail* (New York), 5 January 1908.

[Huneker, James]. "Around the Galleries." *The Sun* (New York), 14 January 1908.

"Contemporary Art at National Club." *The New York Times*, January 1908.

Mary Fanton Roberts [Giles Edgerton]. "The Younger Painters of America, Are They Creating a National Art?" *The Craftsman* 13 (February 1908).

"New York's Art War and the Eight Rebels." *The World Magazine* (New York), 2 February 1908.

"Secession in Art." *New York Herald*, 2 February 1908.

"Striking Pictures by Eight 'Rebels.'" *New York Herald*, 4 February 1908.

"'The Eight' Exhibit New Art Realism." *New York American*, 4 February 1908.

[Hoeber, Arthur]. "Art and Artists." *New York Globe and Commercial Advertiser*, 5 February 1908.

Cortissoz, Royal. "Art Exhibitions." *New-York Daily Tribune*, 5 February 1908.

"Eight Artists Join in an Exhibition." *The New York Times*, 6 February 1908.

"Exhibition of the Eight." *Boston Evening Transcript*, 6 February 1908.

De Kay, Charles. "Eight Man Show at Macbeth's." *New York Evening Post*, 7 February 1908.

"Art and Talk." *The Evening Sun* (New York), 8 February 1908.

Townsend, James B. " 'The Eight' Arrive." *American Art News*, 8 February 1908.

"A Rebellion in Art Led by Former Philadelphians." *The Philadelphia Press*, 9 February 1908

[Huneker, James]. "Eight Painters: First Article." *The Sun* (New York), 9 February 1908.

McCormick, William B. "Art Notes of the Week." *The New York Press*, 9 February 1908.

[Huneker, James]. "Eight Painters: Second Article." *The Sun* (New York), 10 February 1908.

Macbeth Galleries. "Art Notes." (March 1908).

"3 Art Exhibitions At the Academy." *The Evening Bulletin* (Philadelphia), 7 March 1908.

"Art and Artists." *Philadelphia Inquirer*, 8 March 1908.

"Paintings On View at Academy of the Fine Arts." *Philadelphia Public Ledger*, 8 March 1908.

"Art and Artists." *The Philadelphia Press*, 9 March 1908.

Barrell, Charles Wisner. "Robert Henri — 'Revolutionary.' " *The Independent* 64 (25 June 1908).

Oliver, Maude I. G. "Activities at the Art Institute." *Chicago Record-Herald*, 20 September 1908.

_____. [Review of The Eight]. *Chicago Record-Herald*, 29 September 1908.

McCauley, I. M. "Art and Artists." *Chicago Evening Post*, 26 September 1908.

[Review of The Eight]. *Chicago Evening Post*, 29 September 1908.

"Striking Originality in the Work of 'The Eight.' " *Toledo News-Bee*, 15 October 1908.

"At the Museum of Art." *Toledo Daily Blade*, 14 November 1908.

O'Brien, Bertha V. "Canvases of 'The Eight' No Beauty Feast." *Detroit Free Press*, 29 November 1908.

"R. Henri to Head a School. Girl Students Flock to the Support of the Artist." *New York Sun*, 6 January 1909.

Fox, W. H. "Eight Painters' Work Gives Shock to Many." *Indianapolis News*, 9 January 1909.

Behrens, William F. "Art Notes." *Cincinnati Commercial Tribune*, 7 February 1909.

Sutley, M. "The Art Exhibits at Carnegie Library Are Worth Seeing." *Pittsburgh Dispatch*, 14 March 1909.

"Art Exhibition Opens Tomorrow." *Bridgeport Standard*, 9 April 1909.

"Art Notes." *New York Sun*, 22 April 1909.

"Widely Shown Exhibition of 'The Eight' American Artists at the Public Library." *Newark Evening News*, 1 May 1909.

" 'The Eight' Stir Up Many Emotions." *Newark Evening News*, 8 May 1909.

View of the American Gallery, International Exhibition of Modern Art (the "Armory Show"), when installed at The Art Institute of Chicago, March-April 1913. Henri's *Figure in Motion* can be seen in the background just right of center. Photograph courtesy of The Art Institute of Chicago.